Miró

NINETY YEARS

The Publisher gratefully acknowledges the assistance of the
Ayuntamiento, Barcelona and the Galería Maeght, Barcelona

The quotation at the end of this volume is taken from 'Je rêve d'un grand
atelier', *XXe Siècle*, 1ère année, no. 2, May – June 1938, p.25.

A **Macdonald** book
© Francesc Català-Roca 1984 for the photographs
© Lluis Permanyer 1984 for the text
© Ediciones 62 S A 1984 for the original edition
© Arnoldo Mondadori Editore S.p.A. 1985 for the international edition
© Arnoldo Mondadori Editore S.p.A. 1986 for English translation

First published in Great Britain in 1986
by Macdonald & Co (Publishers) Ltd
London & Sydney

A member of BPCC plc

British Library Cataloguing in Publication Data

Català-Roca, Francesc
 Miró, ninety years.
 I. Miró, Joan
 I. Title II. Permanyer, Lluis
 759.6 ND813.M5

 ISBN 0–356–12455–X

Filmset by Tradespools Ltd, Frome, Somerset

Printed and bound in Spain by Artes Gràficas, Toledo S.A.
D. L. TO: 979-1986

Macdonald & Co (Publishers) Ltd
Greater London House
Hampstead Road
London NW1 7QX

Miró
NINETY YEARS

FRANCESC CATALÀ-ROCA

Text by LLUIS PERMANYER

Macdonald

INTRODUCTION

This book is our tribute to the great Catalan artist Joan Miró. A man of legendary silence. Miró strove to communicate by means of his own unique synthesis of graphics and colour. His language was always plastic; his world was always the work to which he obsessively devoted himself, and nothing else really interested him. The sublimation of his artistic legacy was achieved thanks to an incomparable poetic gift. For more than half a century he stood tenaciously and courageously in the vanguard of art. He never made concessions, always retained his capacity to be a rebel, and took it upon himself brutally and systematically to destroy all conservative, academic, traditional and bourgeois canons in order to build a plastic world that would offer new hope for future generations.

He once confessed to me that he wanted to be known by posterity as someone who had worked hard and honourably. This is why nearly all the photographs included in this book capture the true image of the artist either fully absorbed in his daily task of creation, or deep in thought, in different studios, surrounded by his work in an extremely private and personal atmosphere. These images therefore represent a very special testimony for a variety of reasons.

Firstly, Miró was a solitary who shied away from publicity as well as critics and journalists. In addition, he was not a frequenter of salons nor was he a mixer; he loathed gatherings, social conventions and intellectual coteries. This was evidenced by his arrival in Paris when, after being warmly received into dadaist and later, surrealist, circles, he avoided everyone. He cherished only the avant-garde poets from whom he drew inspiration.

Sometimes, however, he would go and see the militant followers of the energetic founder of surrealism André Breton: it was as though he was fulfilling a duty by visiting the family. At these visits he would listen silently, smile, then take his leave. Thus we have only included photographs of Miró at work, as these are the most authentic and truly unique.

Secondly—and I think this is important—Miró never let anyone watch him while he was busy working in his studio. He was distracted by anyone who watched him at work and would become nervous whenever he was photographed or filmed working. Those who have seen this artist on television will know that in interviews he nearly always appeared tense and stiff, with a self-conscious smile or even with the kind of long-suffering expression one sees in the dentist's waiting room. The truth is that he never knew what kind of expression or demeanour to adopt, and if he was filmed at work, I am sure that he was in fact pretending to do so, purely because someone had insisted on it. The only exception was with Català-Roca.

Francesc Català-Roca met Miró more than 30 years ago and they immediately became firm friends. I am convinced that Miró found in him a kindred spirit, whose field happened to be photography. He had shared a similar kinship with Papitu Llorens Artigas

and Joanet Gardy Artigas, the Parelladas (father and son), Josep Royo and Joan Barbarà, when he was creating ceramics, wax-mould sculpture, tapestry and graphic art respectively. Miró, therefore, never considered Català-Roca to be a photographer as such, but rather accepted him as a friend with whom he was working by allowing his picture to be taken while he carried on with his artistic creation as if nothing unusual were happening. From the very beginning Miró managed to ignore his presence even though he nearly always had Català Roca at his side. The photographer is a clear, direct and lively artist, not an intellectual; this is evident thoughout his work, and it is a style that was naturally compatible with Miró's personality.

All this explains how this extraordinary photographic document came into being. I know of no other collection so replete with pictures of a leading world artist in his studio. This book is also unique because of the outstanding quality of the photographs, carefully selected from thousands of shots.

We have here a human testimony offering a glimpse of those mysterious moments when the passionate, stirring miracle of artistic creation is born. I can testify to this, for Miró was kind enough to allow me to stay near him while he was working. He sometimes even explained why he was doing a certain thing or how he felt; he showed me sketches he had made while relaxing after dinner and confided that they were the beginning of a large canvas or a sculpture. When I look at this selection of photographs by Català-Roca, I relive those unforgettable days spent in a number of studios while Miró was busy creating, because these photographs grasp life as it was: there is no fiction, everything is true to life, they have the warmth of Miró's vitality in action and vibrate with the fascinating power of creativity.

This photographic document will have the rare virtue of being a lasting record of the image of Joan Miró the artist at work.

I. BARCELONA, HIS BELOVED HOMETOWN

Barcelona always meant more to Miró than just the town where he was born. Even though he was not an immediate success, even though he was avant-garde and, being young, enthusiastic and full of fighting spirit, decided to leave home and take a leap forward (to Paris), he was still fascinated by the slums that were the home of friends and admirers such as Prats, Gomis, Gasch. It was in Barcelona that he had his first studio; here he returned to live when the Second World War broke out, and here he engraved the denunciation of Franco's regime in his famous *Barcelona Series*. Younger men such as the poet Joan Brossa and the painter Antoni Tàpies found in his example and mastery a committed artistic path along which they could fight against the dictatorship. Barcelona and Miró were firmly attached to one another by the intimate bonds that find spectacular expression in the retrospective at the Hospital de la Santa Creu, in the airport mural and the gigantic 22-metre (72-foot) sculpture, in the painted glass in the Architects' College, in the Foundation that bears his name.

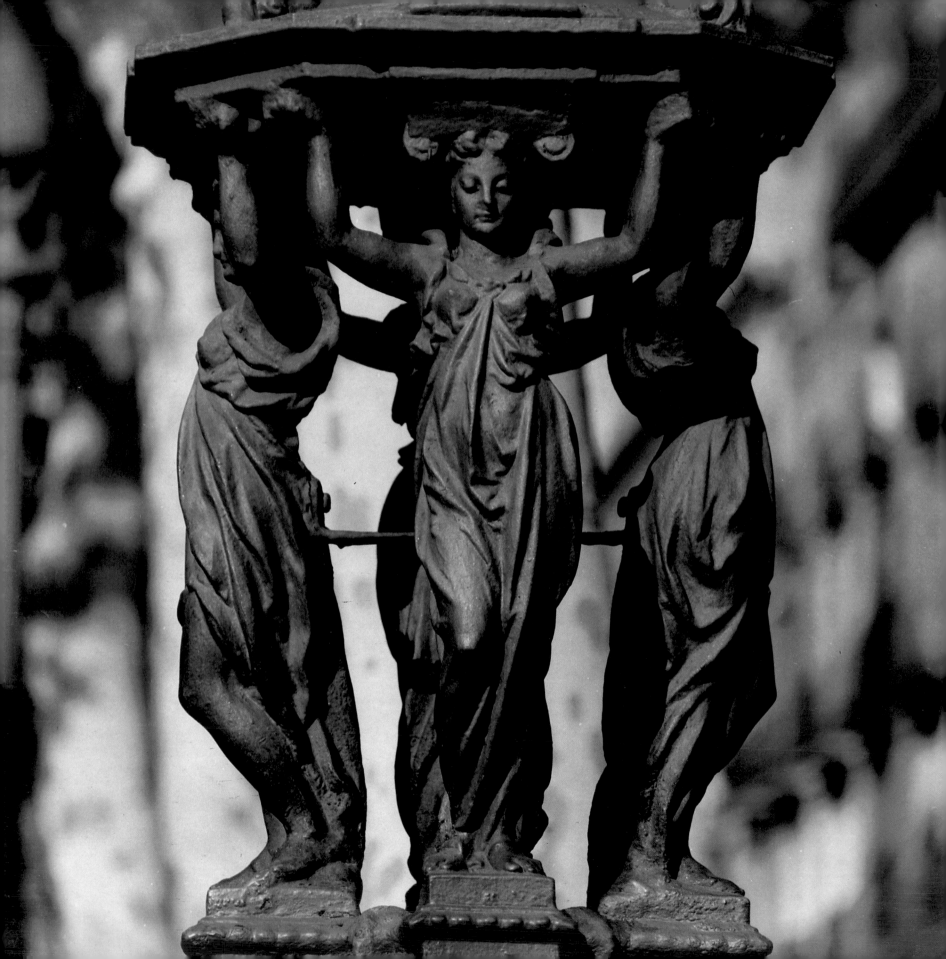

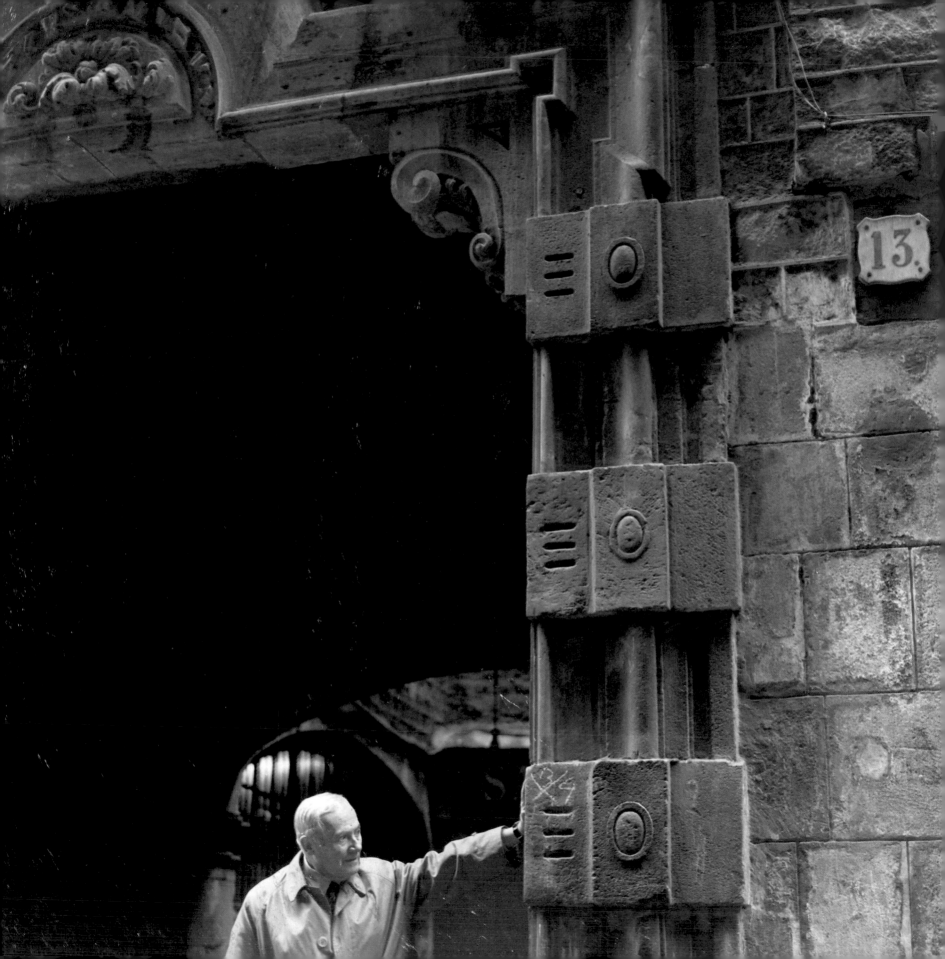

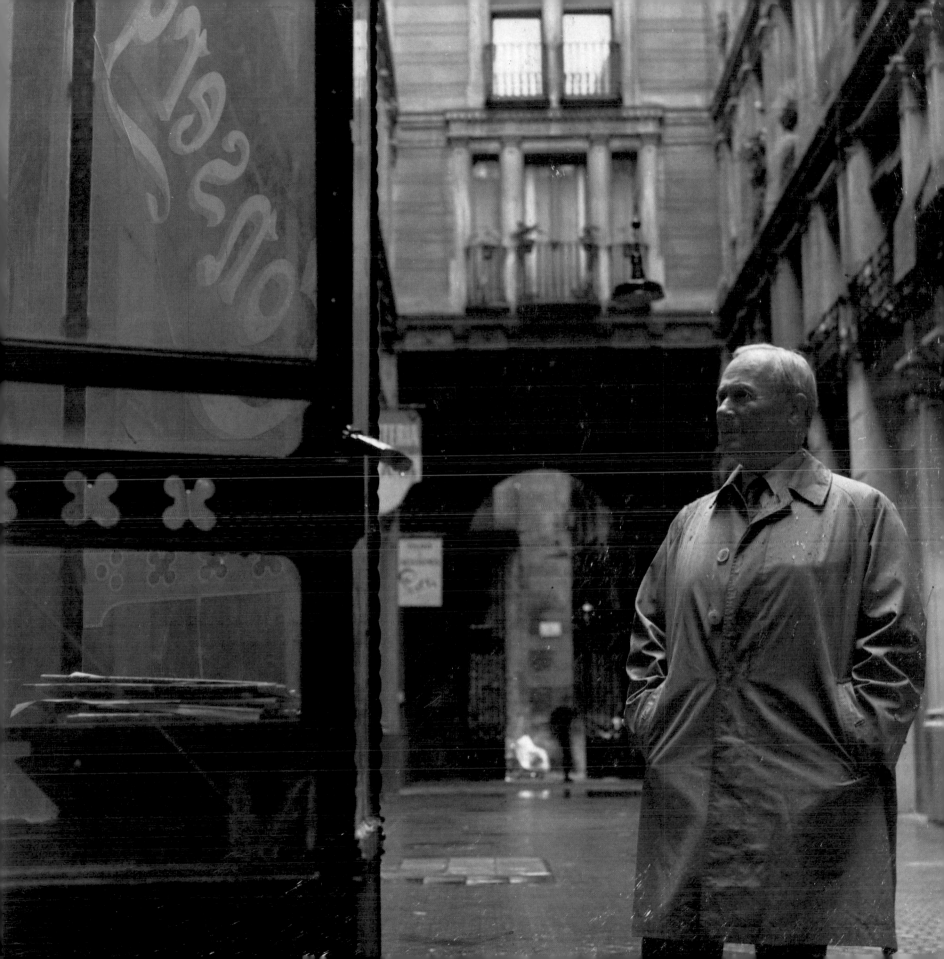

Juan Miró Ferrà 19

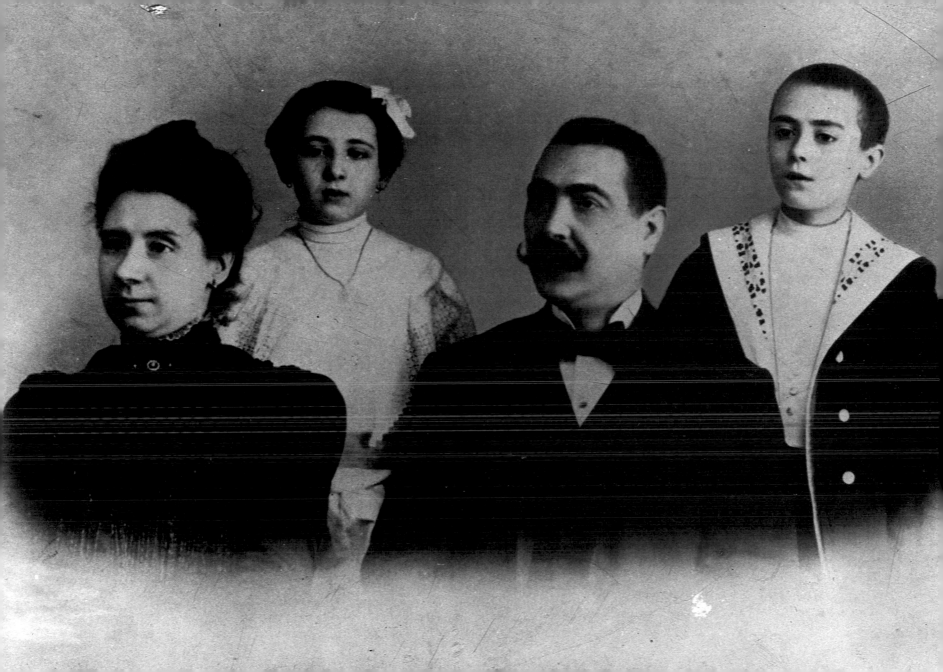

Albarca
1906

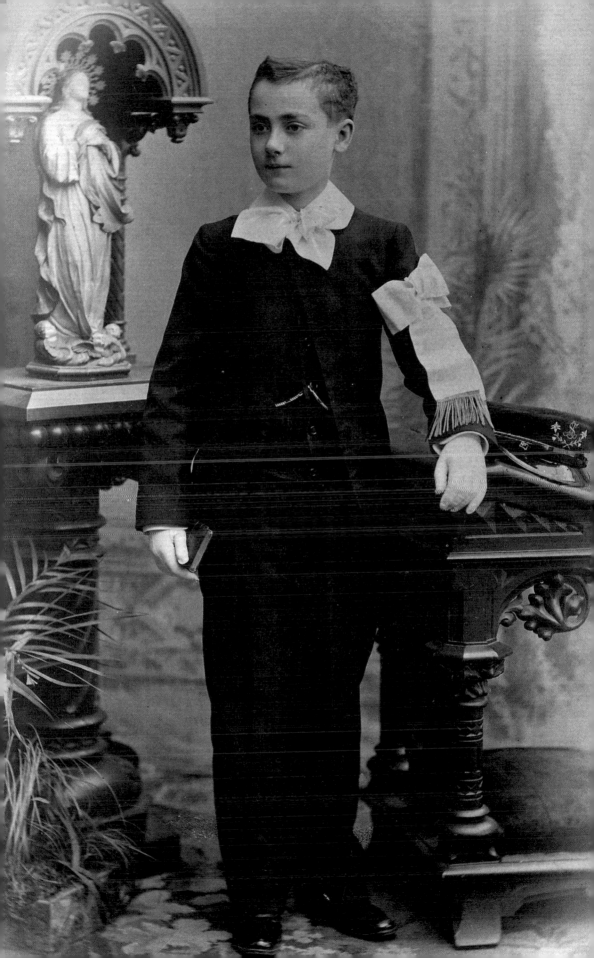

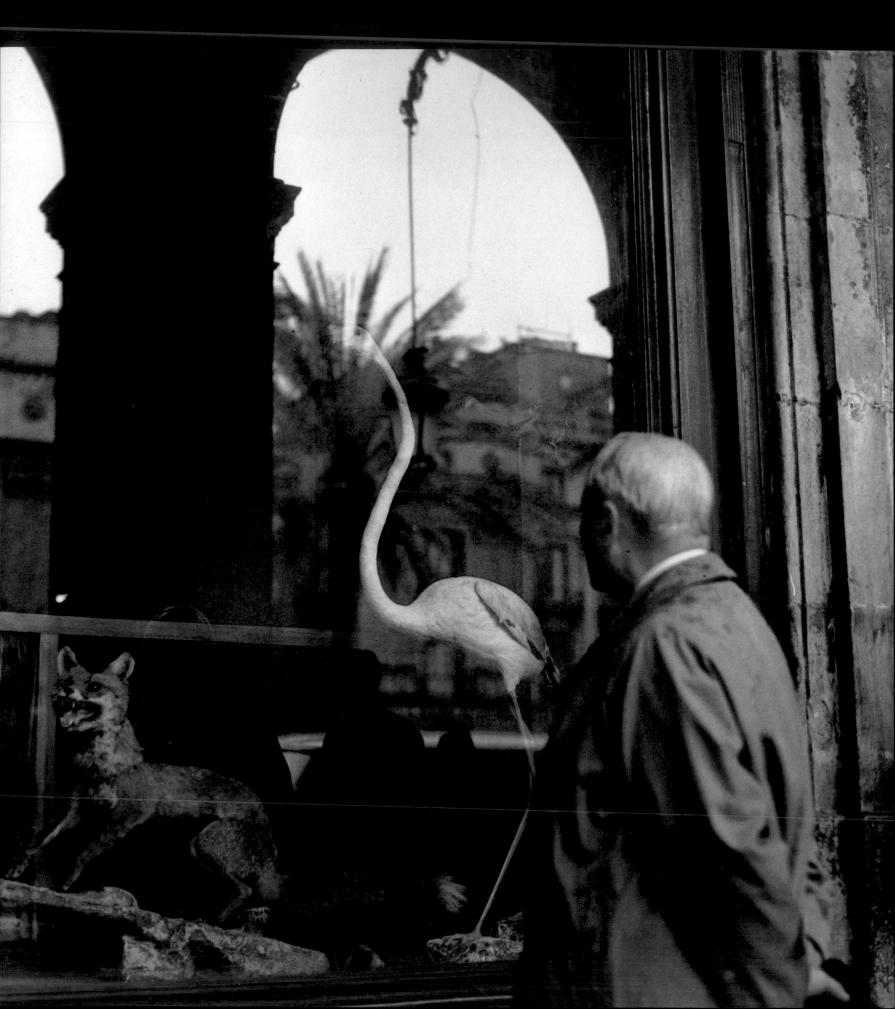

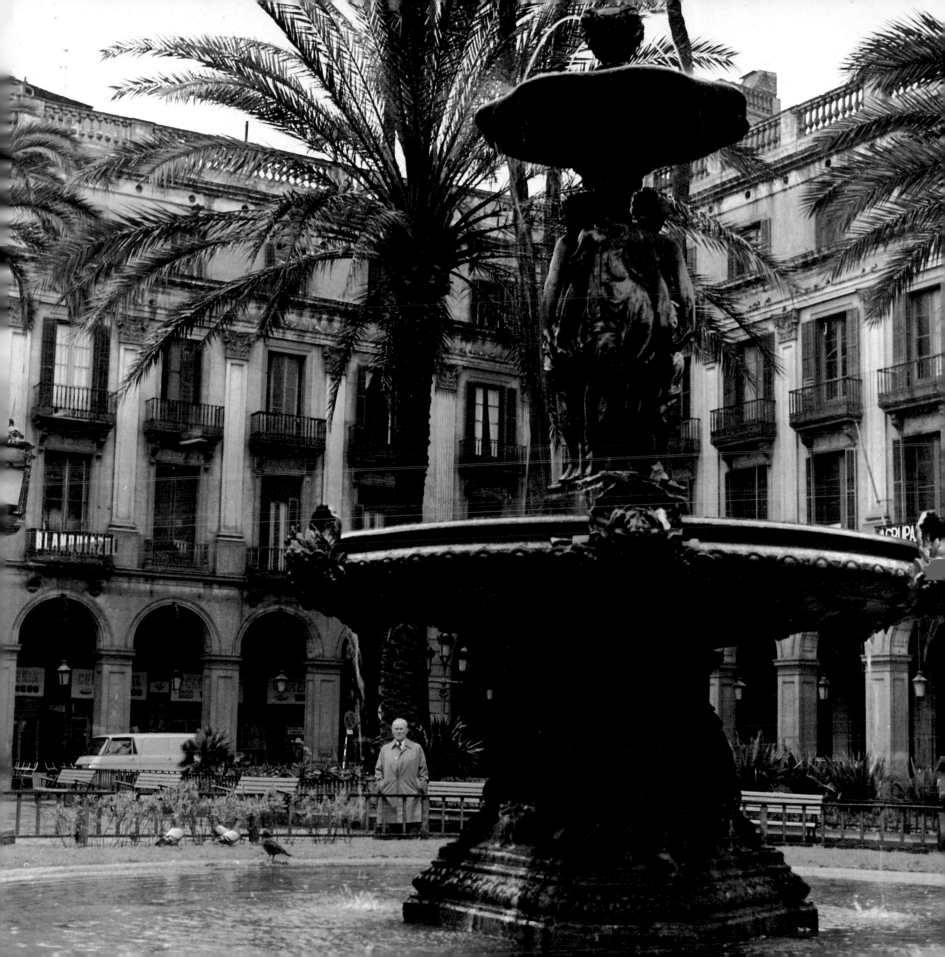

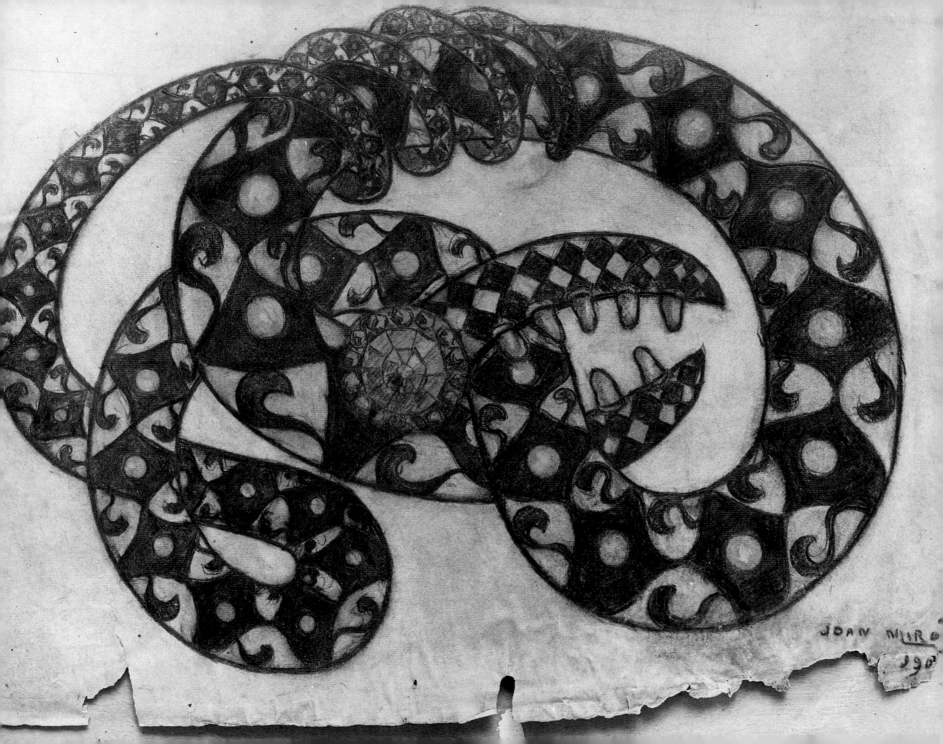

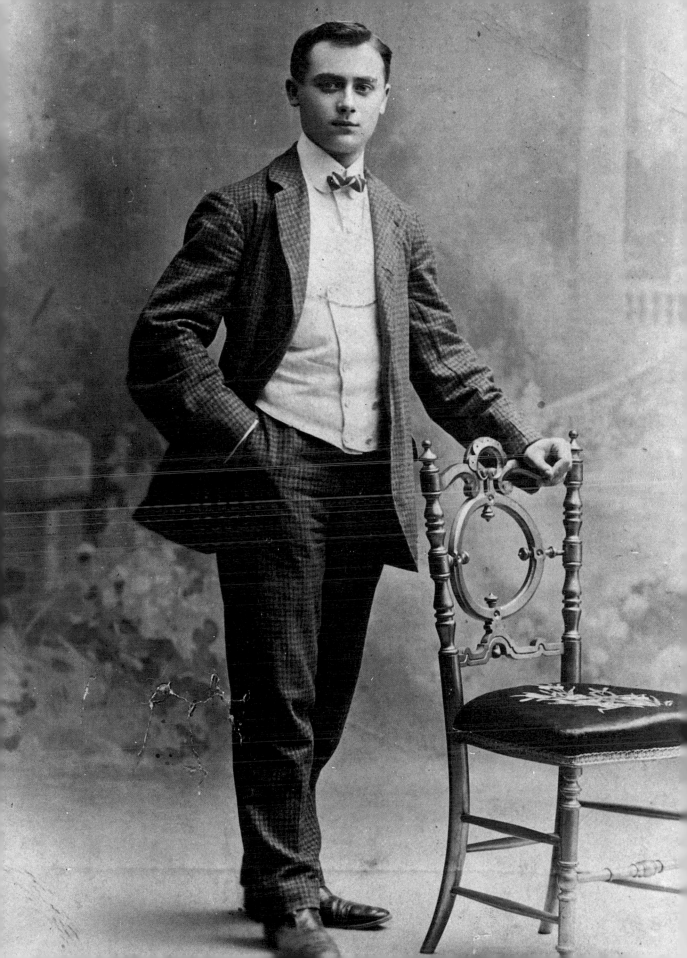

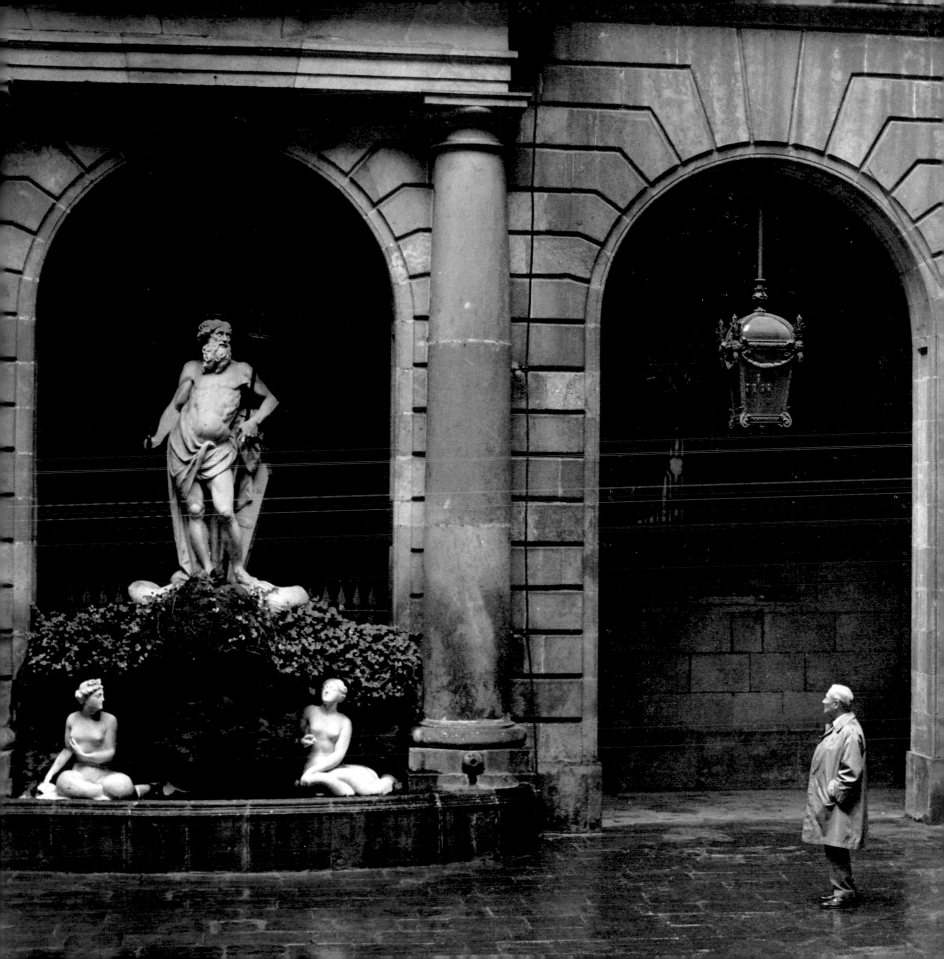

1.
The English philanthropist Sir Richard Wallace presented Barcelona and other cities in the world with three sculpted fountains. The cosmopolitanism of his native city had a decisive influence on the young Miró.

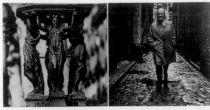

2.
Old Barcelona and the slums were what really attracted him. He gazed with fascination at the phallic sculptures on display in certain shop windows in the red-light district.

3.
This doorway in Calle Regómir led to the school he first attended. Miró was more interested in drawing than studying.

4.
Joan Miró i Ferrà was born in this street in the heart of Barcelona: Pasaje de Crédito, no. 4, at 9 o'clock on the evening of 20 April, 1893.

5.
The artist who has painted more stars than anyone, creator of Constellations, was born in this star-decorated room. He believed in premonitions.

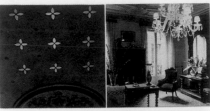

6.
A room in the house where Miró was born. He installed his studio first on this floor and then on the one above, until he decided to move to Palma (Majorca) in 1956.

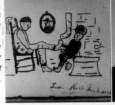

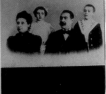

7.
His strong artistic vocation soon asserted itself. This is one of his first drawings, executed when he was only eight. A strange picture for a child, it depicts a scene at the chiropodist's.

8.
A family photograph: Miguel Miró i Adzeries, jeweller and clockmaker, and Dolors Ferrà, daughter of a Palma (Majorca) cabinetmaker, with their children Joan and Dolors (four years his junior).

9.
At 12 years old Miró already carried a sketchbook to record the places he saw on visits to his relatives in Cornudella and Majorca.

10.
A portrait of the well-groomed young Miró on the day of his first communion. He was seven.

11.
With the disturbing animals in the famous taxidermist's shop in Plaza Reial, a place that influenced him deeply. The fountain and the palm tree held a powerful attraction for him.

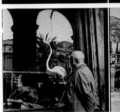

12.
He saw in that cascading water a lively echo of the form of the palm fronds. The palm-tree—he declared—was the starting-point of Catalan Gothic.

13.
His father did not approve of Miró's drawing but as a goldsmith he believed there was profit to be made in the applied arts. This jewel project at the School of Fine Arts at La Lonja dates from 1908.

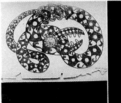

14.
A youthful photograph of the artist. Miró always stood out for being extremely elegant and tidy in his appearance, even in the early years in Paris when he was penniless.

15.
Pencil study (1919/20). Miró was always unflinching in his fight against the lack of natural conditions for drawing.

16.
Here, in the School of Fine Arts at La Lonja, he studied in 1907 under Modest Urgell and Josep Paxcó. He showed enormous appetite for learning.

II. 'PARIS, PARIS, PARIS'

The name of the French capital, repeated three
times, is the complete text of a letter Miró wrote to
his friend Llorens Artigas. It sums up the aim of a
whole generation, and it represented a goal that he
had obsessively set himself. In Paris Miró was to go
hungry—the hallucinations provoked by hunger are
depicted plastically in the canvas *Harlequin's
Carnival*—and he met with great hardship when, in
the drawing class at the Grande Chaumière, he was
initially overcome by a strange feeling of paralysis.
But he had arrived in the French capital at the ideal
moment, a revolutionary instant when his talent was
coming to the boil. It is true that Dada suited him
and that Breton and his followers instilled in him a
vast capacity to dream, but his greatest and most
fruitful encounter was with the poets. His work then
took a brilliant turn. An artist rooted in the essence
of the Catalan country, who had remained closely
faithful to his origins, he found in Paris the ideal
place from which to project throughout the world the
most savagely, vitally poetic, surrealistic, avant-
garde messages of our century.

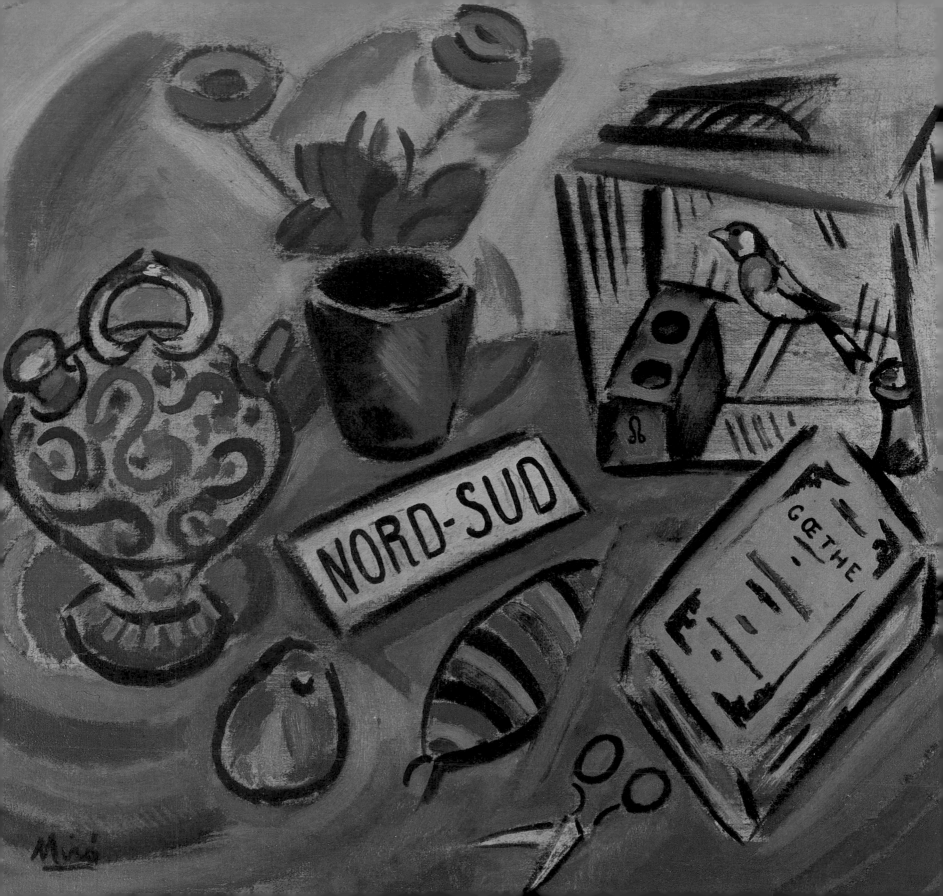

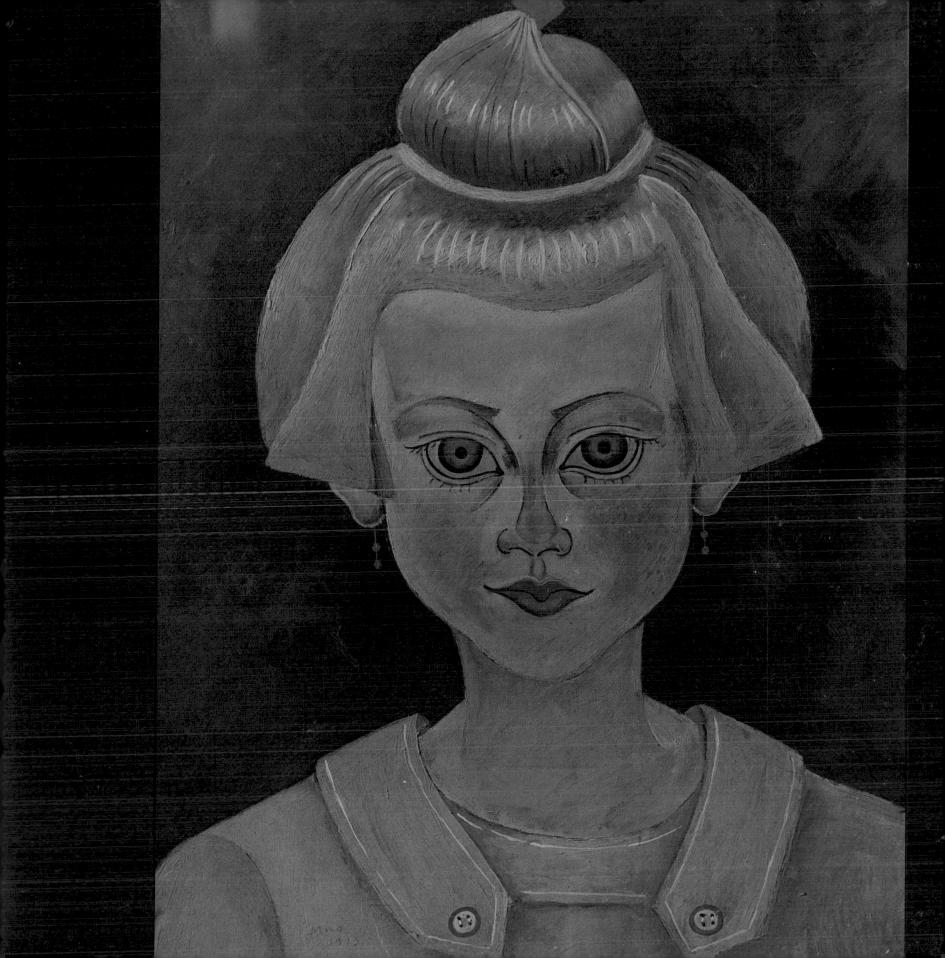

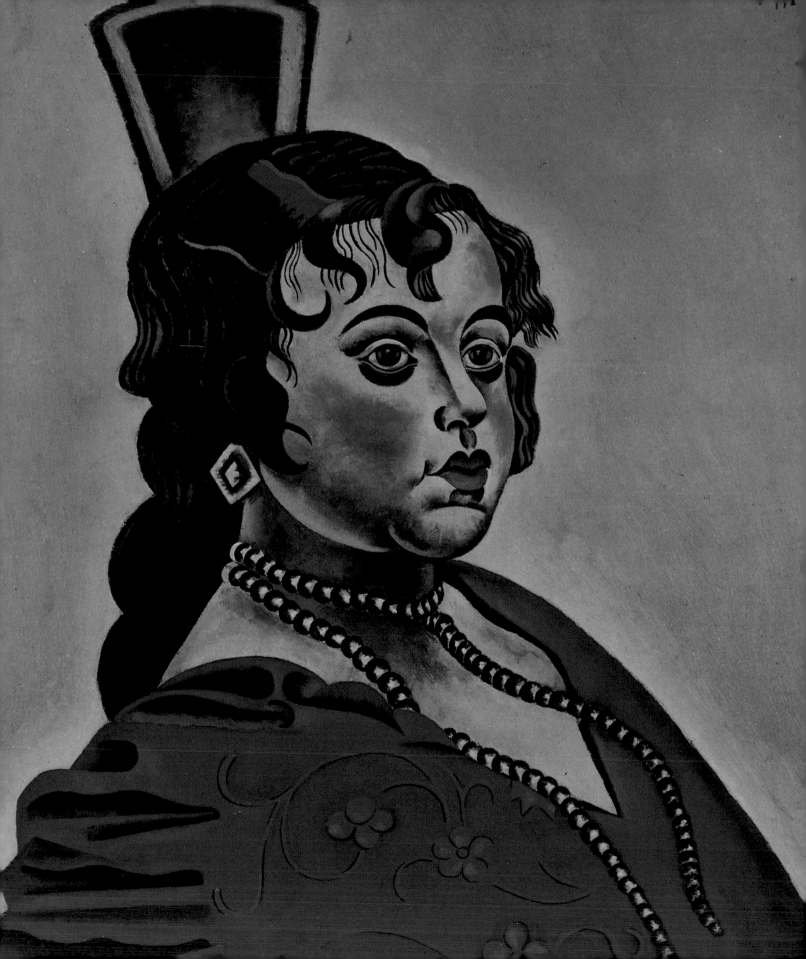

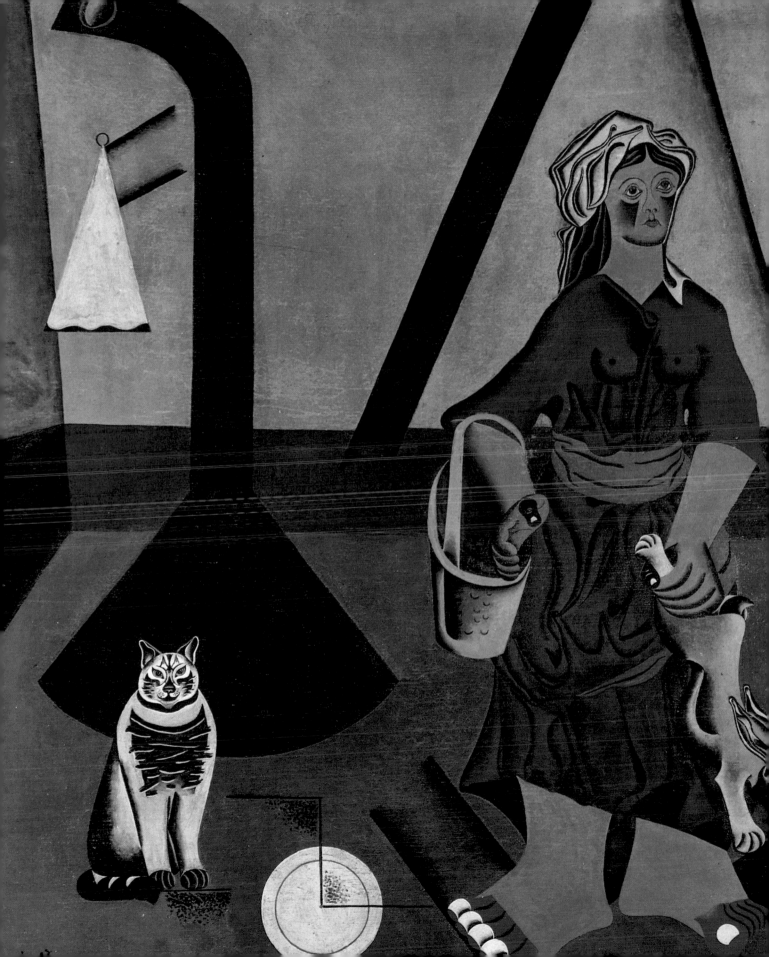

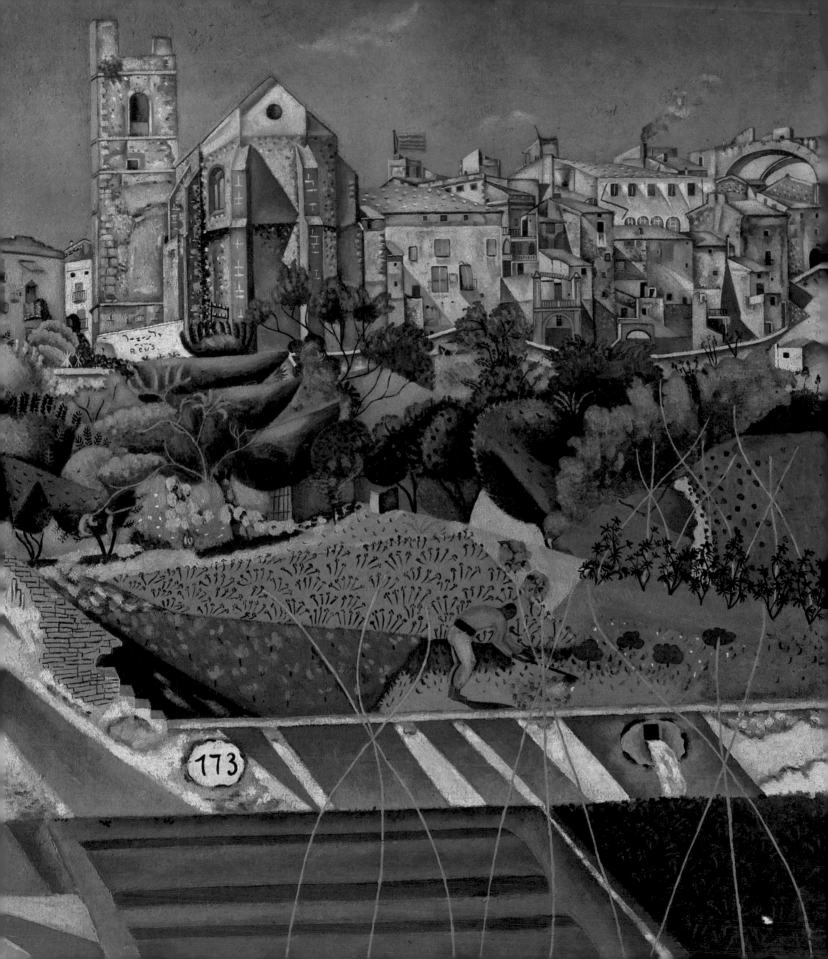

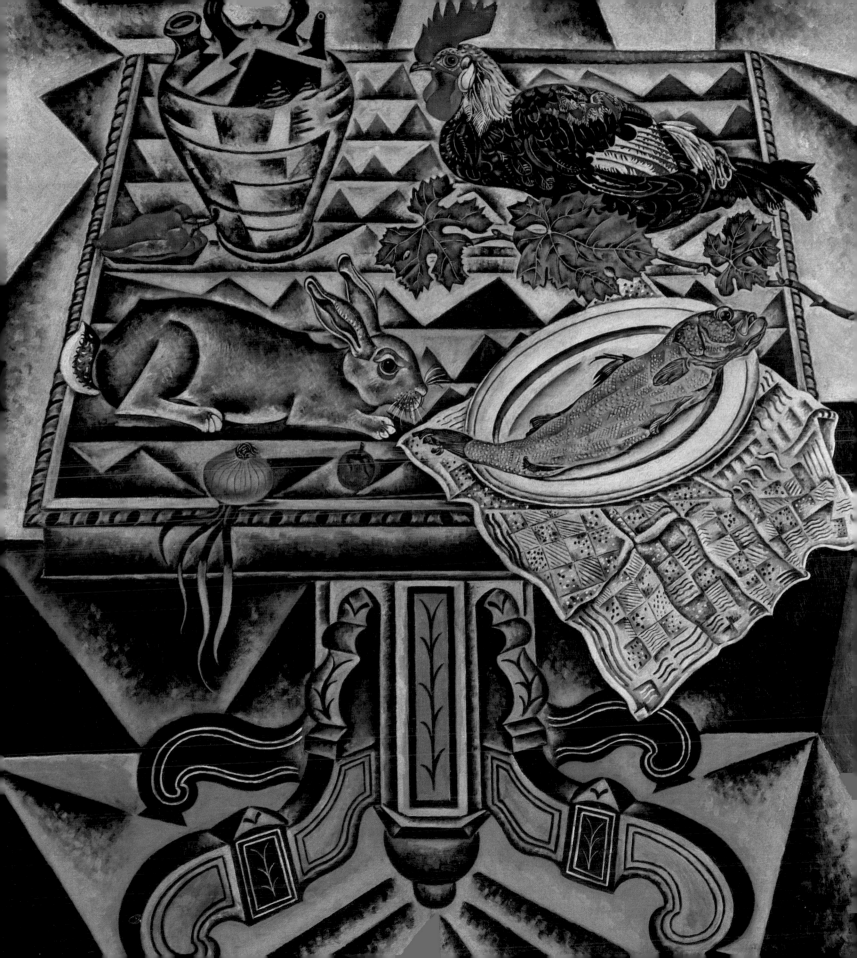

17.
North-South *(1917) is a canvas dating from the fauve period. The painter subjectively interprets a series of objects belonging to an intimately-known world.*

18.
In Portrait of a Little Girl *(1918) he reveals that, as well as strikingly violent works, he can also paint profoundly tender pictures.*

19.
Portrait of a Spanish Dancer *(1921), which he painted two years after his arrival in Paris. Unbeknown to Miró, Picasso bought the canvas from the dealer Pierre Loeb.*

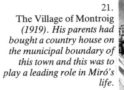

20.
The Farmer's Wife *(1922/ 23) which belongs to the Marcel Duchamp collection, is a homage to the Catalan peasant woman, whom he knew so well at his Montroig country house.*

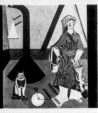

21.
The Village of Montroig *(1919). His parents had bought a country house on the municipal boundary of this town and this was to play a leading role in Miró's life.*

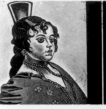

22.
Still Life with Rabbit *is one of the four still lifes Miró painted in 1920. It clearly reveals his individual approach to cubism.*

III. MONTROIG—THE ESSENCE OF CATALONIA

When his father refused to let him become a painter and forced him to work as a clerk, it seemed to young Miró that the life he led had no meaning. He became deeply depressed and suddenly contracted typhoid fever. Physically he was so weak that his family sent him to convalesce at a country house they had recently bought near Montroig. He recovered, and that part of the Tarragona countryside always held a vast symbolic power for him. Later, when he lived in Paris, he always returned there each summer, and painted some of the most famous canvases belonging to the end of the realist period, such as *The Farm*. He confessed that he needed contact with the primitive, direct, essential things of his country, and declared that strength rose in him through his legs so that he had to have his feet on the ground; he realized that he had to be firmly on that ground in order to jump as high as possible. Encouraged by a revitalization of spiritual, sentimental and nationalist feeling, he never once renounced the strong Catalan spirit that was always so much a part of his work.

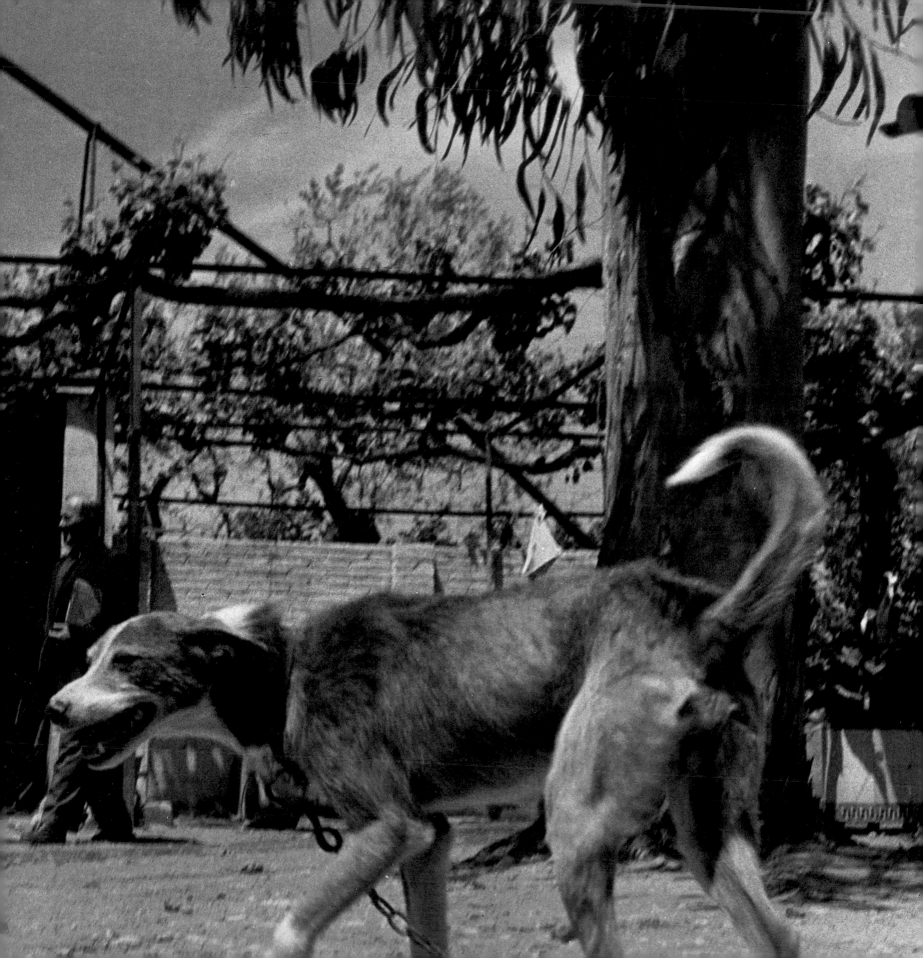

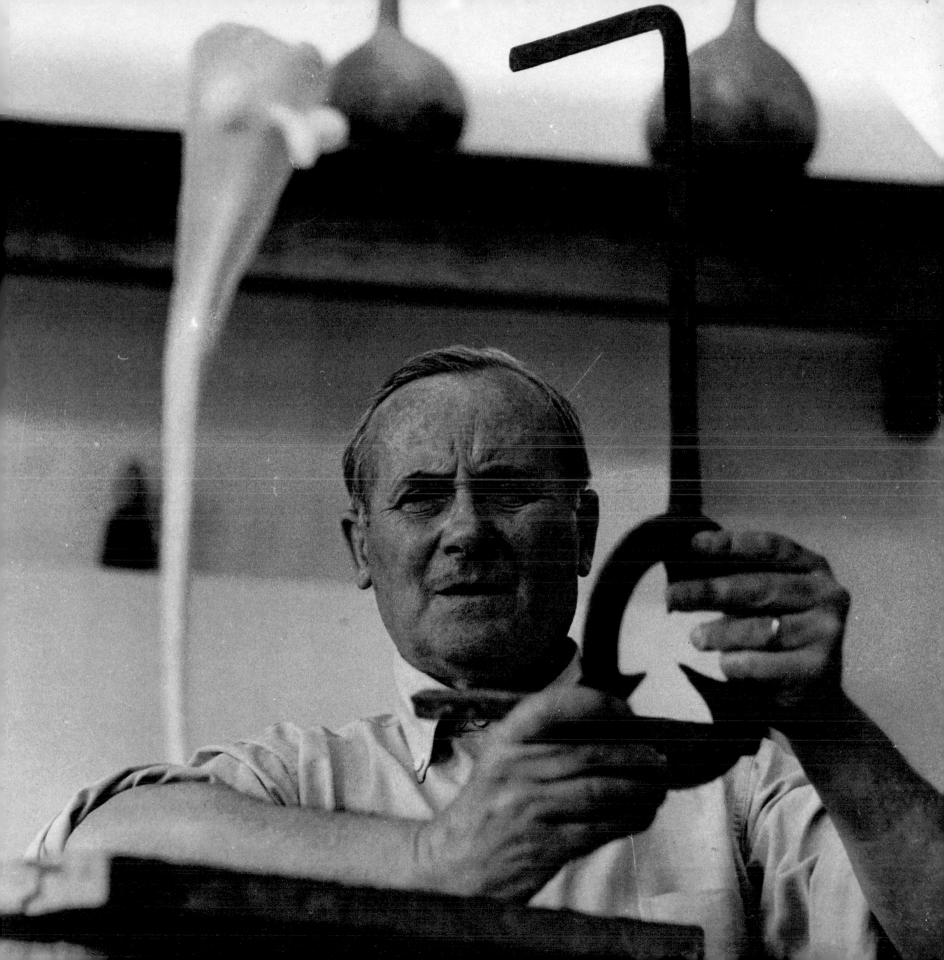

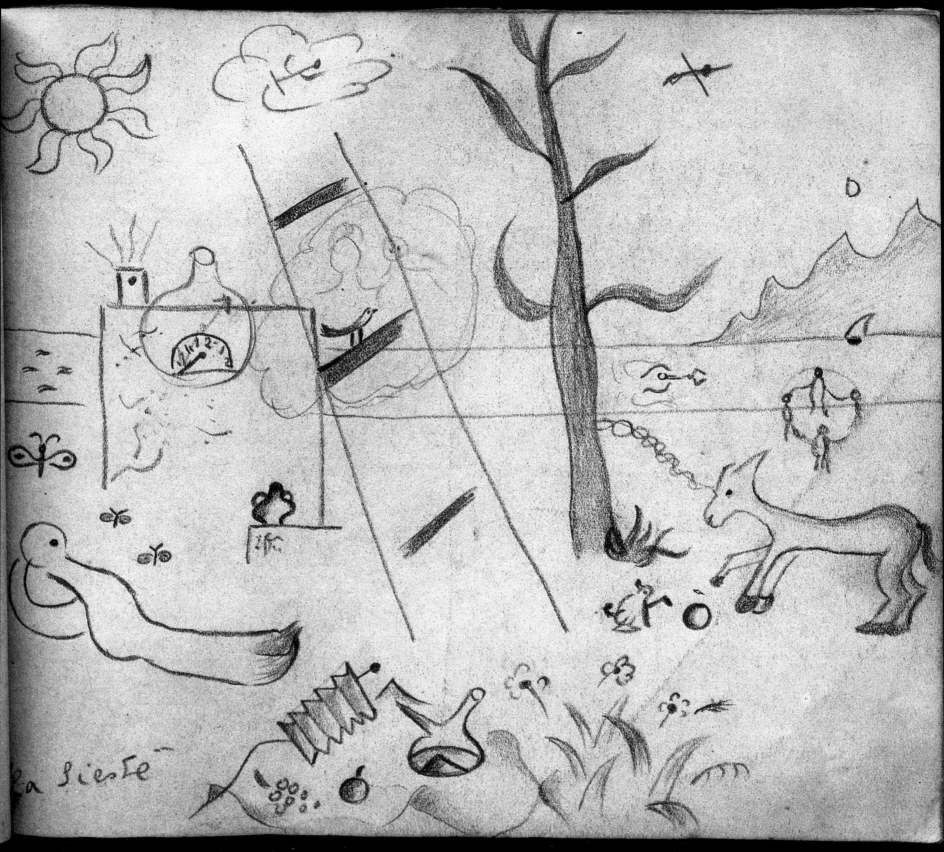

la Sieste

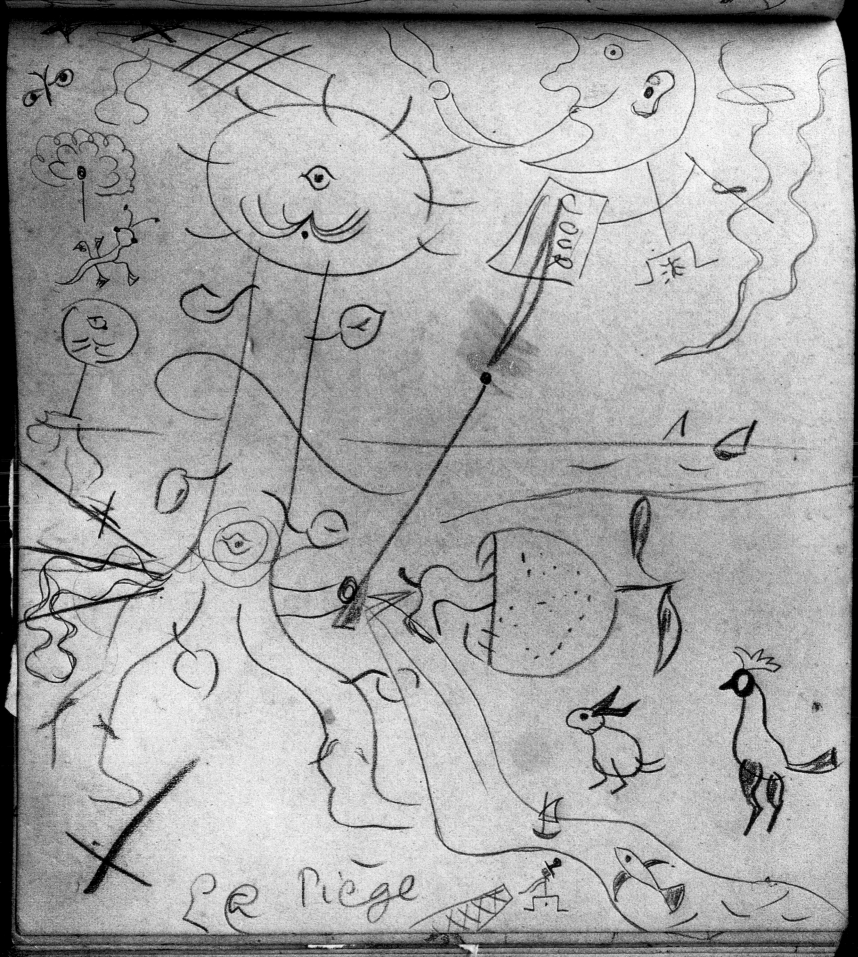

Le Piège

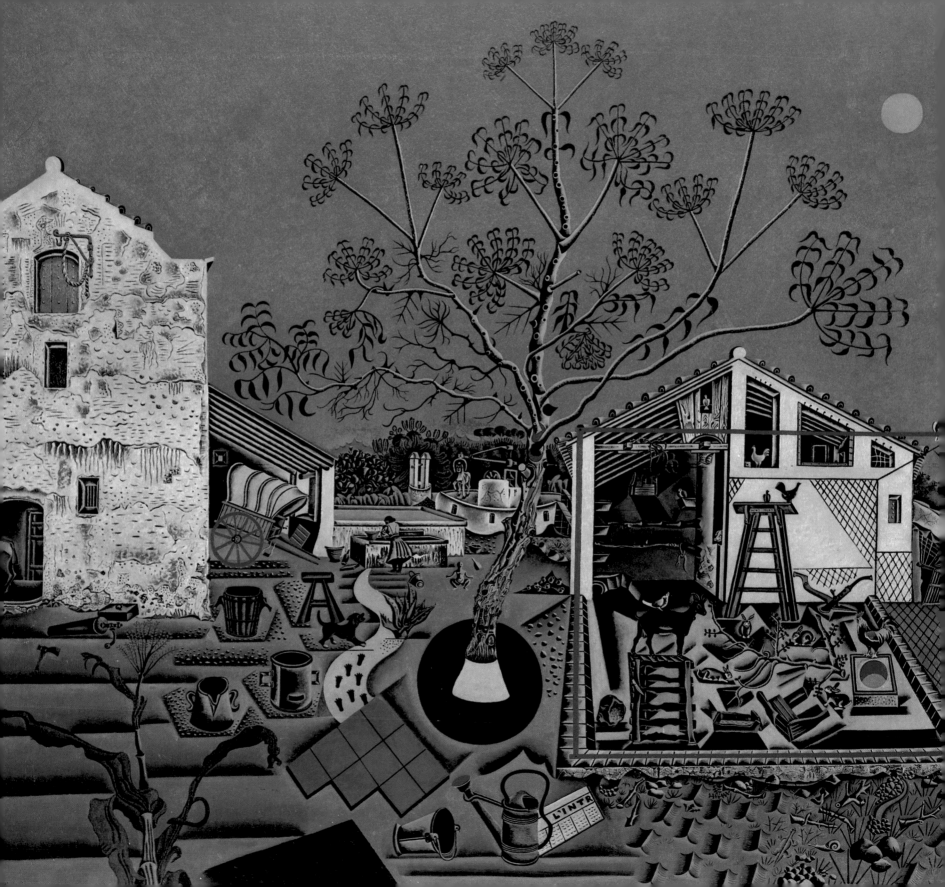

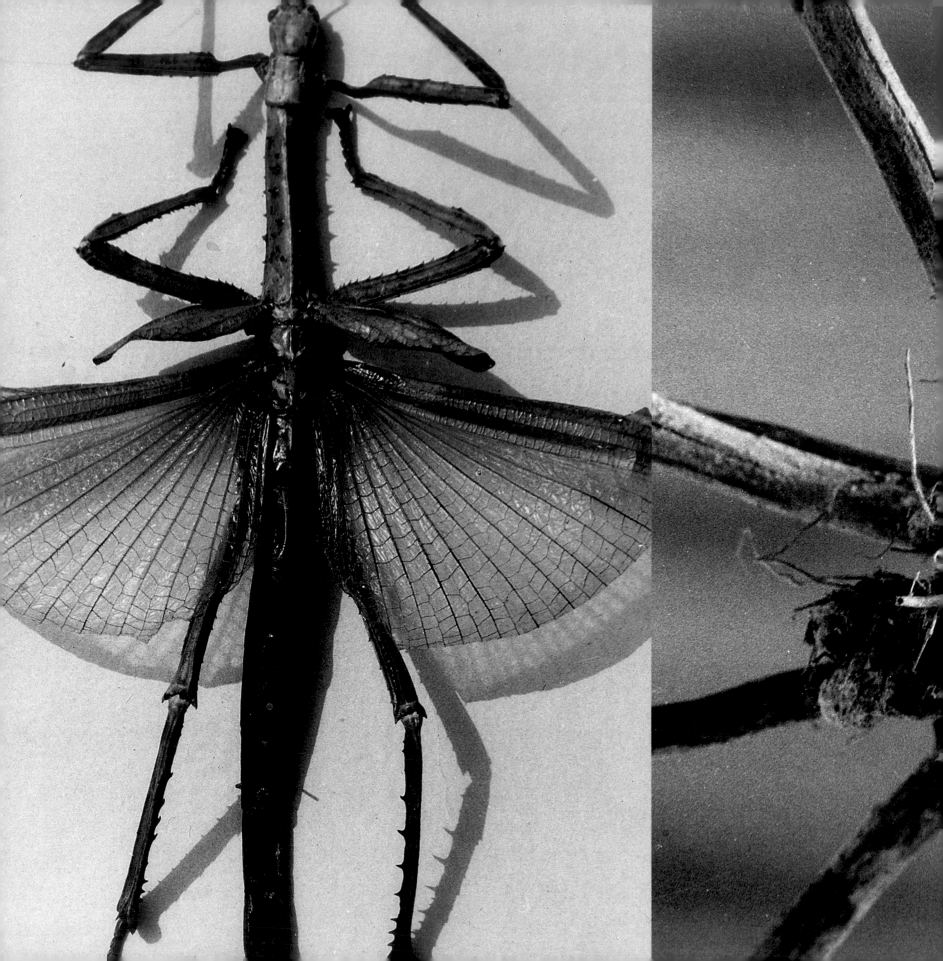

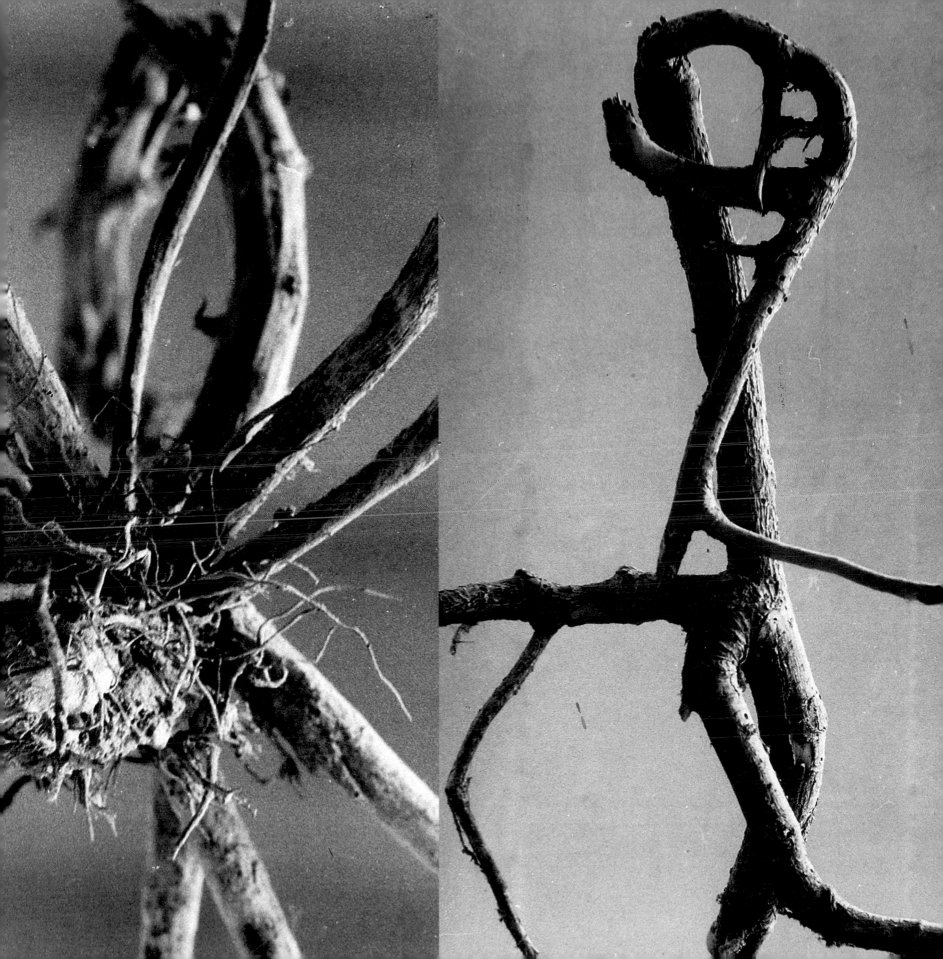

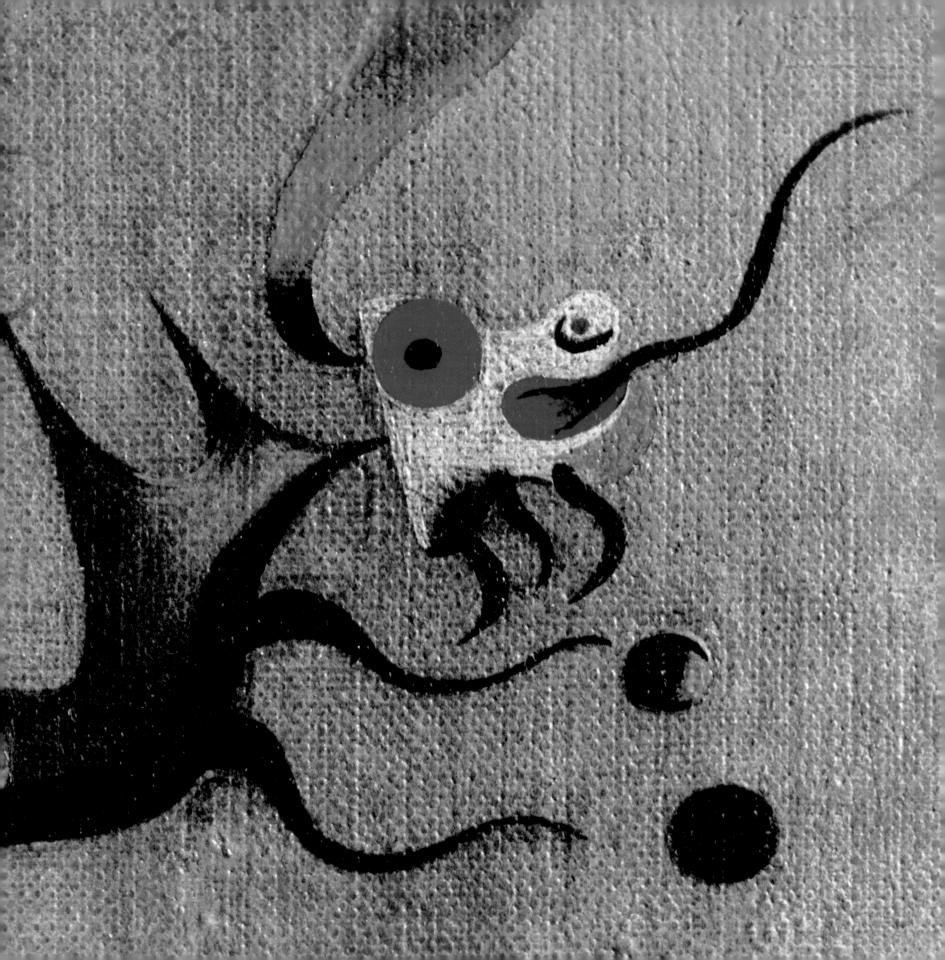

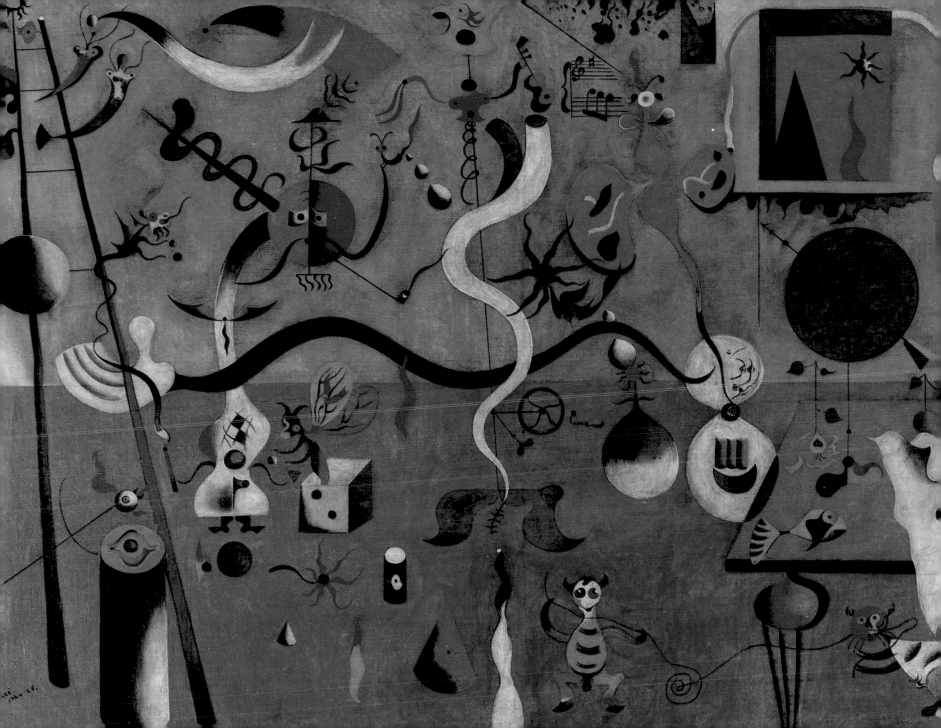

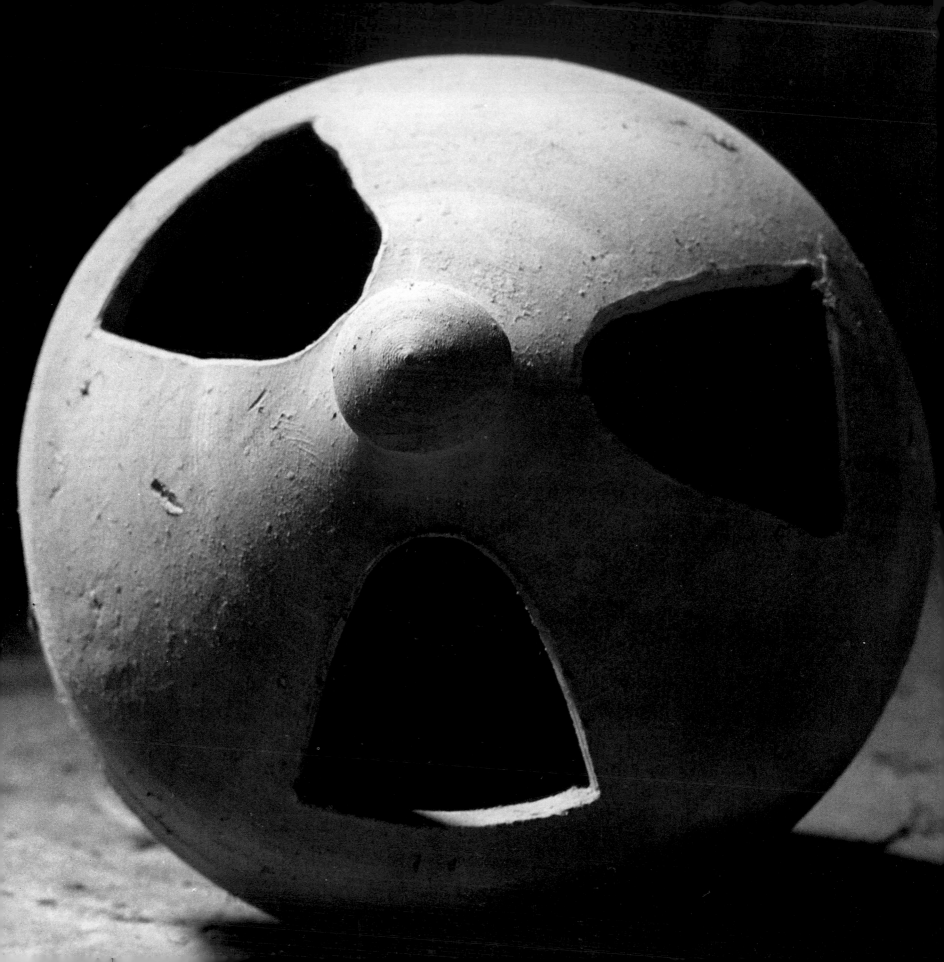

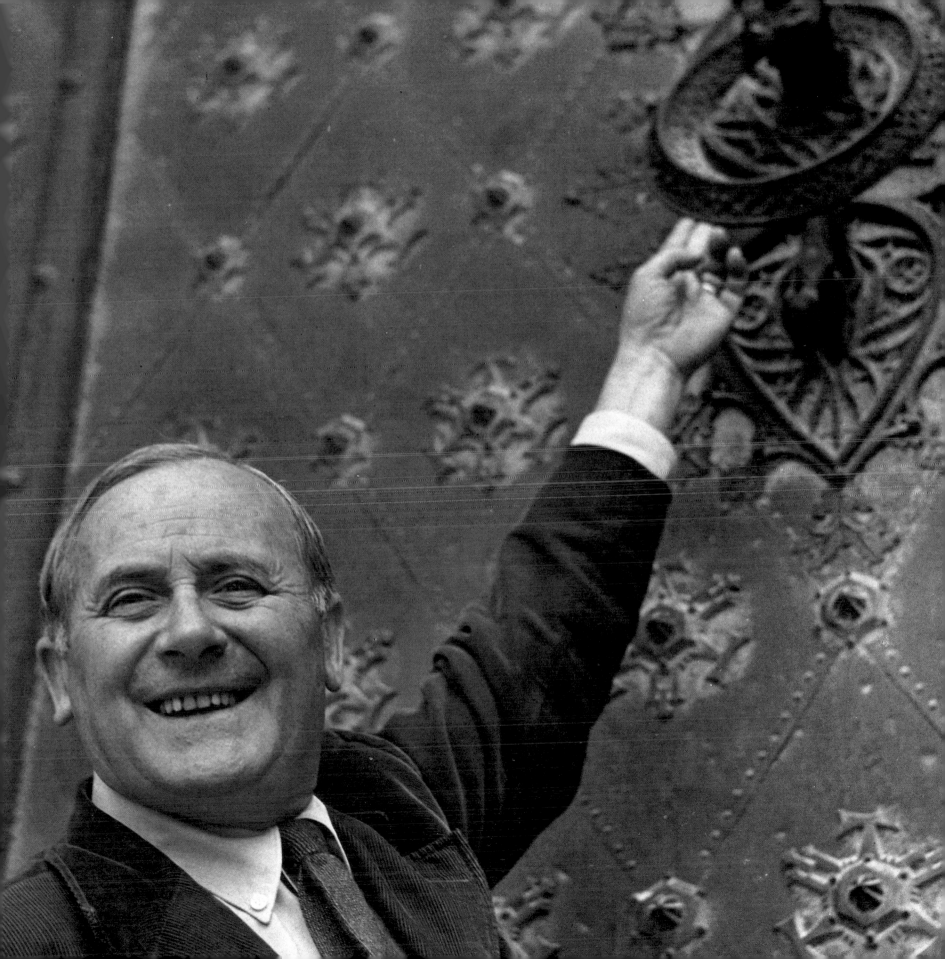

23.
In 1911 he recovered from a serious illness in the Montroig country house. In that place, which became mythical for him, he discovered the countryside and the essence of his homeland, Catalonia.

24.
While living in Paris, he always returned each summer to the Montroig country house, where he had installed a studio and worked intensively. Here we see him in the 1950s perfecting a sculpture.

25.
La Migdiada (oil on canvas) alludes to country customs. Miró painted it in 1925 after this detailed preparatory sketch.

26.
Preliminary drawing of The Trap (oil on canvas 1924), also set in rustic surroundings. Miró donated about 5,000 of these sketches—starting-points for the paintings—to the Miró Foundation.

27.
The Farm (1922/23) is a hymn to the house where he convalesced and lived, an inventory of country life and a sublimation of the realism which he was preparing to abandon forever.

28.
This detail of The Farm evokes the love, meticulous detail and poetry, that the painter brought together in a work of art that ended the period before the radical change in his style.

29.
Highly evocative natural forms are a constant source of inspiration and a fundamental basis of his poetic vision of the world.

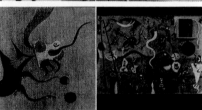

30.
Anything that he chose or collected was transformed, thanks to an almost magical power, into a genuine Miró, as his old and most intimate friend Joan Prats realized.

31.
He soon managed to develop an unmistakeable plastic language, at once personal and very powerful. This detail of Harlequin's Carnival reveals this strength.

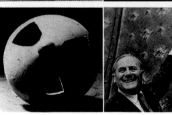

32.
In Harlequin's Carnival he gave form to the hallucinations caused by the hunger he experienced in Paris. A masterpiece of the new period.

33.
The strong, simple forms of popular craftsmanship, born of the practical need for simplification and effectiveness, always attracted and inspired him.

34.
He admired Catalonia's renowned craftsmanship—our forging was famous throughout Europe. At the door of the Catedral de Tarragona in 1955.

IV. THE MURDER OF PAINTING

In Paris Miró became an even more radical avant-garde fighter. It is not surprising that he cried out crazy and irrational things like: 'Down with the Mediterranean' or, against the cubists, 'I'll smash their guitar' and that he even declared himself willing to 'murder painting'. Let us not forget that this was the dynamic revolt of a positive, creative spirit who wanted to destroy everything he considered ridiculous, bland or decadent, in order to impose a total change on painting. And this is how he himself gave life to one of the most colourful, luminous and renovating movements in art. He gave himself up obsessively to this task, perhaps because outside this special world there was nothing else that interested him, but above all because he had to fight against a considerable lack of facility in drawing and painting. I suspect that this constant effort to surmount difficulties was precisely what helped him to instil into each work a sense of tension, striving and severity that are as brutal as they are rare. And the sensitive beholder feels the ineffable impact of this intensively creative struggle.

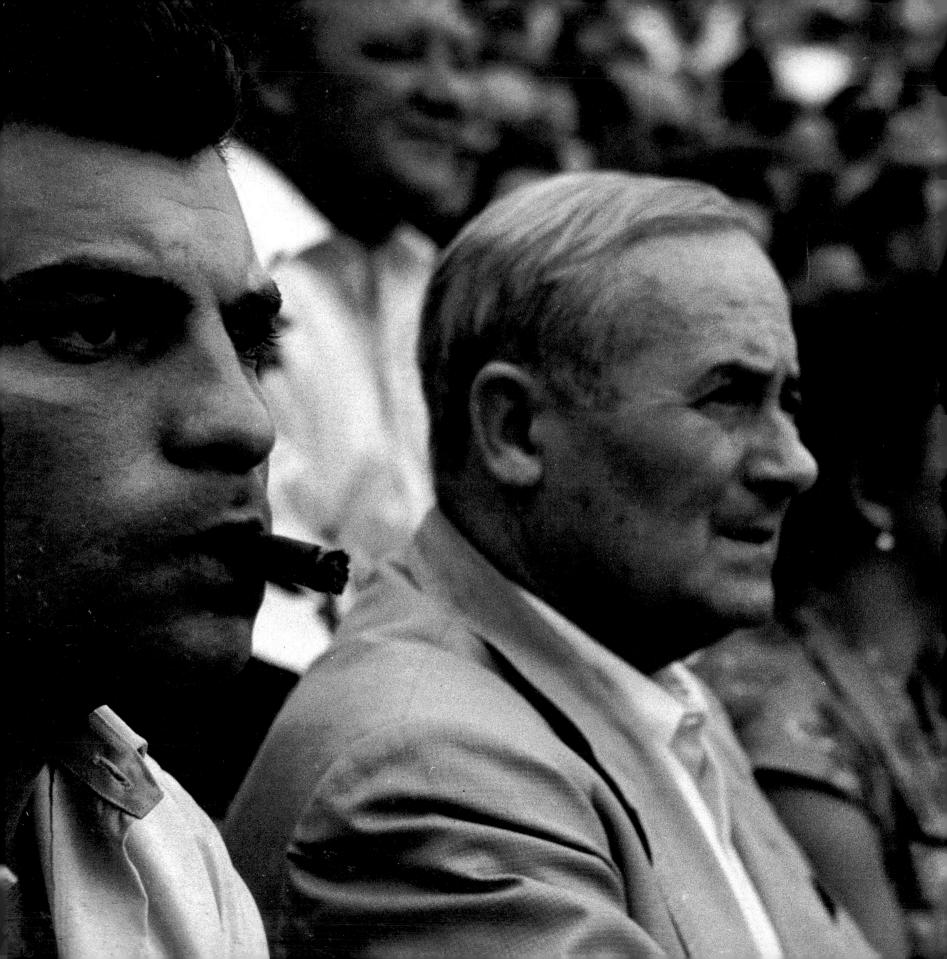

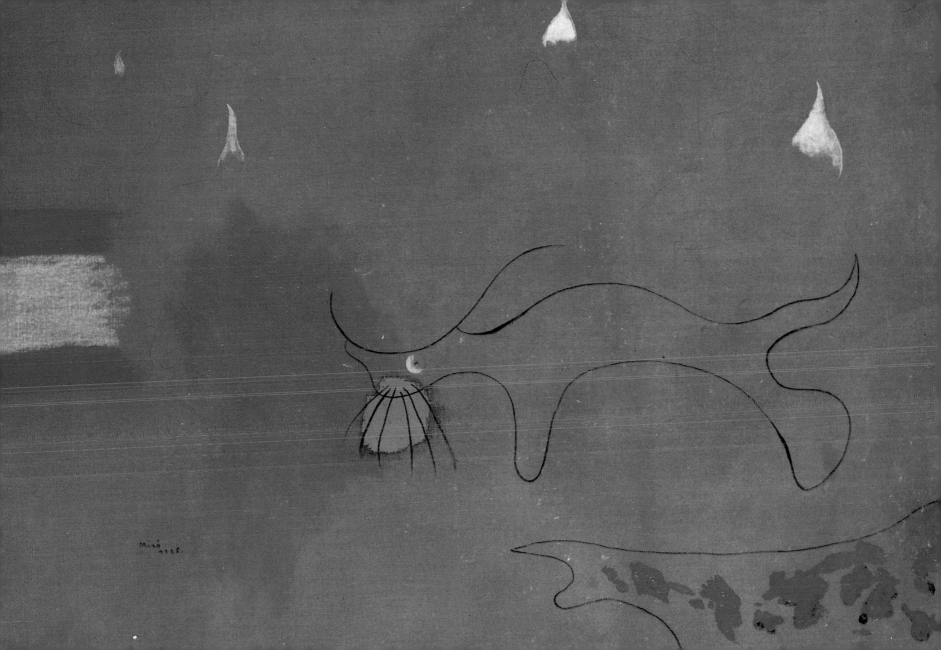

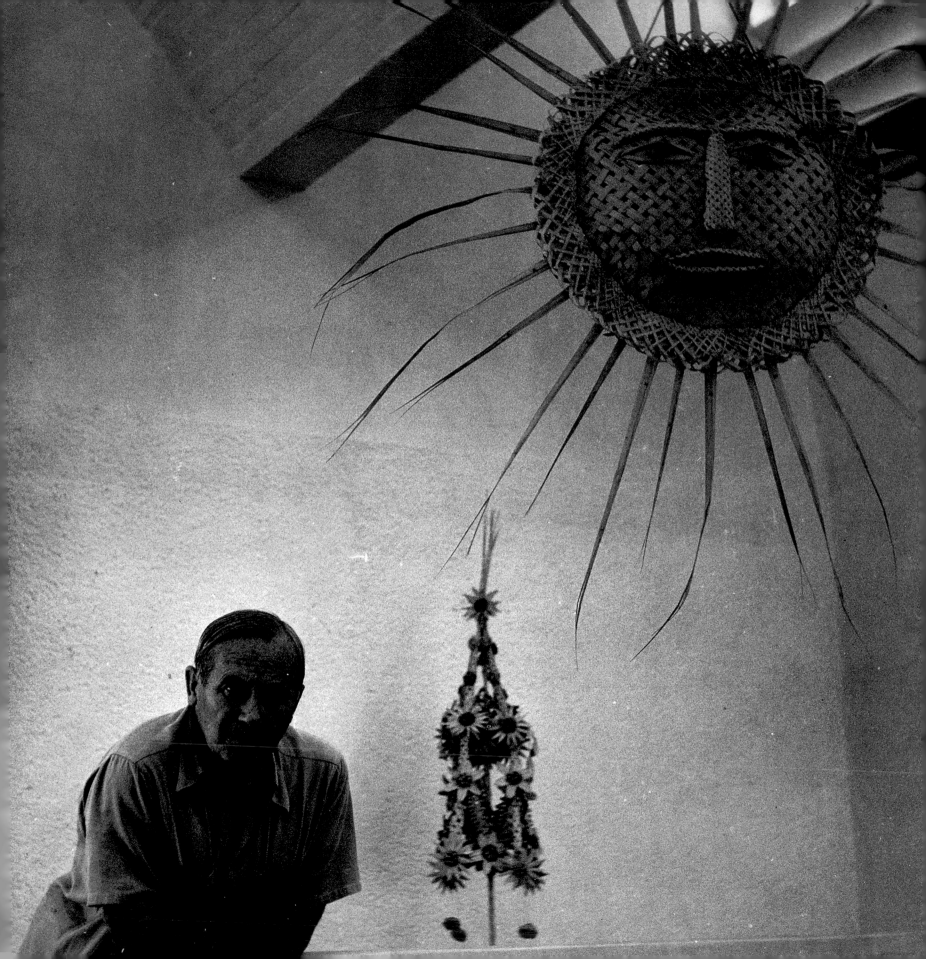

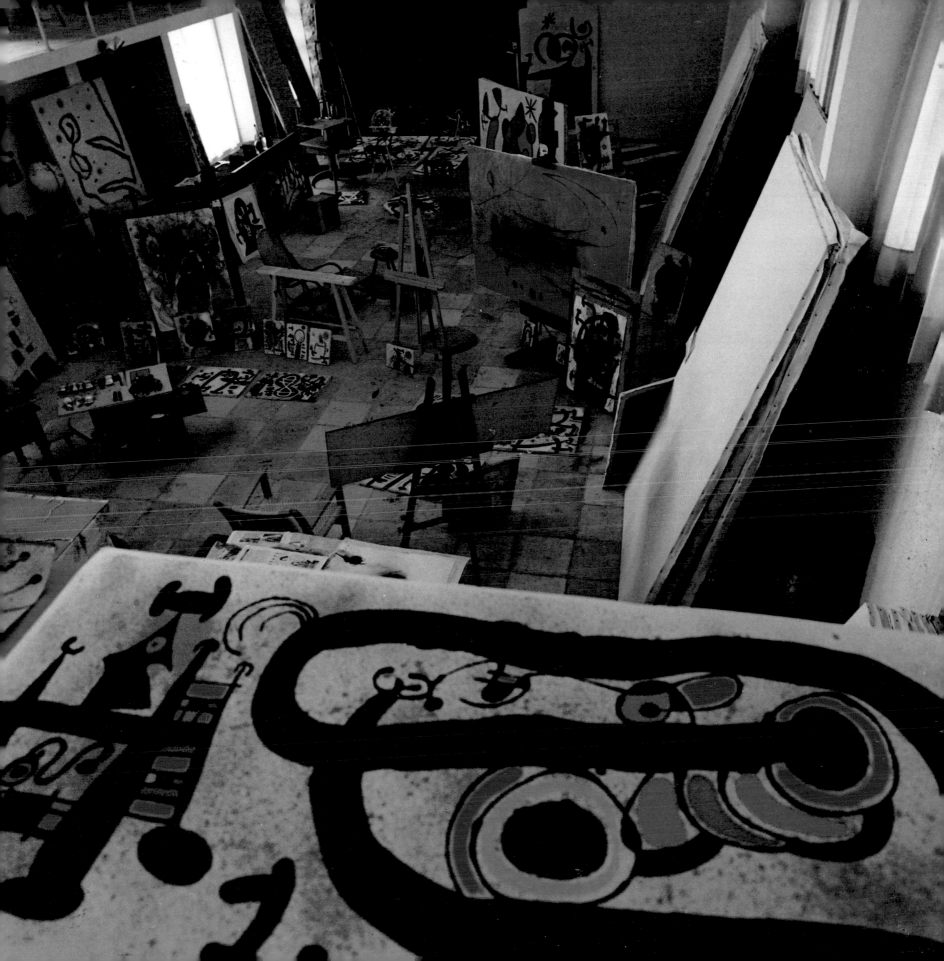

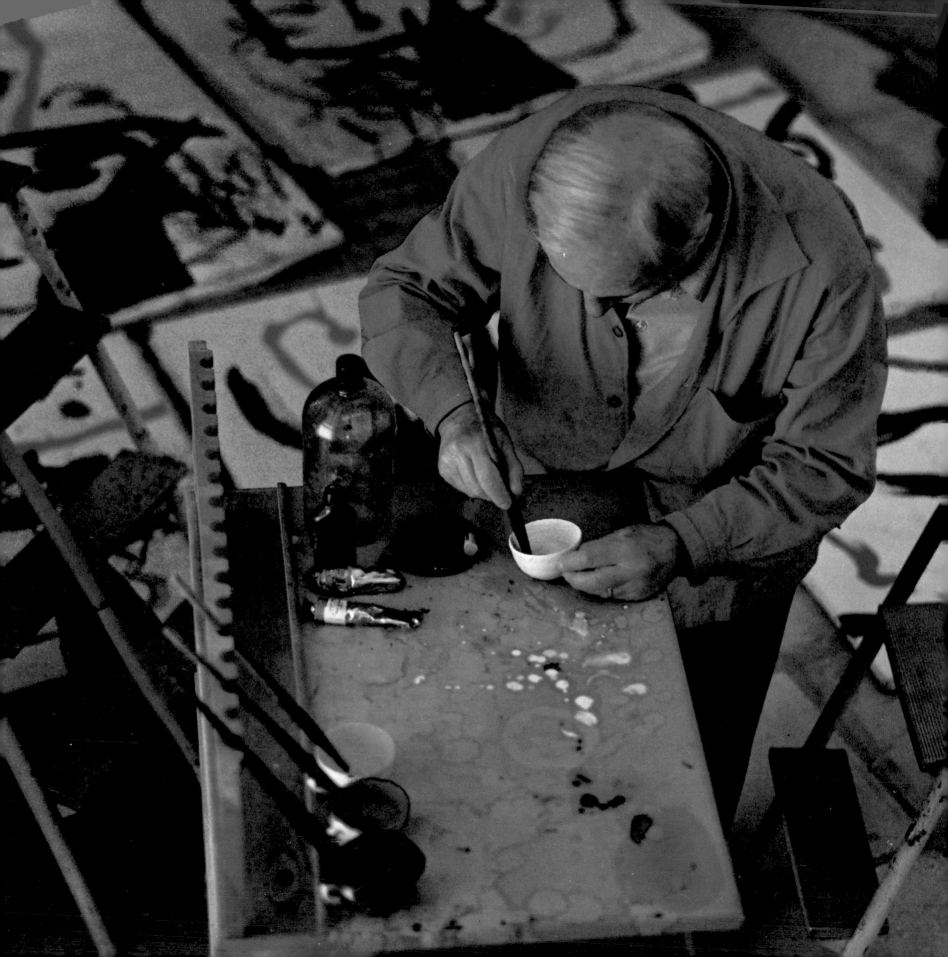

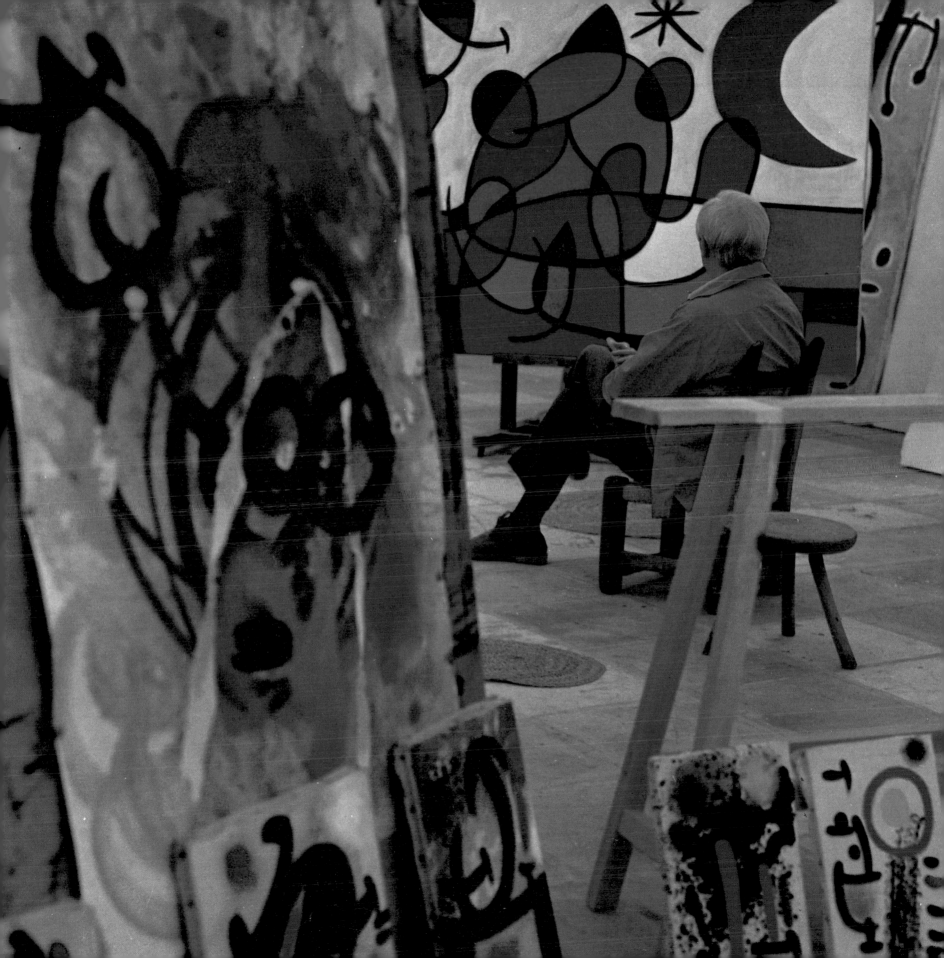

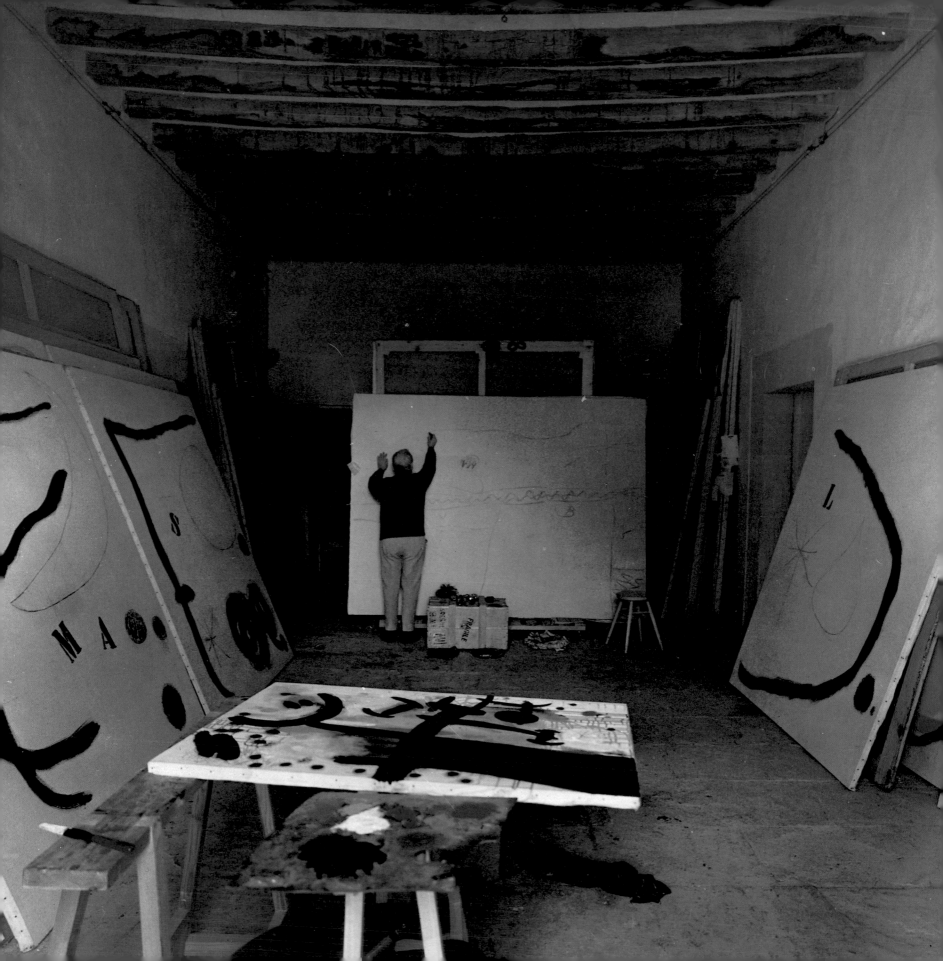

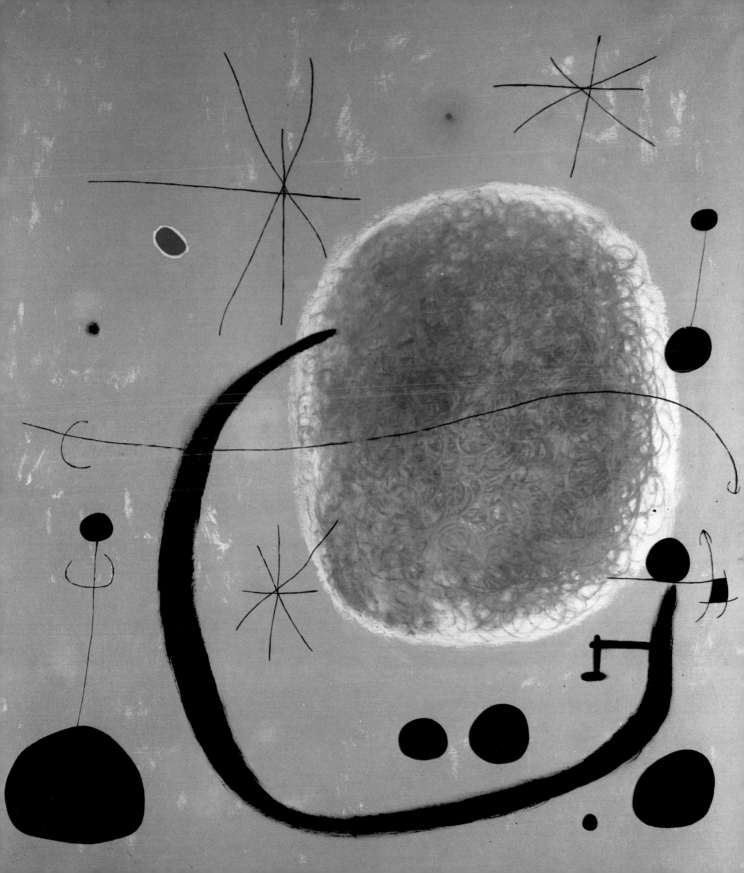

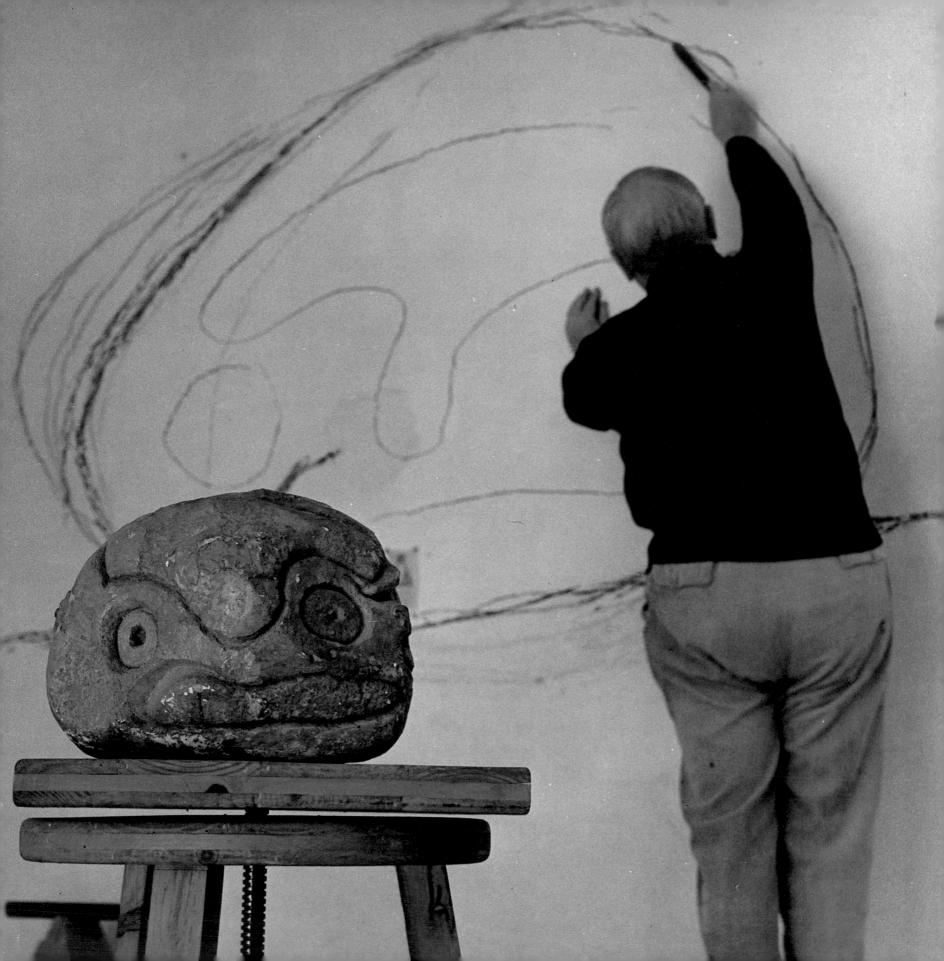

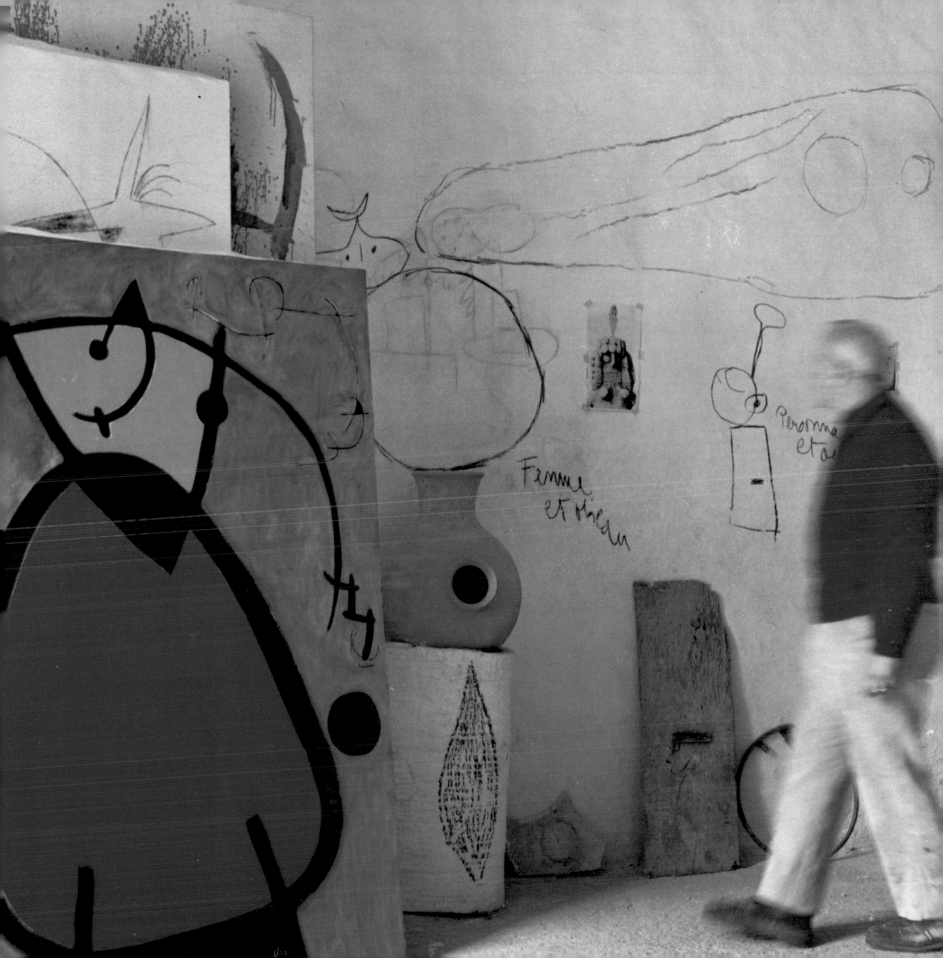

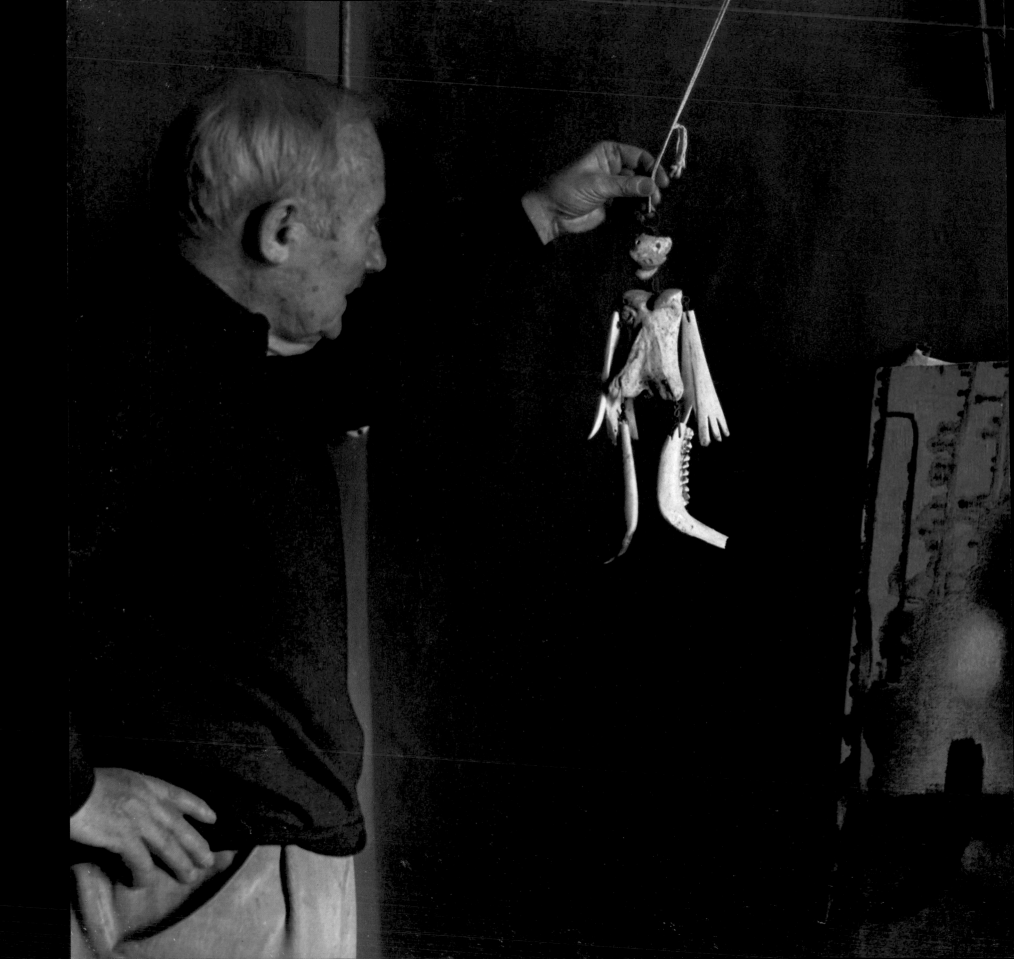

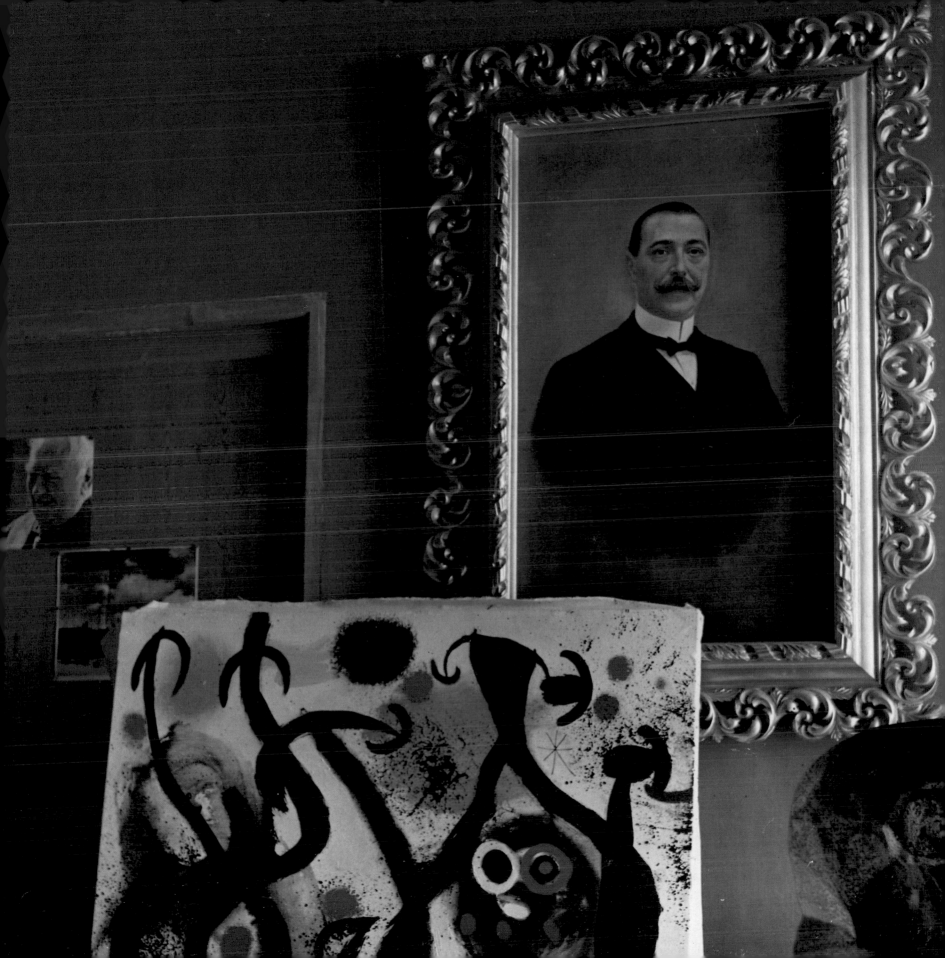

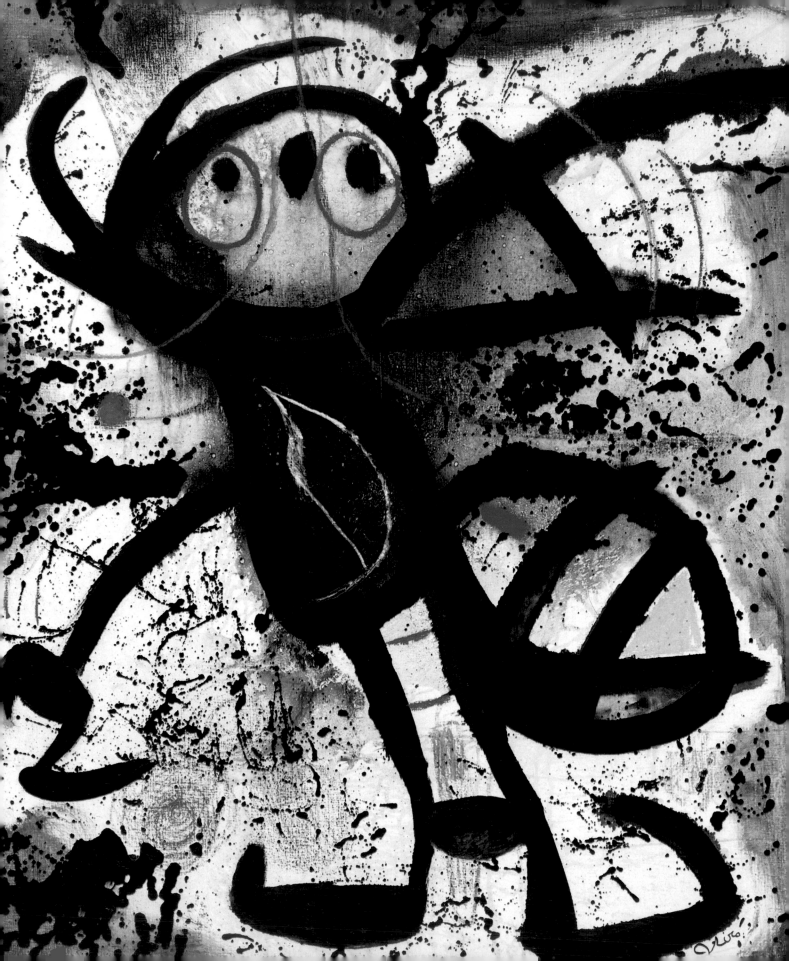

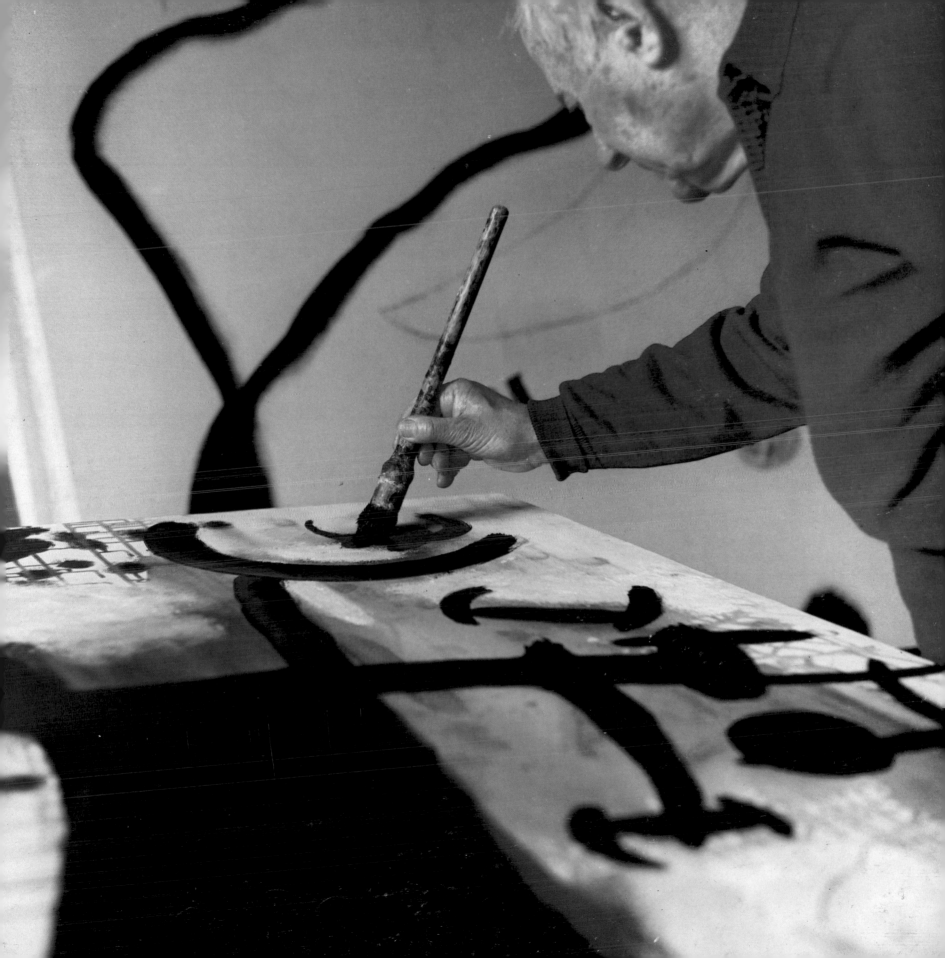

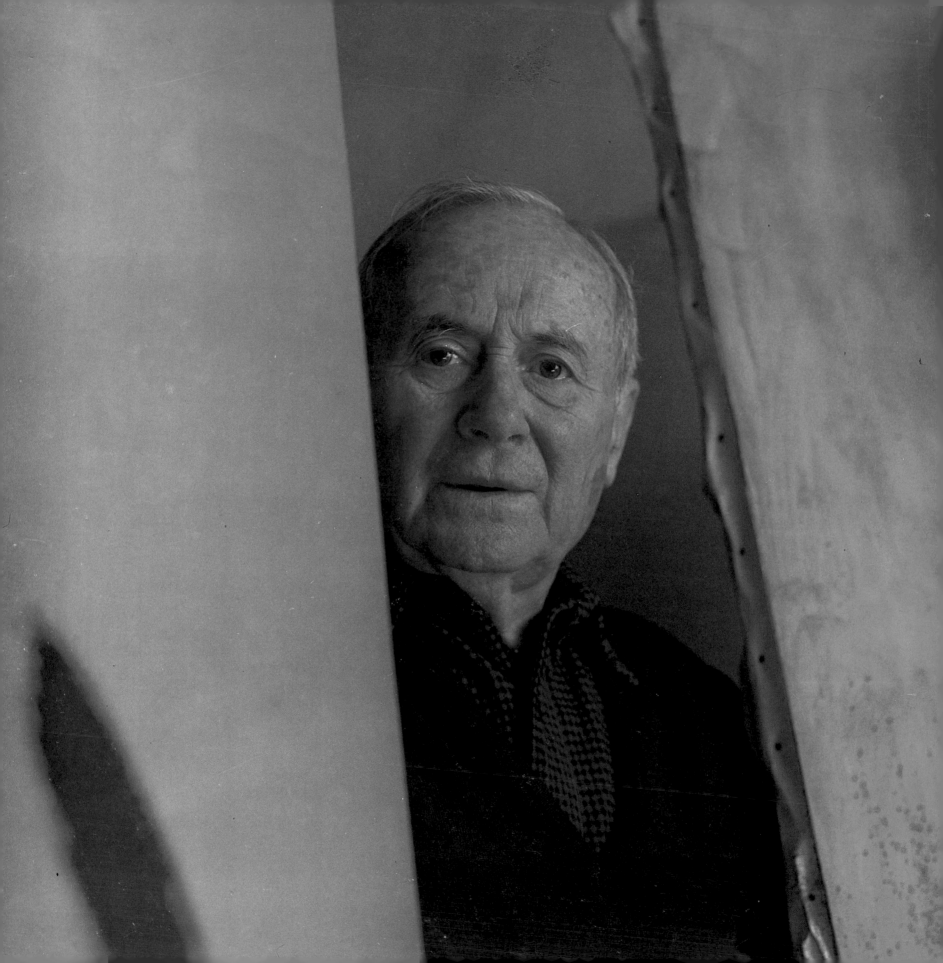

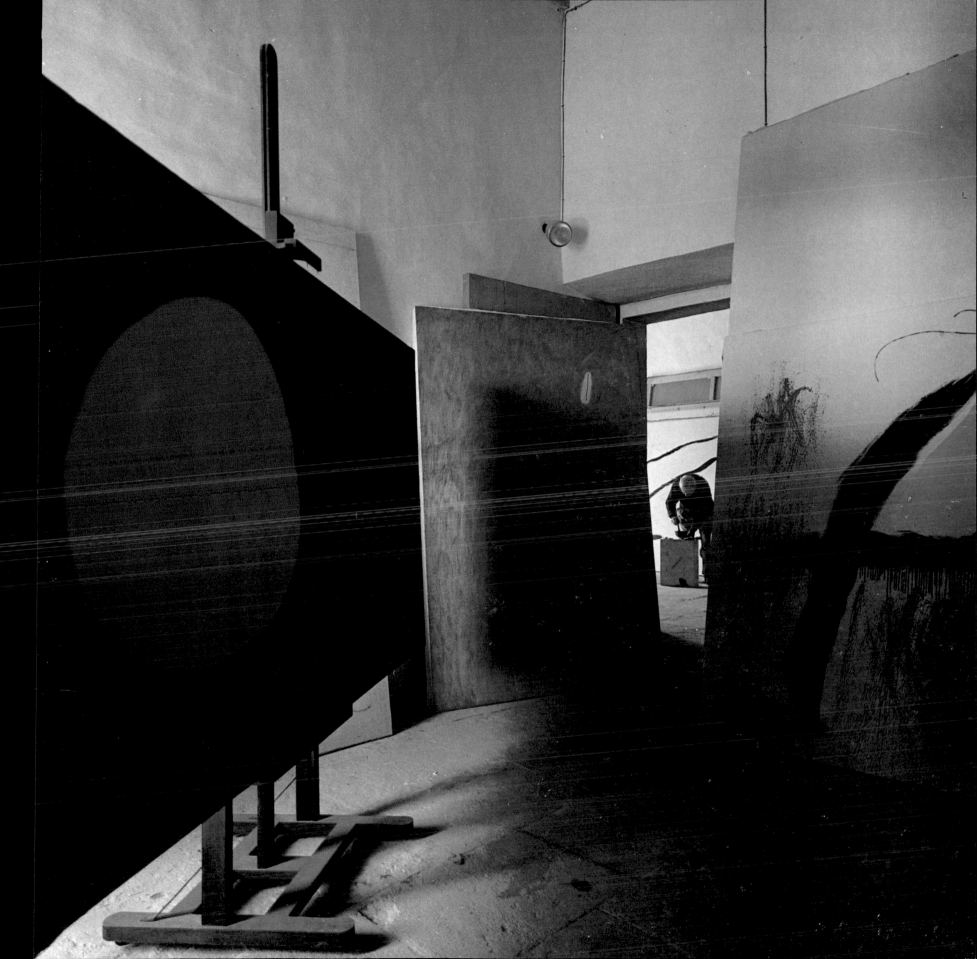

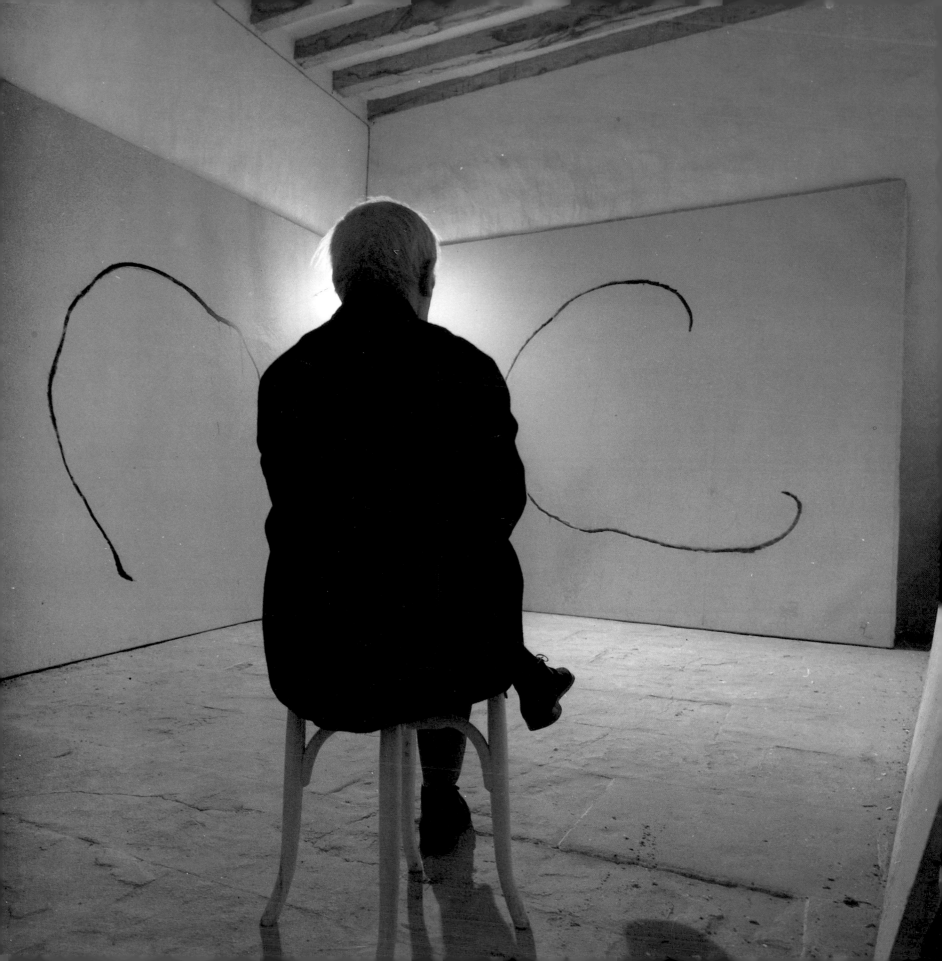

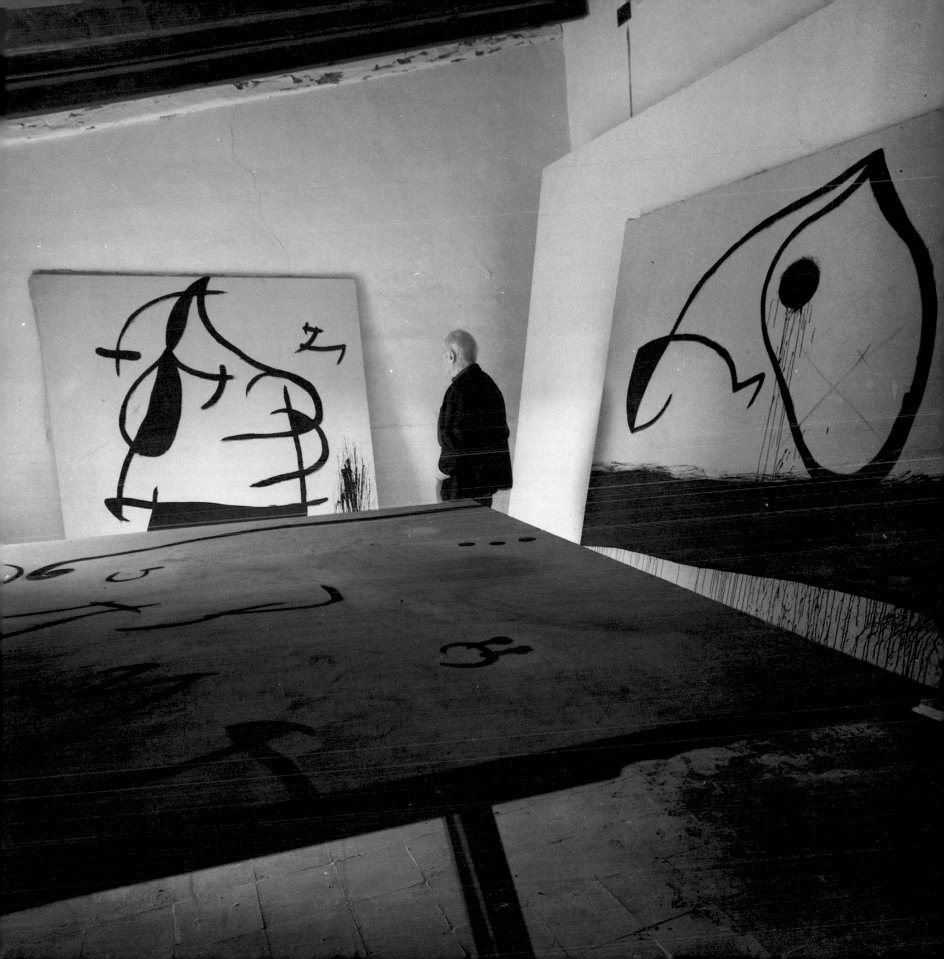

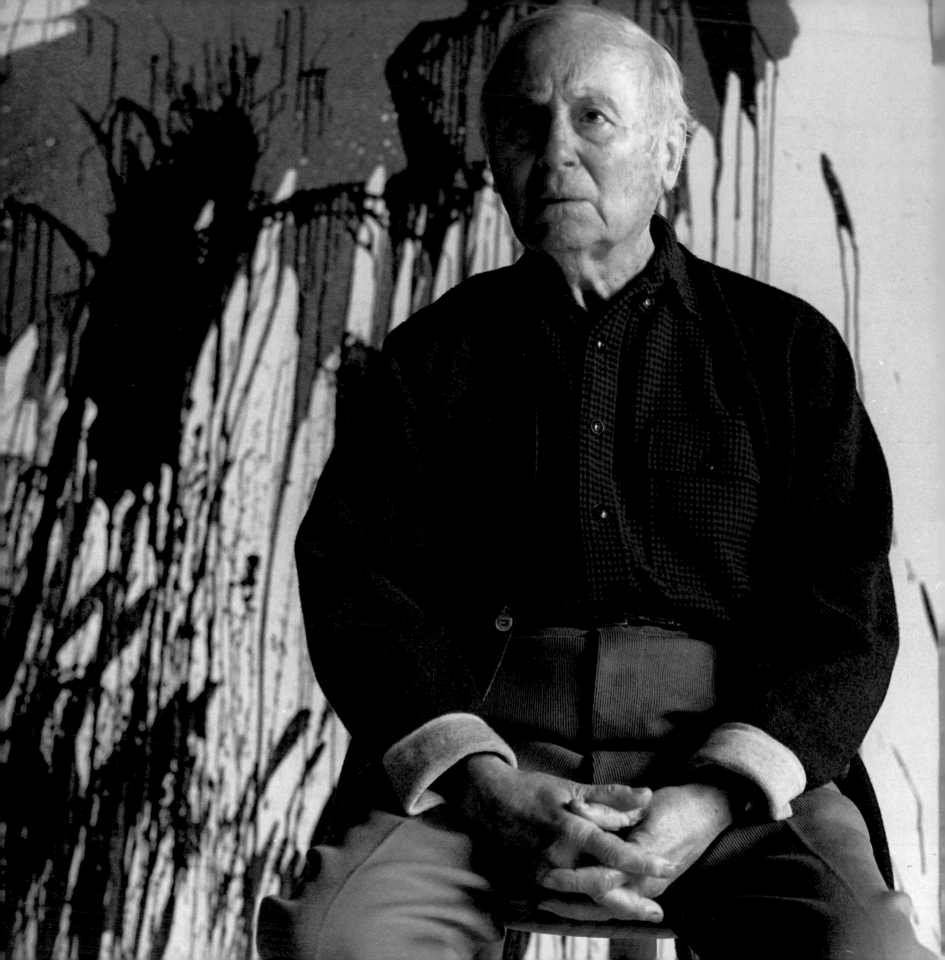

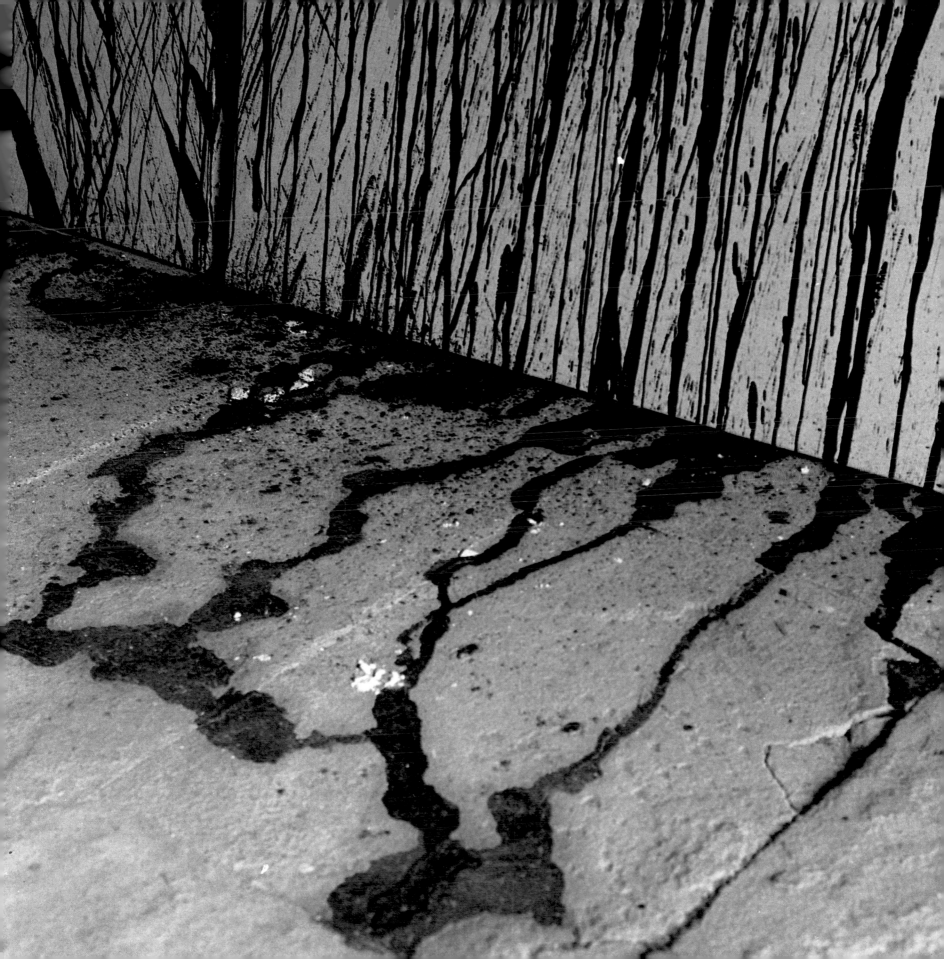

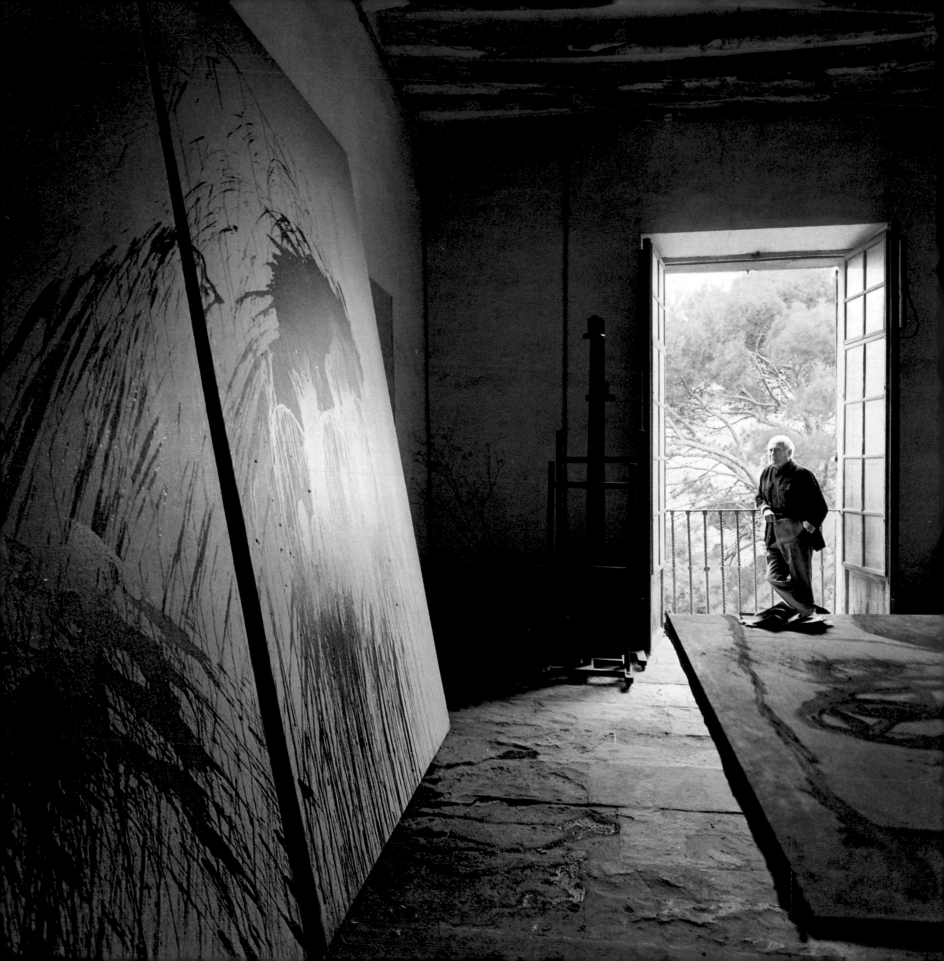

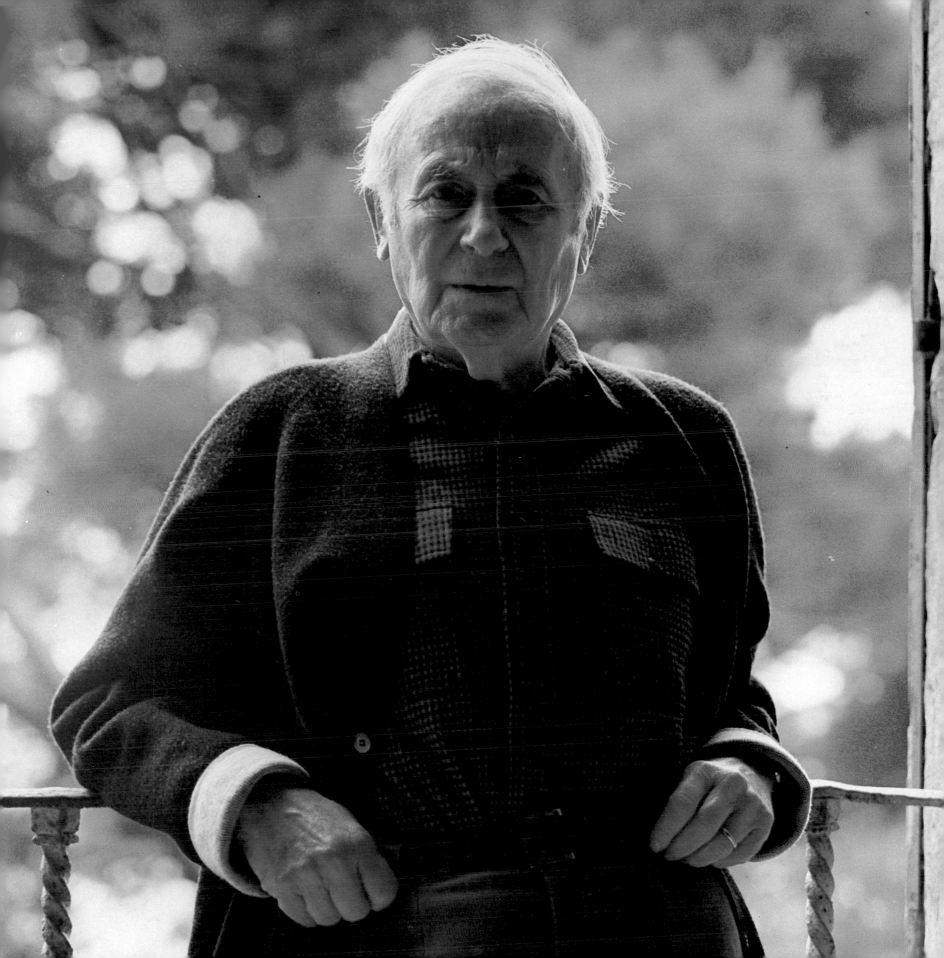

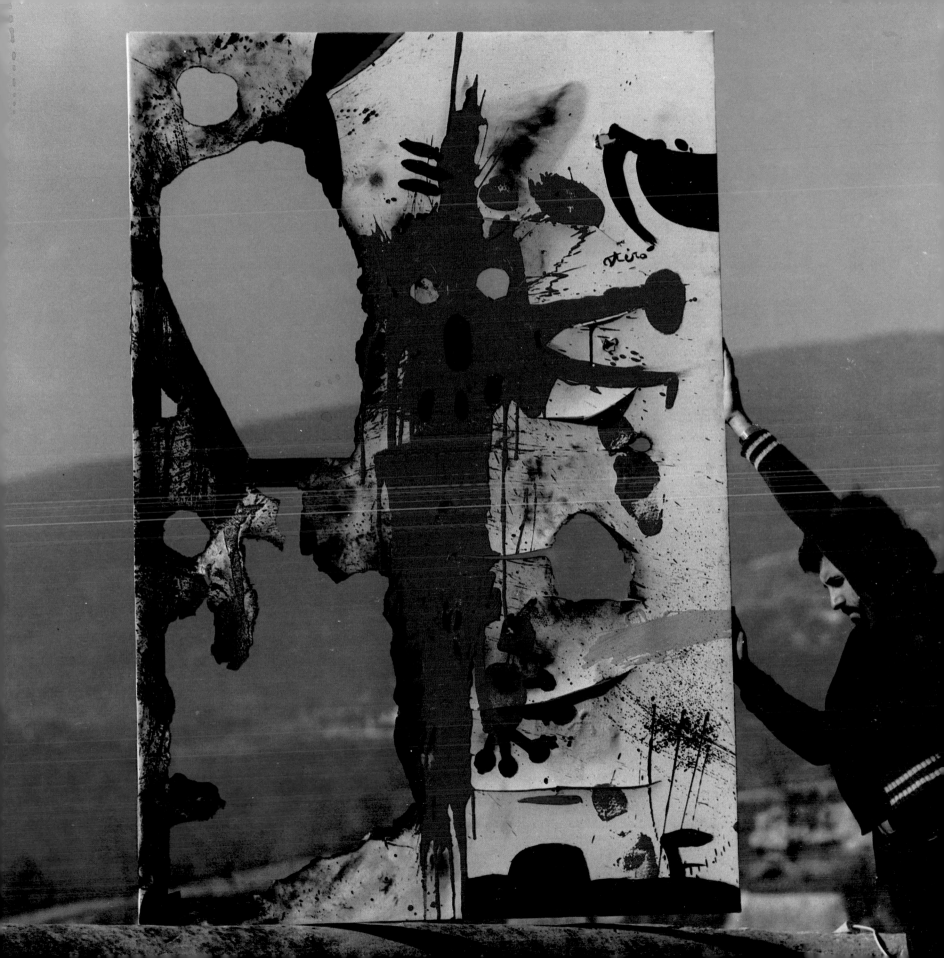

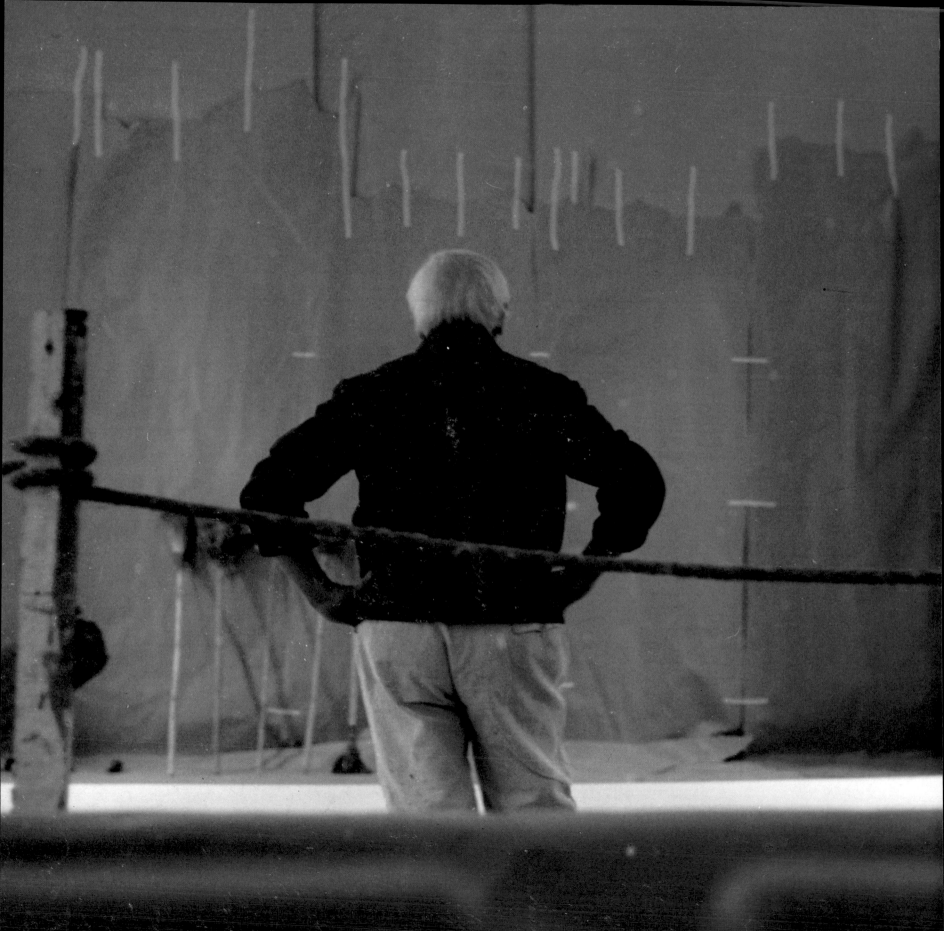

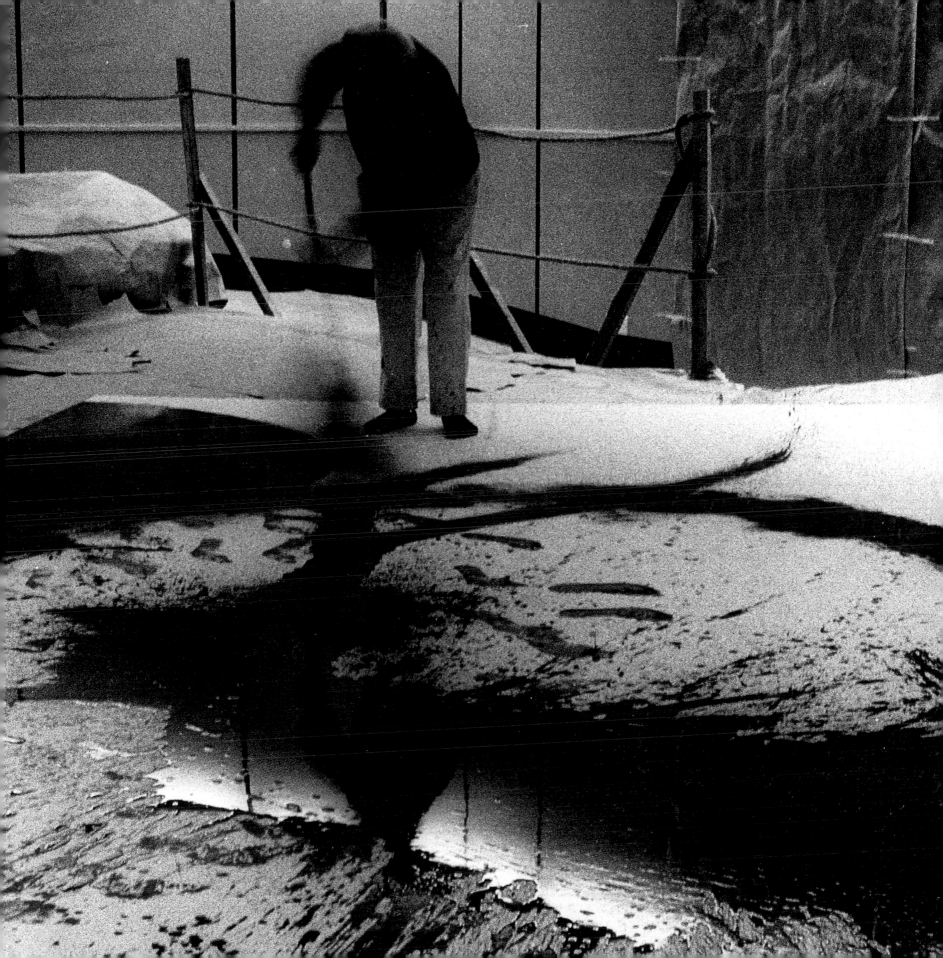

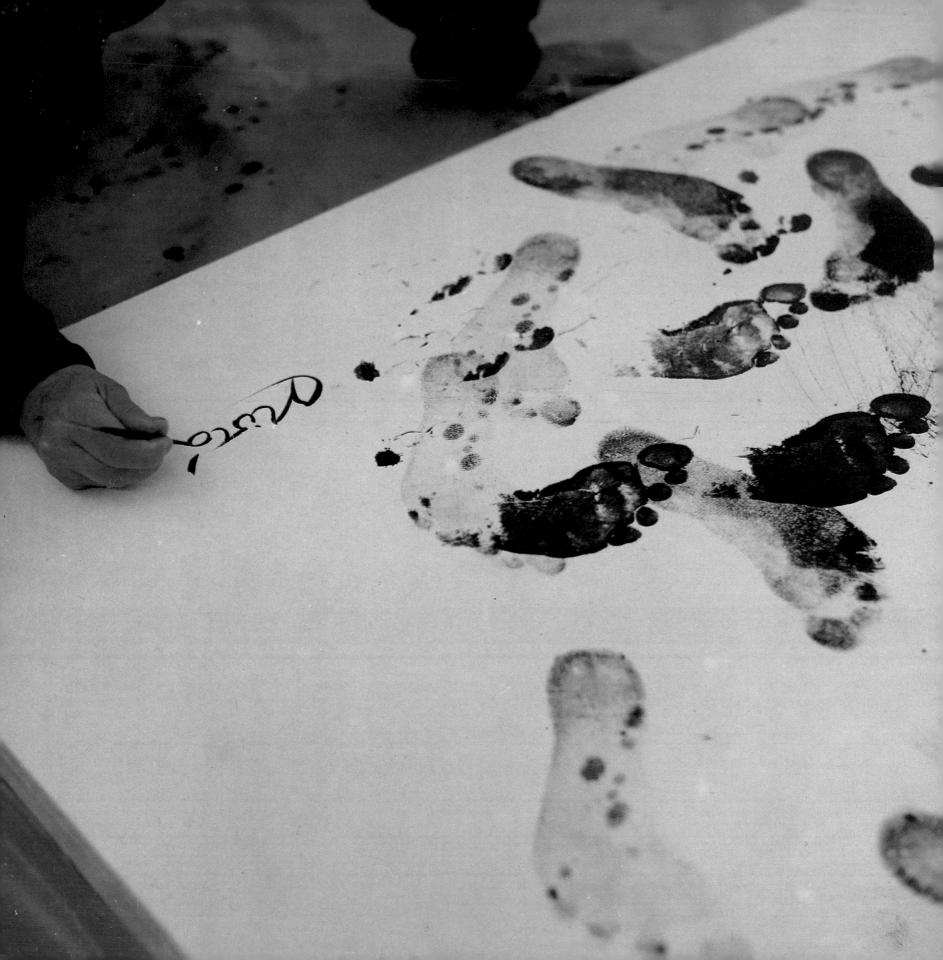

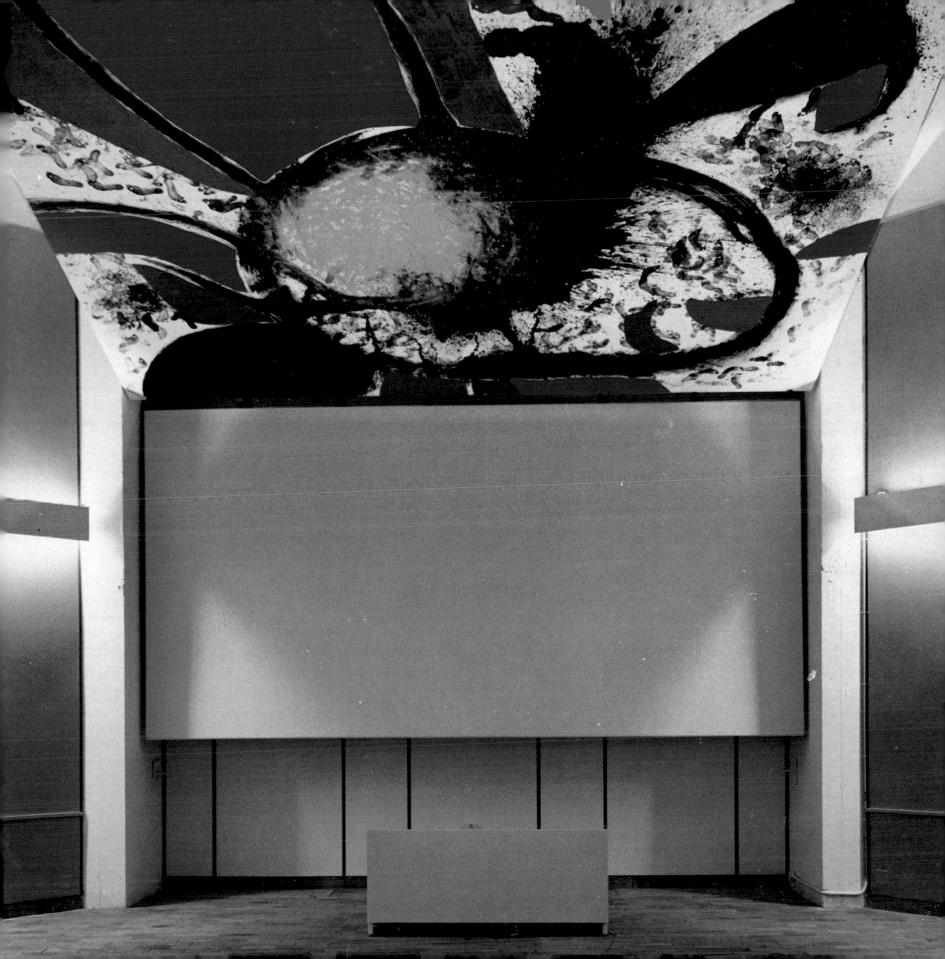

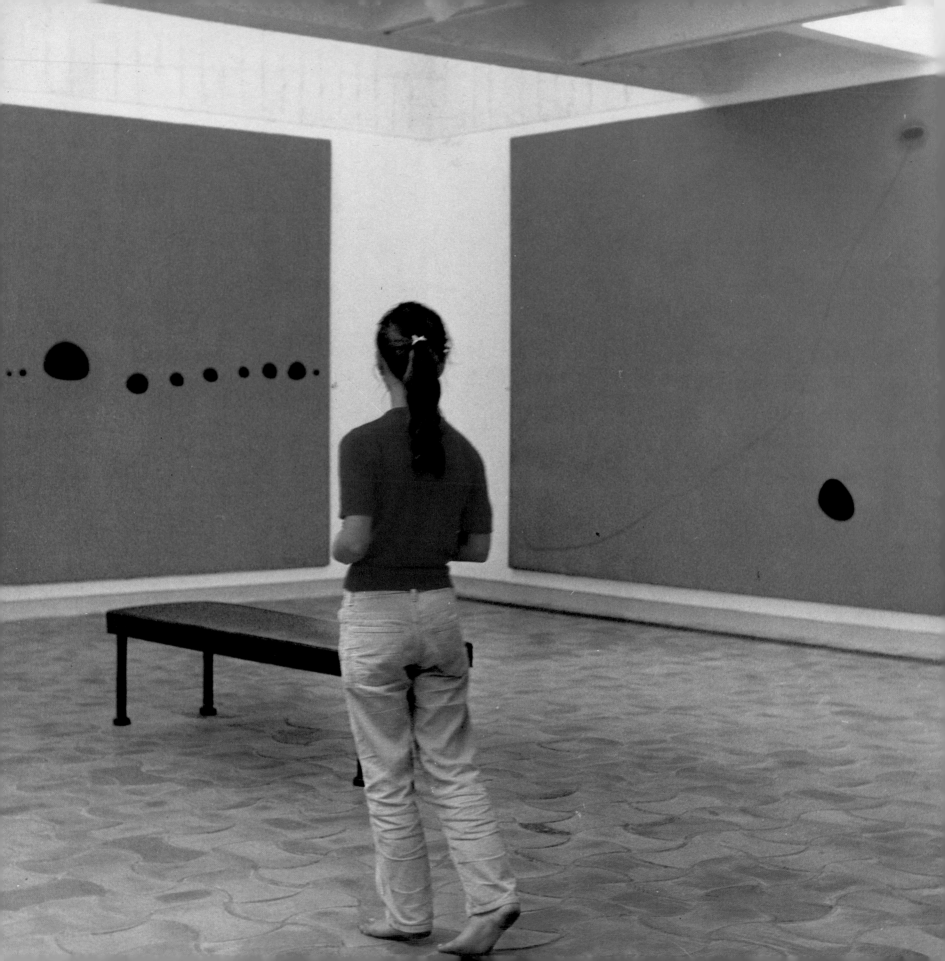

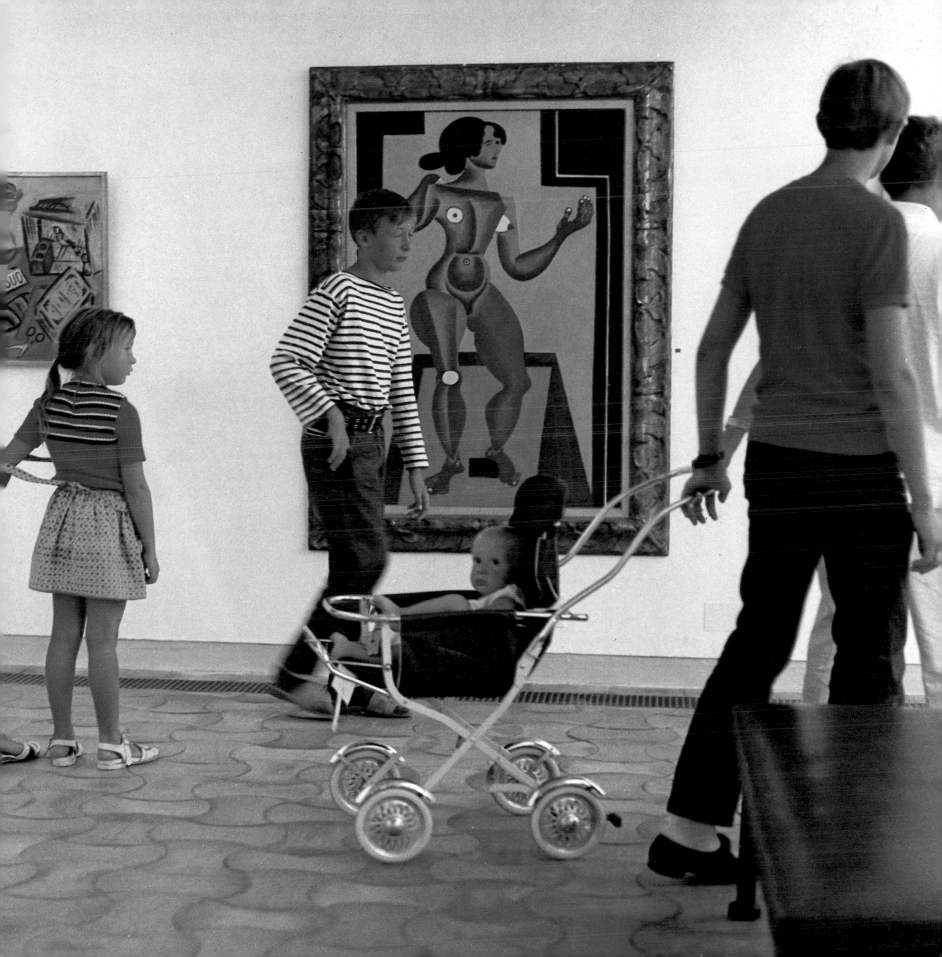

35.
Miró liked bullfights. Here we see him with the young French poet Jacques Dupin, author of a reference work on the artist.

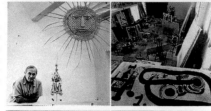

36.
Bulls inspired a number of his works. Cursa de braus was painted in 1925, when his mode of expression was undergoing a radical transformation.

49.
He always suffered deeply while at work: he understood creation as a constant struggle against vulgarity and facility.

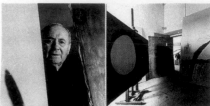

50.
'Don't worry', his teacher Galí told him. 'If you don't have a gift for lines, for drawing, you can concentrate on colour'. Miró was one of the greatest colourists of all time.

37.
'I dream of a large studio', he wrote. And his close friend, the Catalan architect Josep Lluís Sert, built one for him on the Palma (Majorca) estate. The view from the balustrade embraces everything.

38.
The view from the above mentioned balustrade. The studio reflects Miró's disposition: tidy, yet bursting with life and colour.

51.
Two parts of Tríptic de l'esperança d'un condemnat a mort (1974). The line is the life of Salvador Puig Antich, an anarchist who was garroted under Franco's dictatorship.

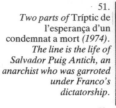
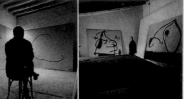

52.
He often used bold black strokes to weld the composition and colours, and he therefore started by creating this essential element.

39.
The artist's brushes, neatly set out. Everyday, when he finished working, Miró would clean them. While performing this routine chore he discovered the background that enriches the famous Constellations series.

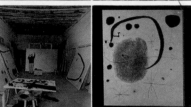

40.
He always worked on a number of paintings at the same time, sometimes leaving one aside for a while; later, at the most unexpected moment—up to several years could go by—he would finish it.

53.
All his life he remained in the front line of the avant-garde and cultivated a constant spirit of revolt which kept him young, even when he had reached old age.

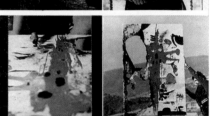

54.
It is true that he launched the slogan regarding the 'murder of painting', but he did so as an active painter in order to revitalize it, and thus it was an emotionally creative cry.

41.
Son Boter, a seventeenth-century house on the Palma (Majorca) estate, soon became another improvised studio, overflowing with enormous canvases.

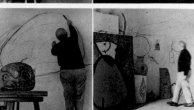

42.
He was one of the few modern painters capable of creating not only his own language, but an entire cosmos, rich and thought-provoking.

55.
The only thing that attracted him obsessively was work and he never stopped, even while he was asleep. He took meticulous notes of his dreams.

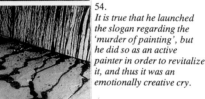

56.
He told me that he would like to be remembered by posterity as a man who had worked hard and with absolute honesty.

43.
Any white surface is good enough to sketch the next work on; from a diary page to an entire wall of the Son Boter studio.

44.
It goes without saying that any room in Son Boter has an intense, unmistakeably Mironian atmosphere.

57.
He was over eighty when he set about burning canvases. This was not the first time that he had acted violently towards his work.

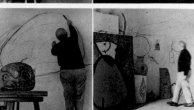

58.
In a searing attack on a bourgeoisie that only valued the millions that his creations cost, he decided to produce a series of obviously burnt canvases.

45.
He had a magic touch in transforming objects. A heap of bones becomes a person, without needing any manipulation.

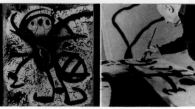

46.
The stern countenance of his father, at Son Boter, reflects the relationship between them: he never understood his son Joan. There was never a reference point for any dialogue between them.

59.
When he created large murals he never fell into the temptation of delivering a small maquette to have it enlarged. Though he made sketches, he faced the challenge himself.

60.
Miró drawing enormous strokes with a broom on a sounding board: composition in the Miró Foundation auditorium.

47.
He also knew how to create powerful, lively strokes with surprising, unique results.

48.
He followed the advice of masters of the Far East, belatedly introduced into the West by the surrealists: one must let unconsciousness guide the hand.

61.
The sounding board is a gigantic work he painted on the floor and signed as soon as it was finished.

62.
This is the effect the sounding board produces once it has been hoisted and fitted into the place where it performs its particular function.

63.
The Miró Foundation is a stirring testimony of the love of the artist for his native city, where he started painting and lived a good part of his long life.

64.
Miró wanted the Foundation to be a sort of living blank notebook: he would only fill in the first page and the rest would be up to others, especially young artists.

V. NEW PATHS OF EXPRESSION: GRAPHIC ART

From his earliest days, Miró pursued an artistic investigation that went beyond the traditional, academic easel; searching for new horizons, he tried alternative means of expression. In 1930 he made his first engravings. He loved working with craftsmen—on sculpture, ceramics, tapestry—and through this he discovered the sensuality of materials, to which he was extremely sensitive: metal sheets, paper, boxwood, tools and instruments. There was also the additional appeal of a broader public. From the very beginning Miró received so much encouragement—from Dutrou, Lemoigne, Celestin, Mourlot, Frélaut and Barabarà—and was fascinated to such a degree by creating graphic art that he dedicated his creative genius to it, heart and soul. It is no wonder that in this field he alone is the artist who, after the outstanding pioneer Toulouse-Lautrec, was immensely innovative in this area and made a decisively enriching contribution to the genre.

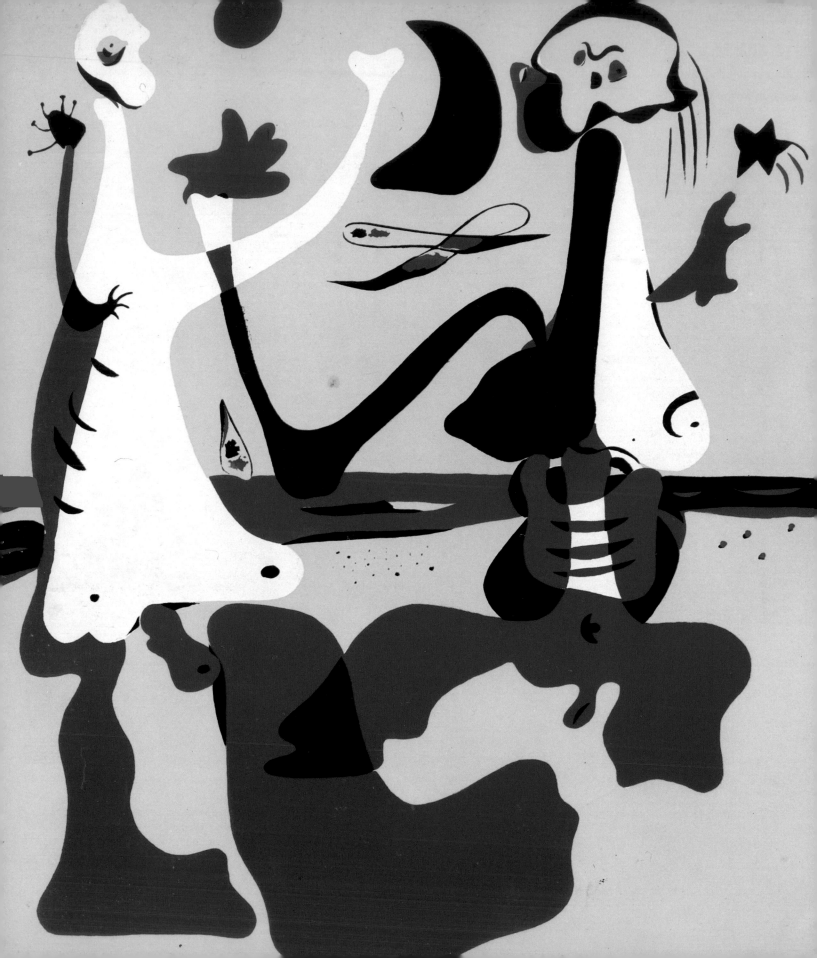

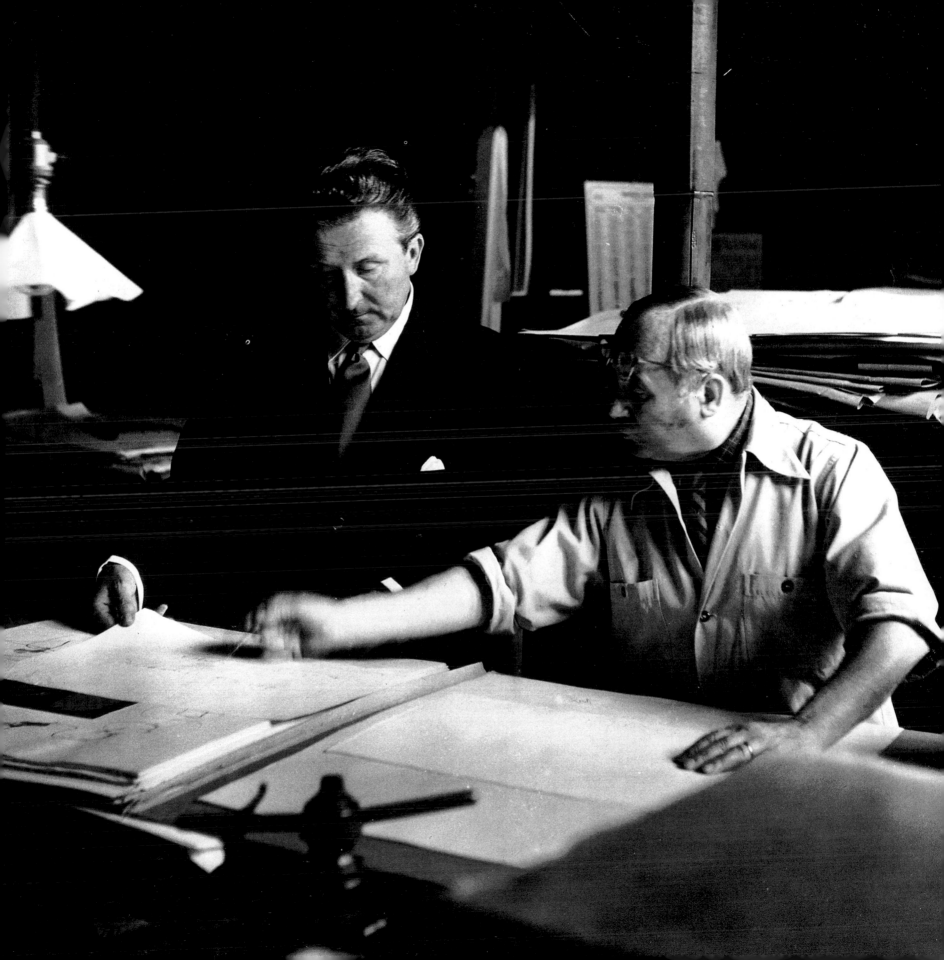

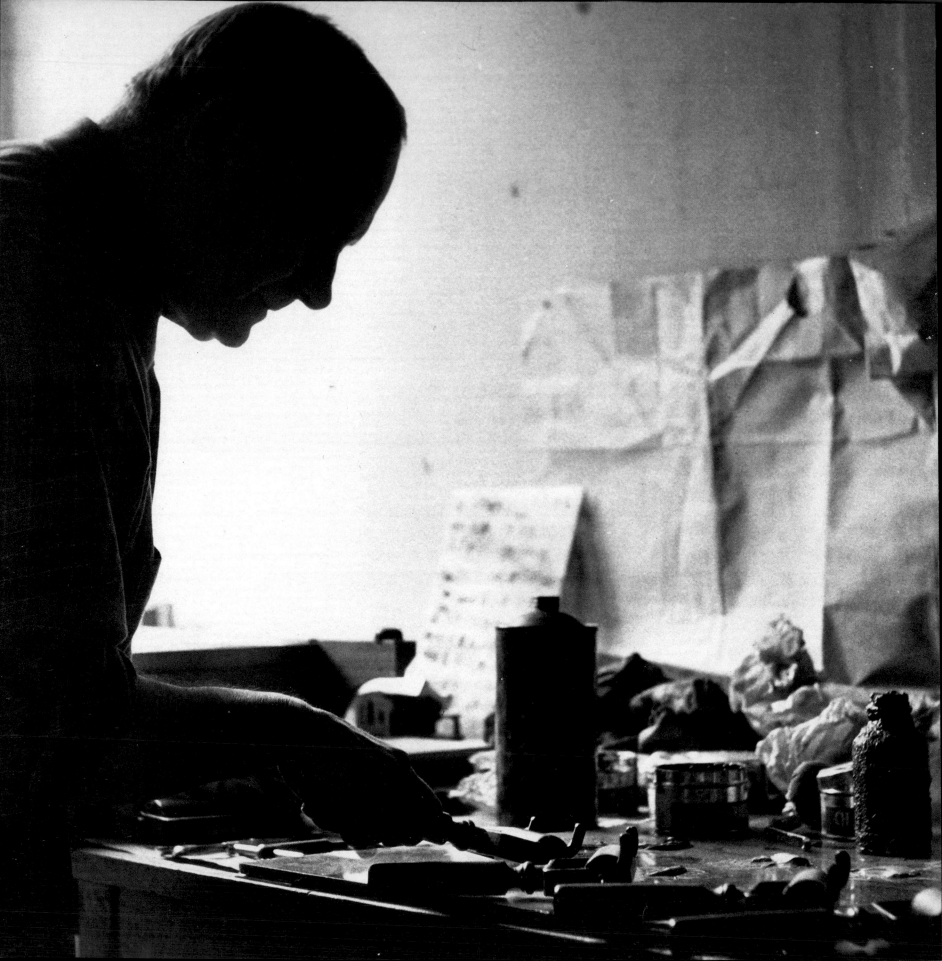

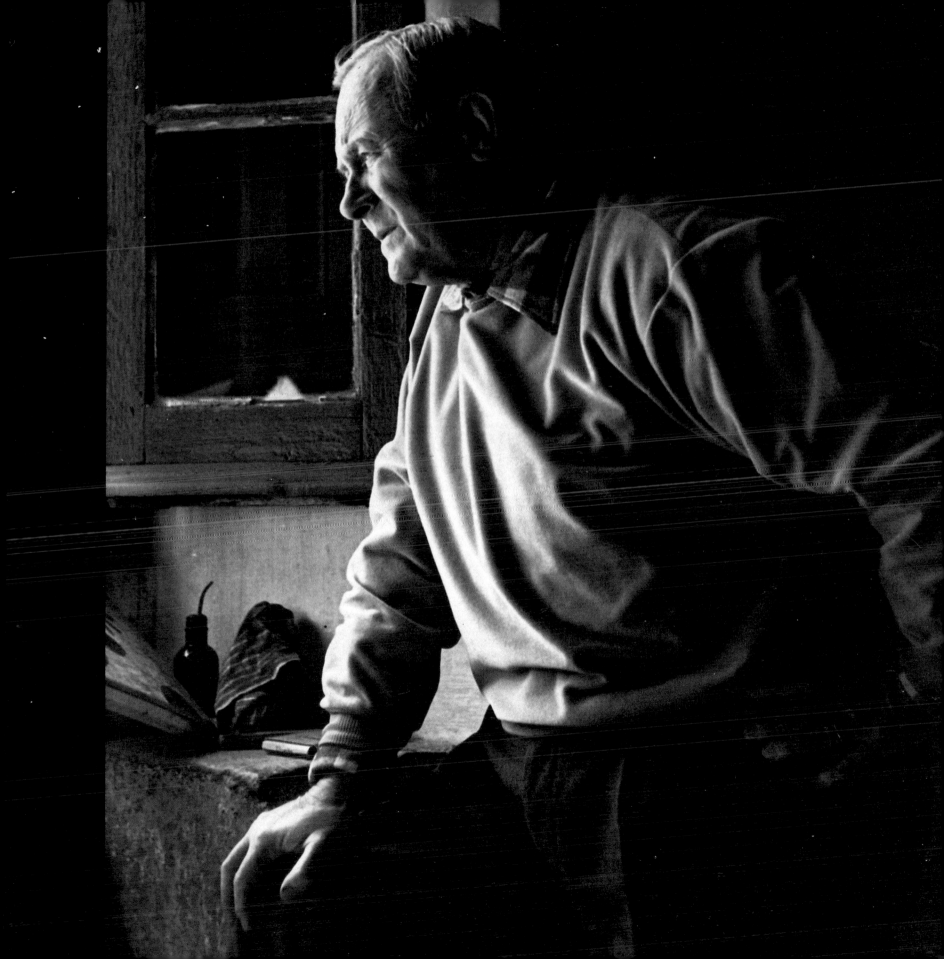

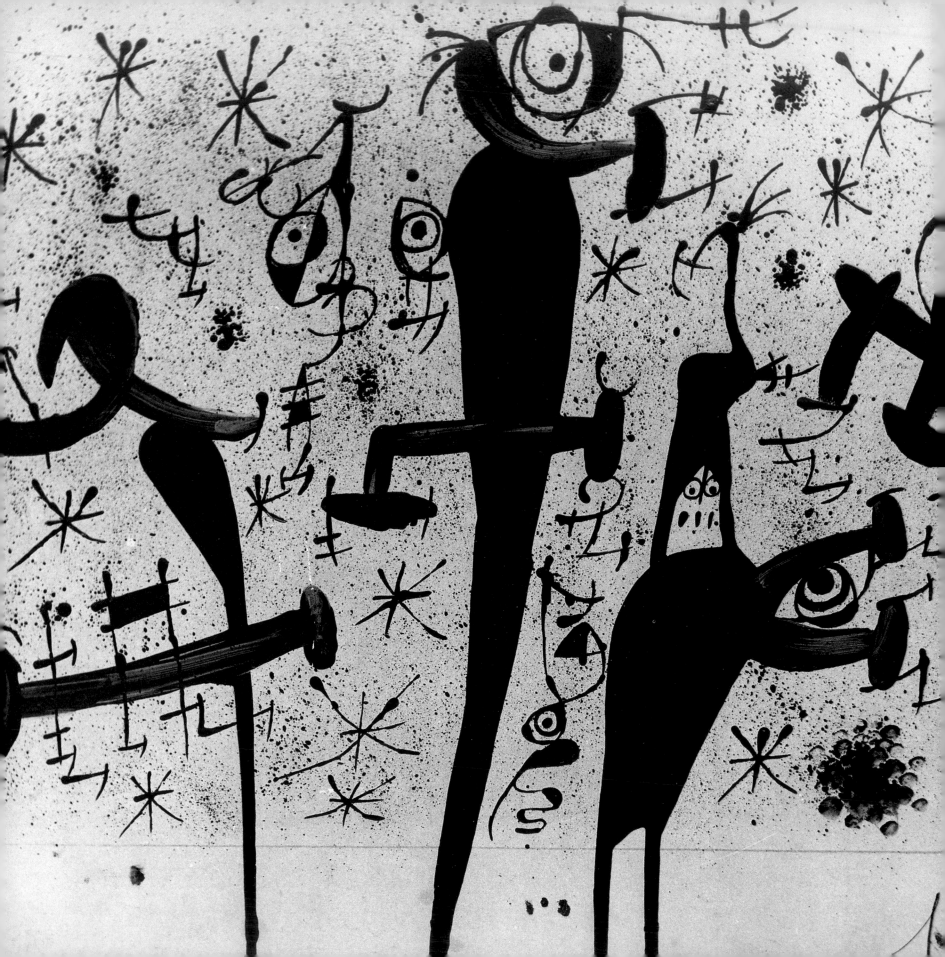

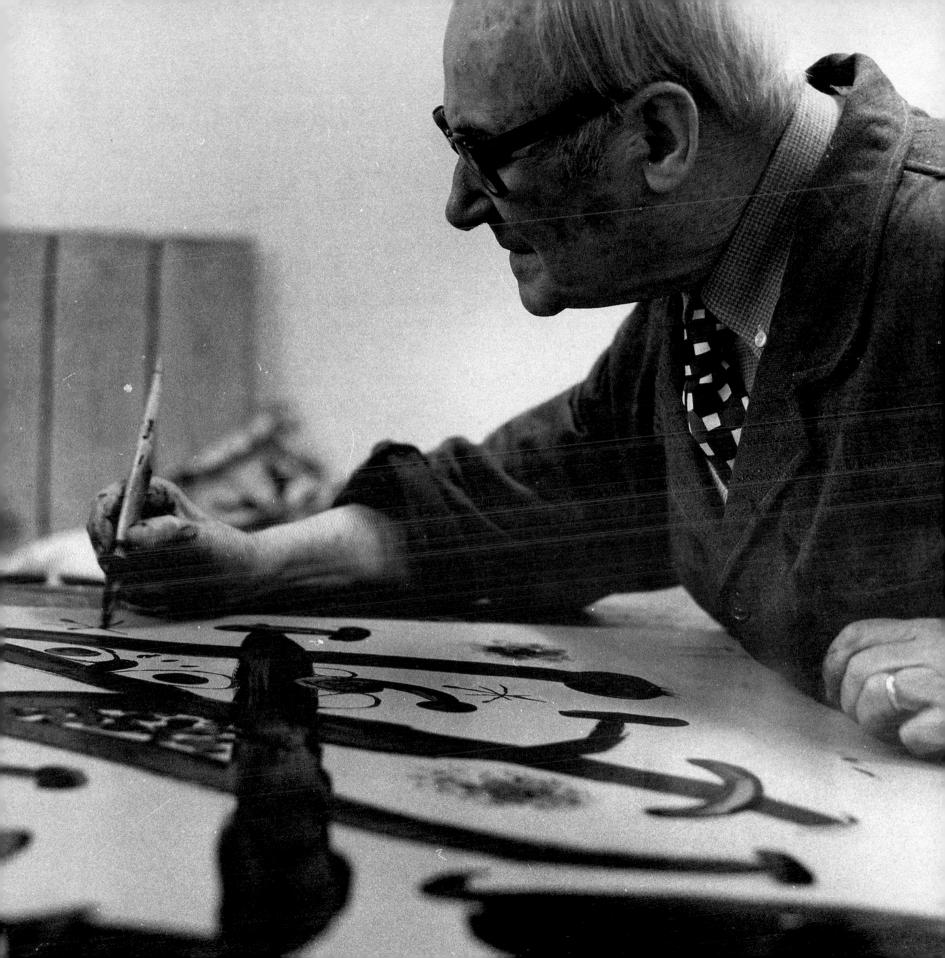

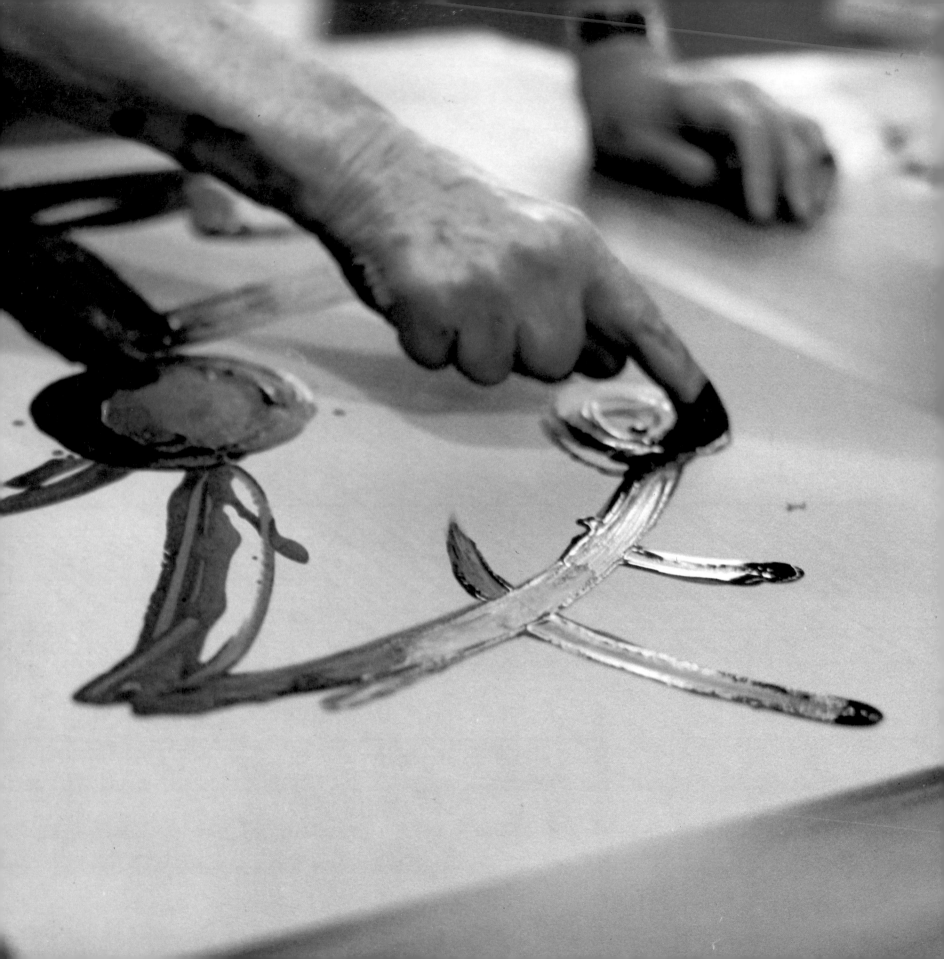

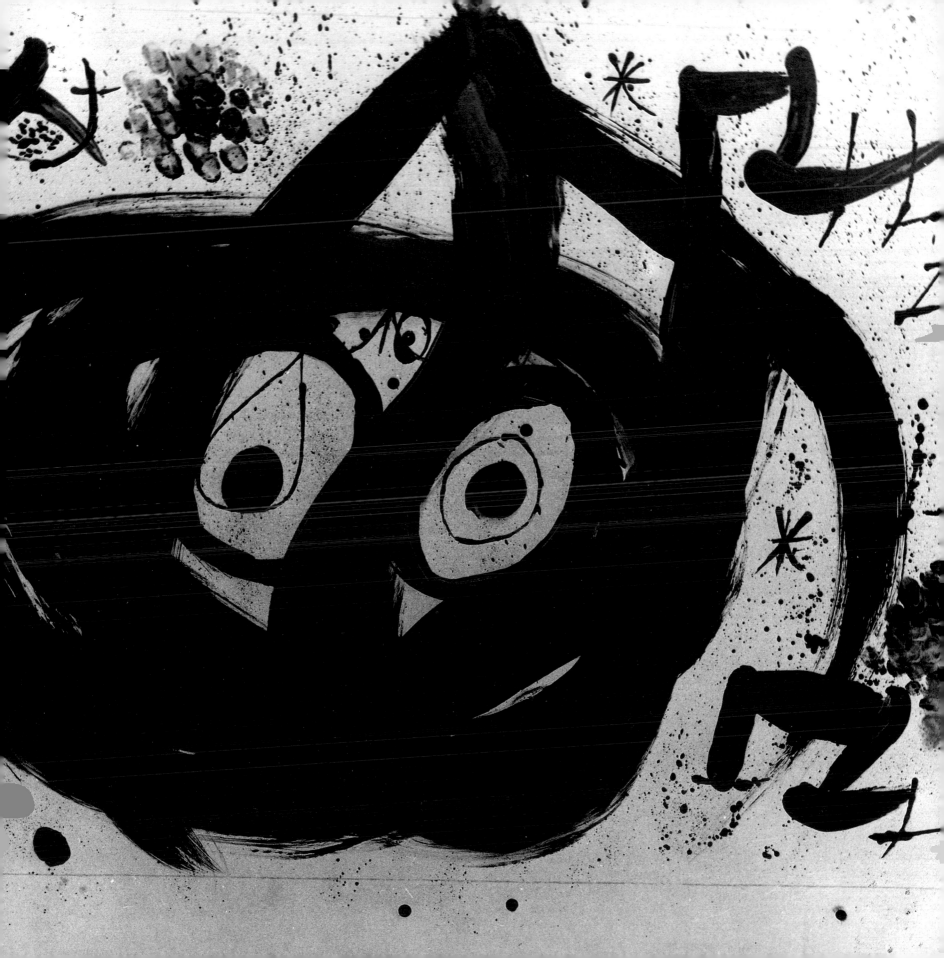

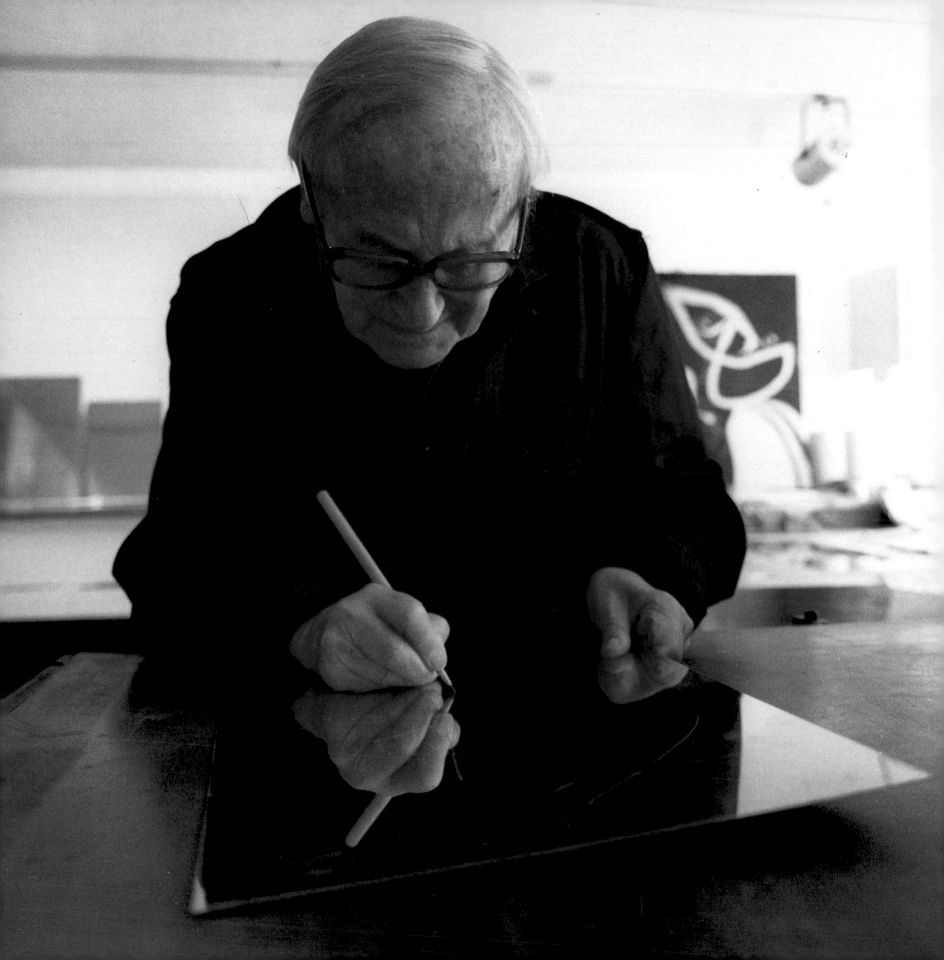

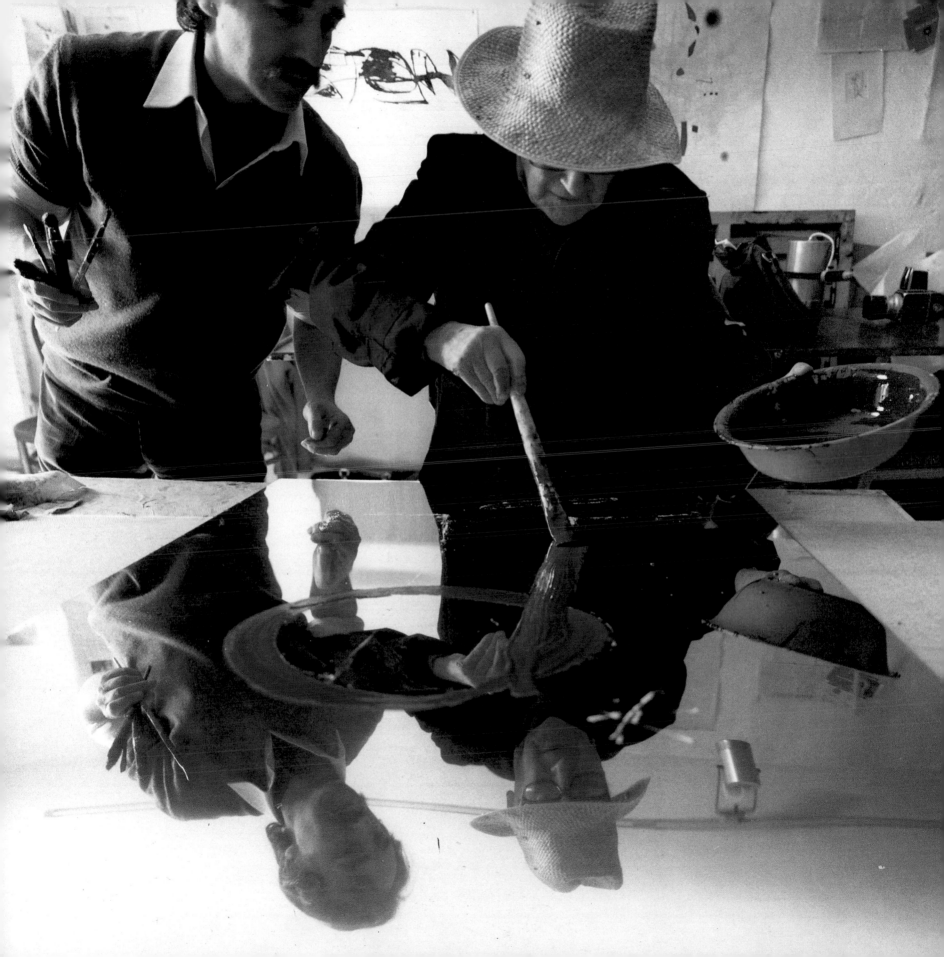

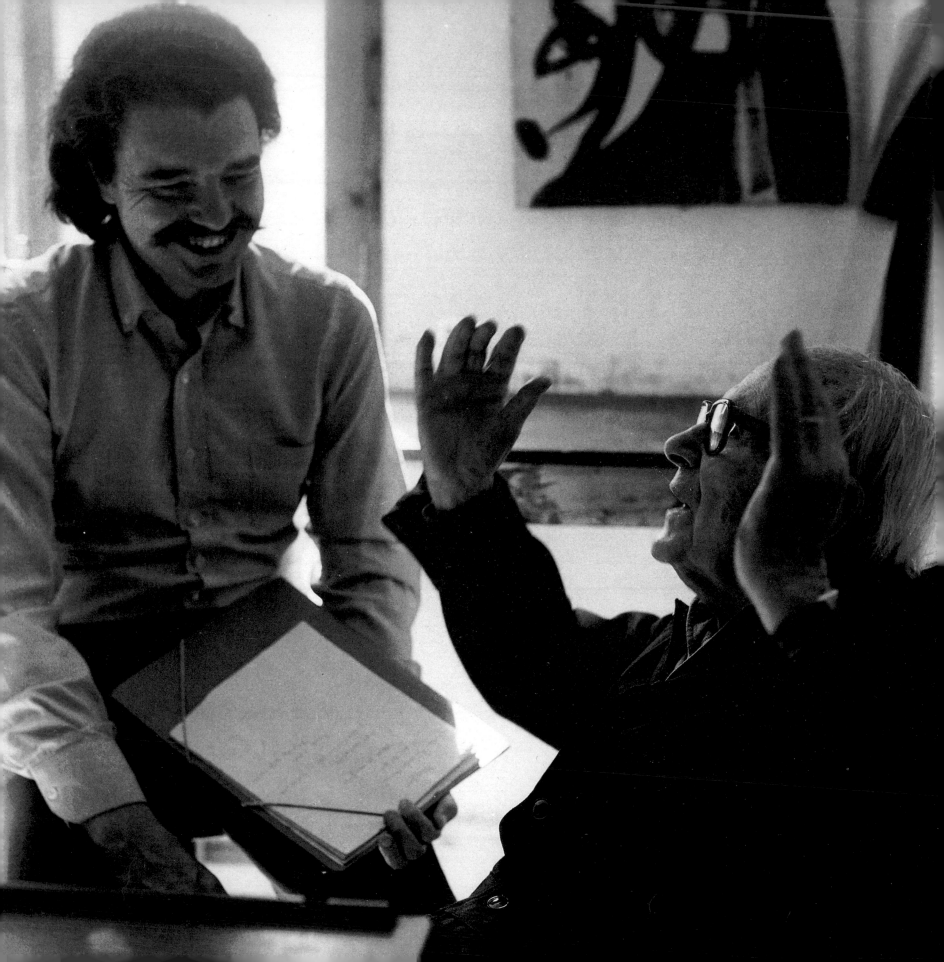

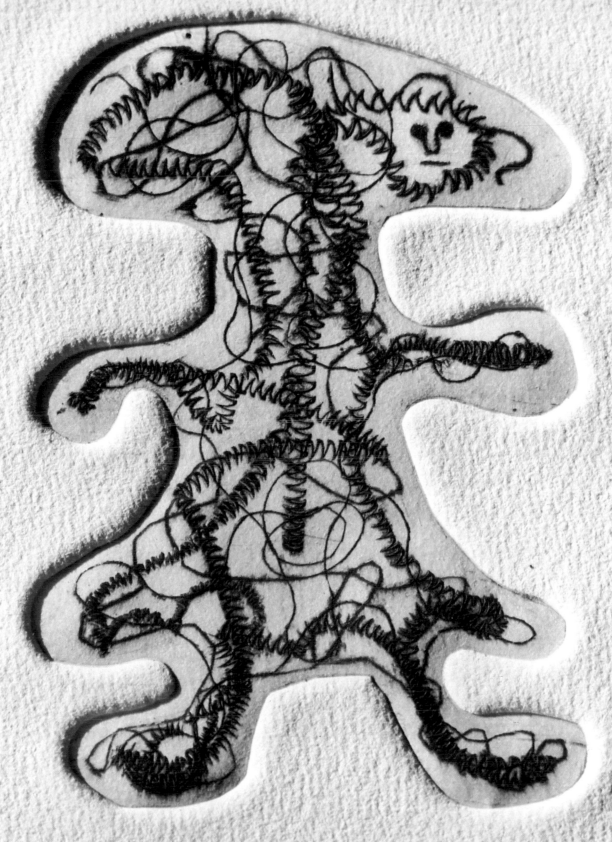

épreuve d'artiste Miró.

2/5

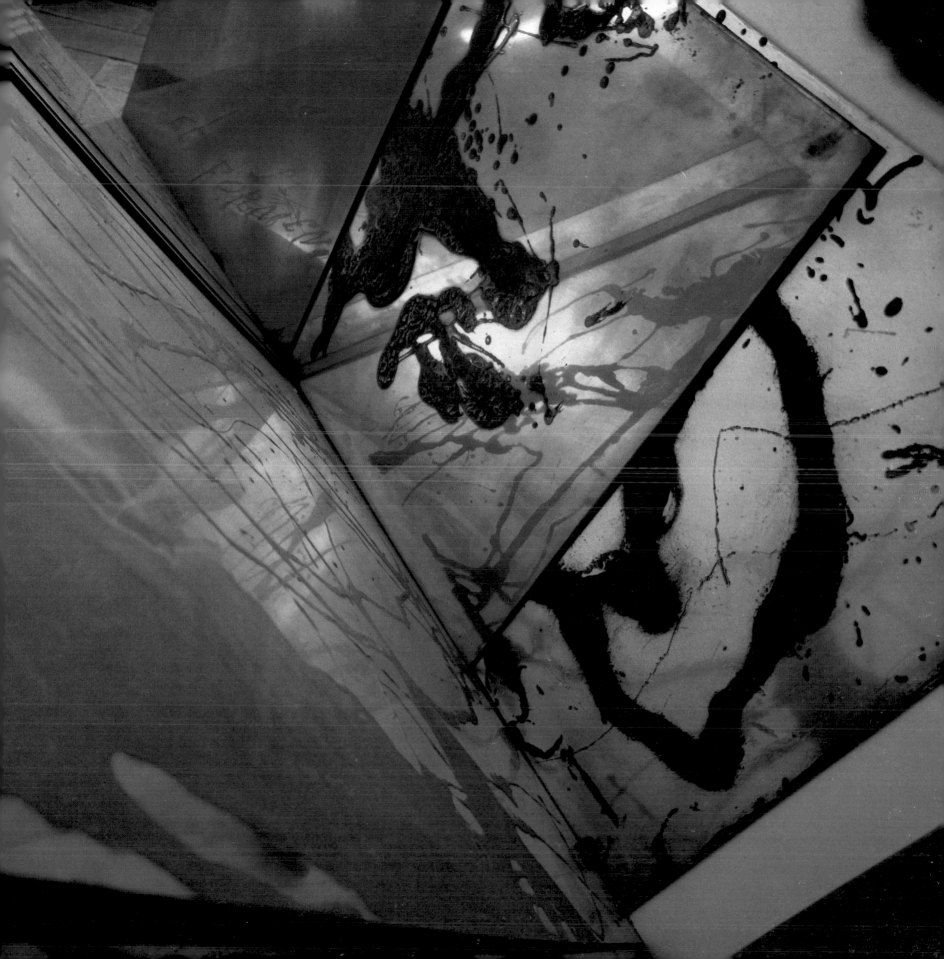

65.
In 1934 he made a pochoir for the cover of a special issue of D'Ací d'Allà. This is another one inside the magazine.

66.
Aimé Maeght, who was his dealer for the last 40 years of his life, encouraged him to devote himself to the graphic arts.

67.
He always preferred heterodox instruments of his own choice. An engraver's burin, for example, left him cold; on the other hand, a nail gave him the power to transmit his warmth.

68.
He felt at home in the workshops of the craftsmen he respected. He spent many hours working there, taking only short breaks to rest.

69.
One of Miró's qualities was that he could find just the right language for each one of the various genres and techniques he cultivated.

70.
Bold strokes that seem to have been created with one quick, instinctive sweep, were actually composed little by little, with great care, giving each new stroke its true value.

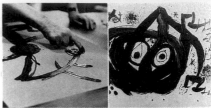

71.
He sometimes opted for the most anti-academic solutions imaginable in order to achieve a result that was, above all, warm and full of life.

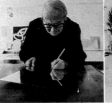

72.
This engraving emerged on a plate worked over with the finger. This creature, so characteristic of Mironian art has strength, movement and life.

73.
He created engravings and lithographs intuitively without a preliminary sketch. It was stirring to see how he took a blank plate and attacked it directly with the steel tip.

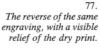

74.
He found in the engraver Joan Barbarà the kind of craftsman with whom he loved to work. Here we see him making an etching in the engraving studio he had set up in Son Boter.

75.
I spent an unforgettable day at Son Boter, where Miró was kind and trusting enough to let me observe an engraving session, as we talked.

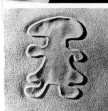

76.
Over the outline of a typically Mironian character obtained through relief engraving, he drew nervous, automatic lines.

77.
The reverse of the same engraving, with a visible relief of the dry print.

78.
These etched plates bear witness to a day of unhampered, passionate labour, carried out when he was nearly 90 years old!

VI. TOWARDS SCULPTURE THROUGH TOUCH

In the anti-academic Galí School the young Miró had learned to draw blindfold, having touched and explored every detail of the model with his hands. He thus developed an extraordinary sensitivity to form, which logically led him to sculpture. He dedicated himself entirely to this medium when he decided to 'murder painting'. From 1928 to 1931 he created a revolutionary series of collage–objects, constructions and sculpture–objects using materials that would be considered meagre a few decades later. After the war he took up sculpture, inspired by the beauty of natural forms, which he discovered while systematically gathering unexpected objects that he would immediately combine with the irrationality that Lautréamont recommended. Miró, who had an infallible flair for detecting true craftsmen with whom he could work, met and worked with the Parelladas, father and son, who were smelters. His legacy to us as a sculptor is a poetic, inquisitive work, at once provocative and surprising, which gradually evolved towards large forms.

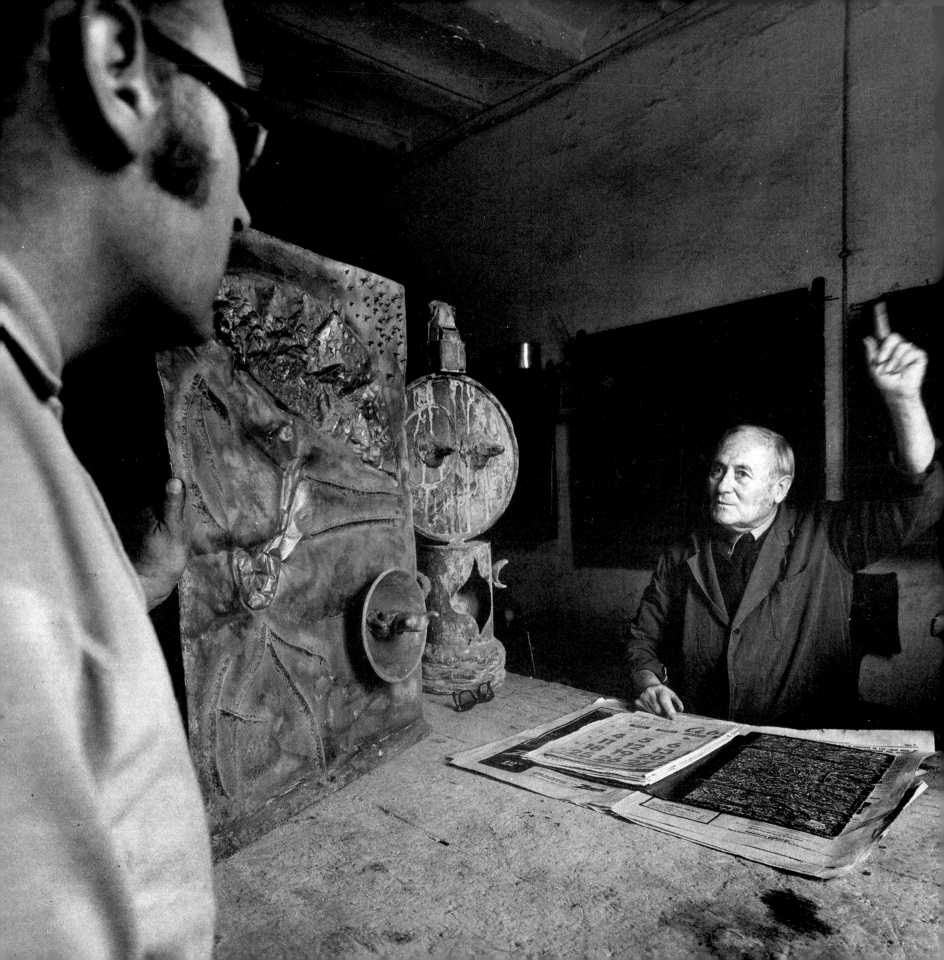

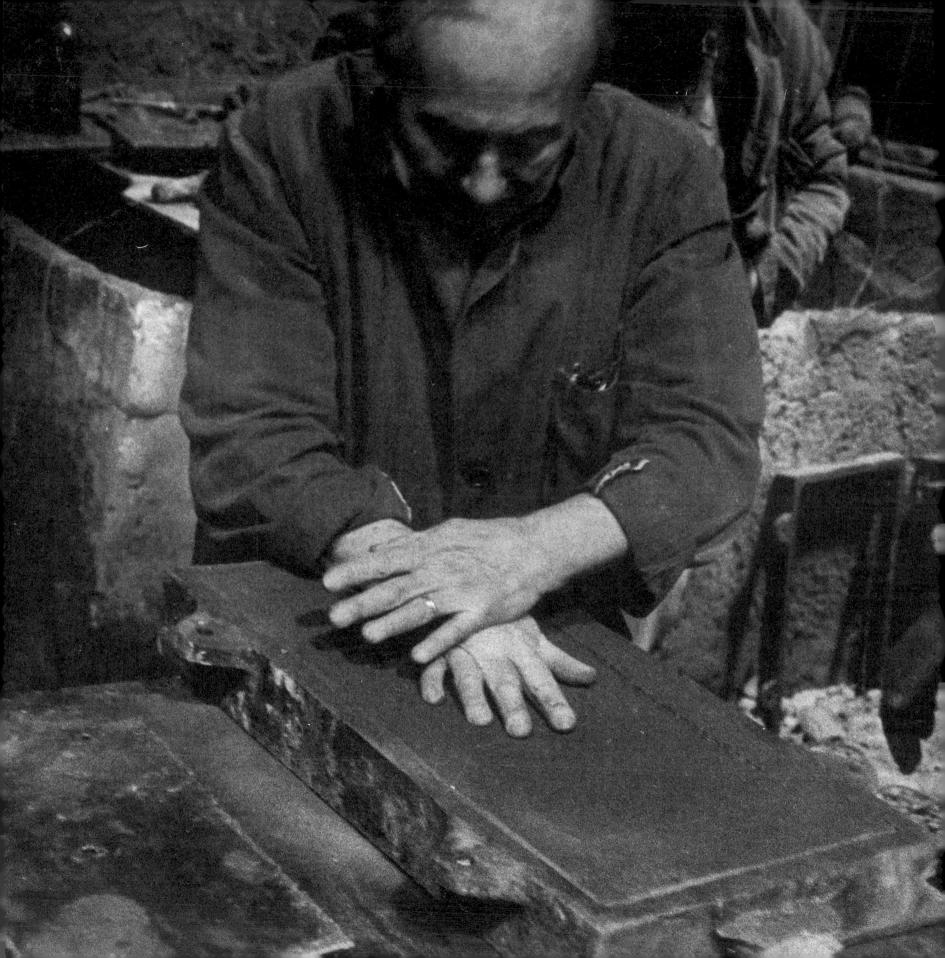

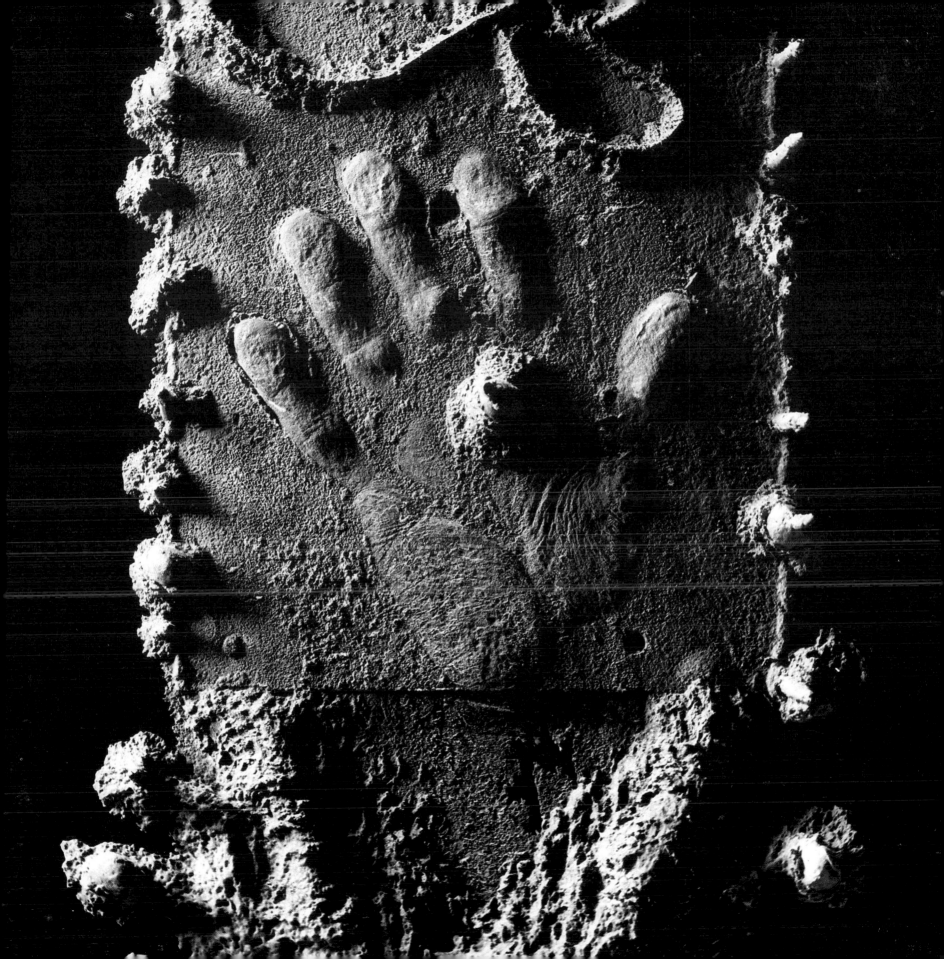

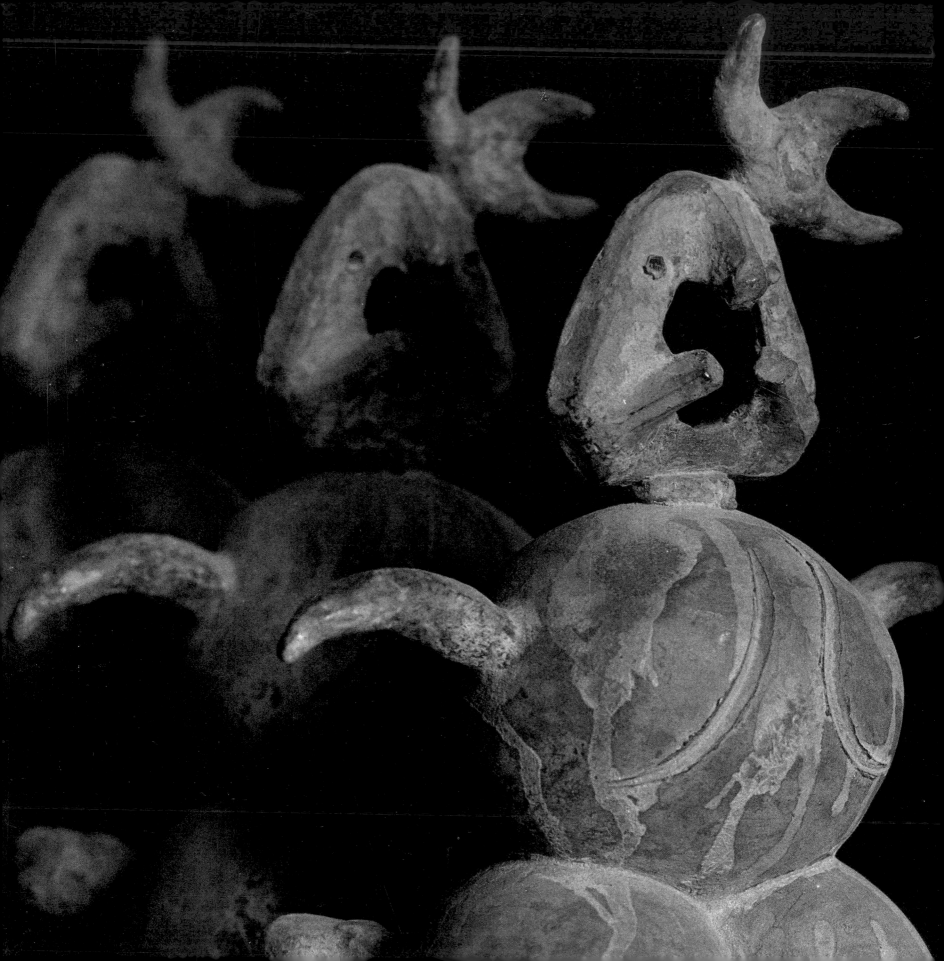

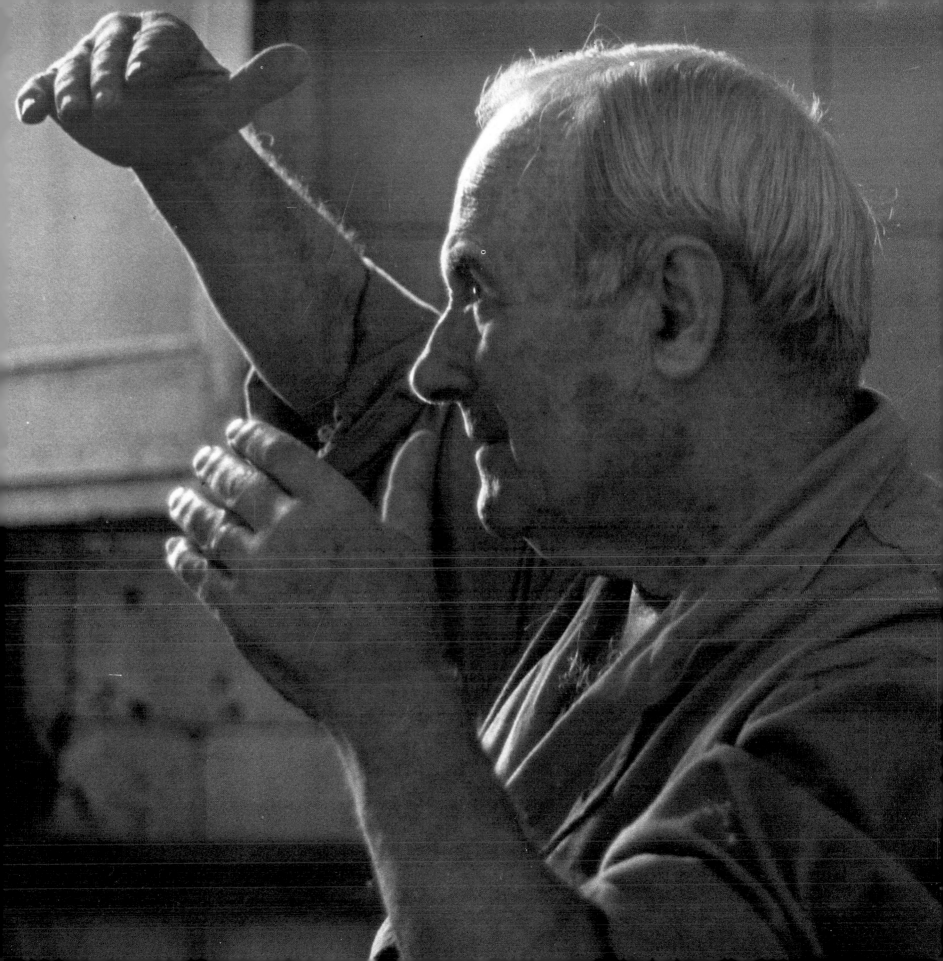

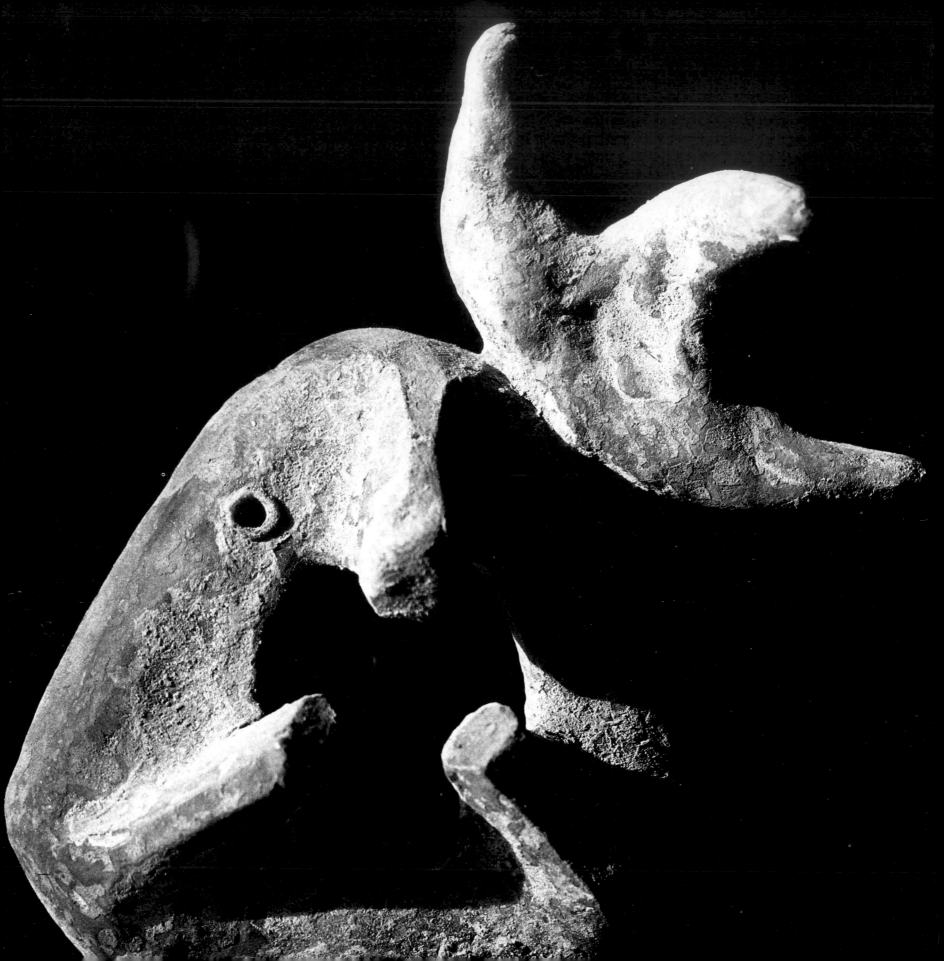

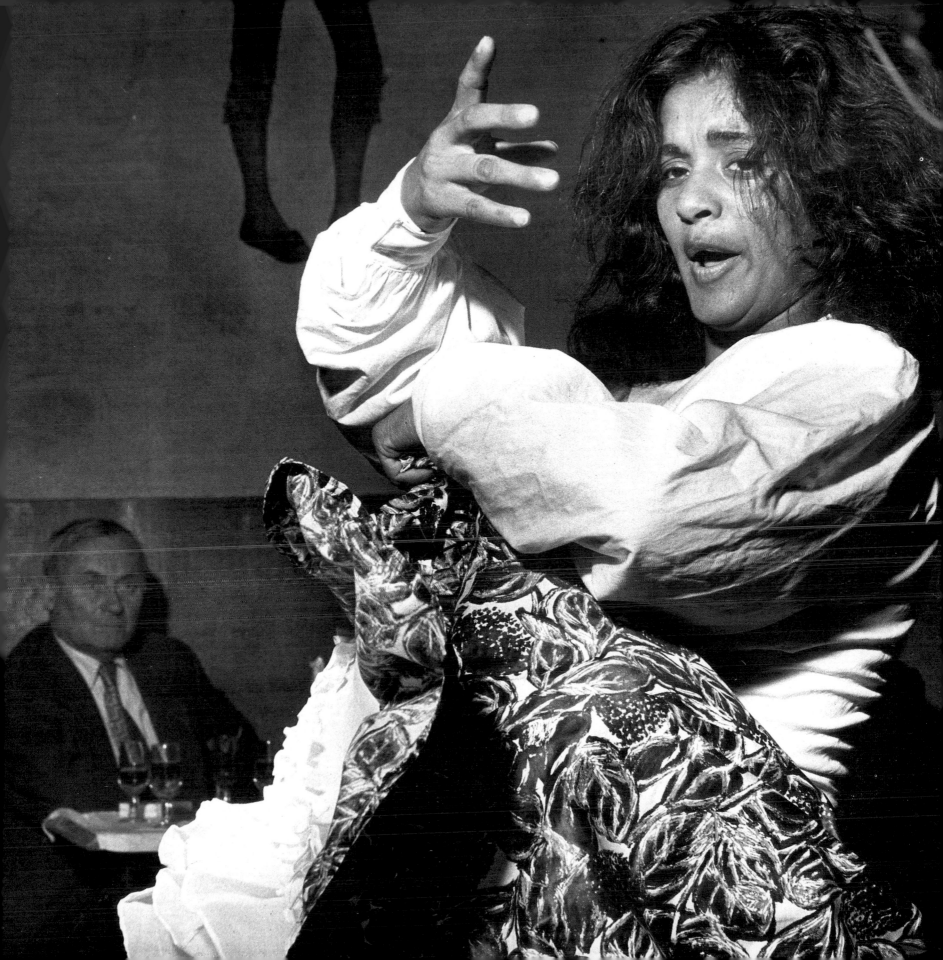

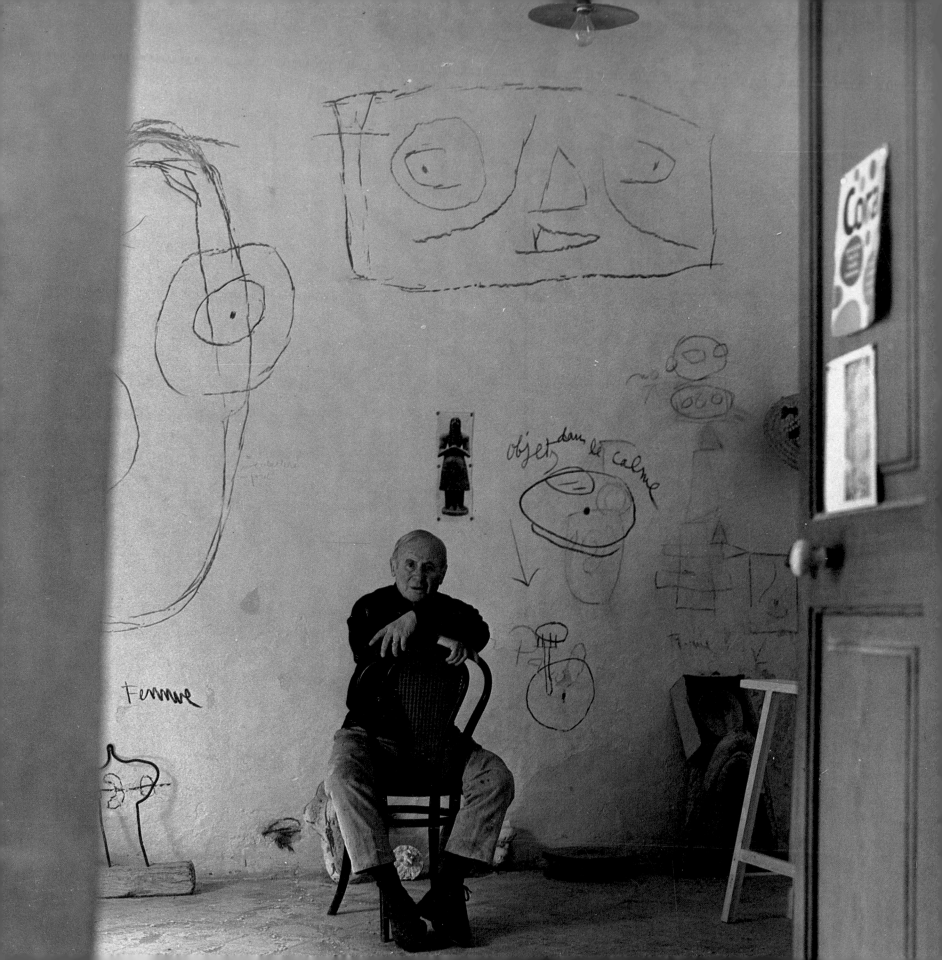

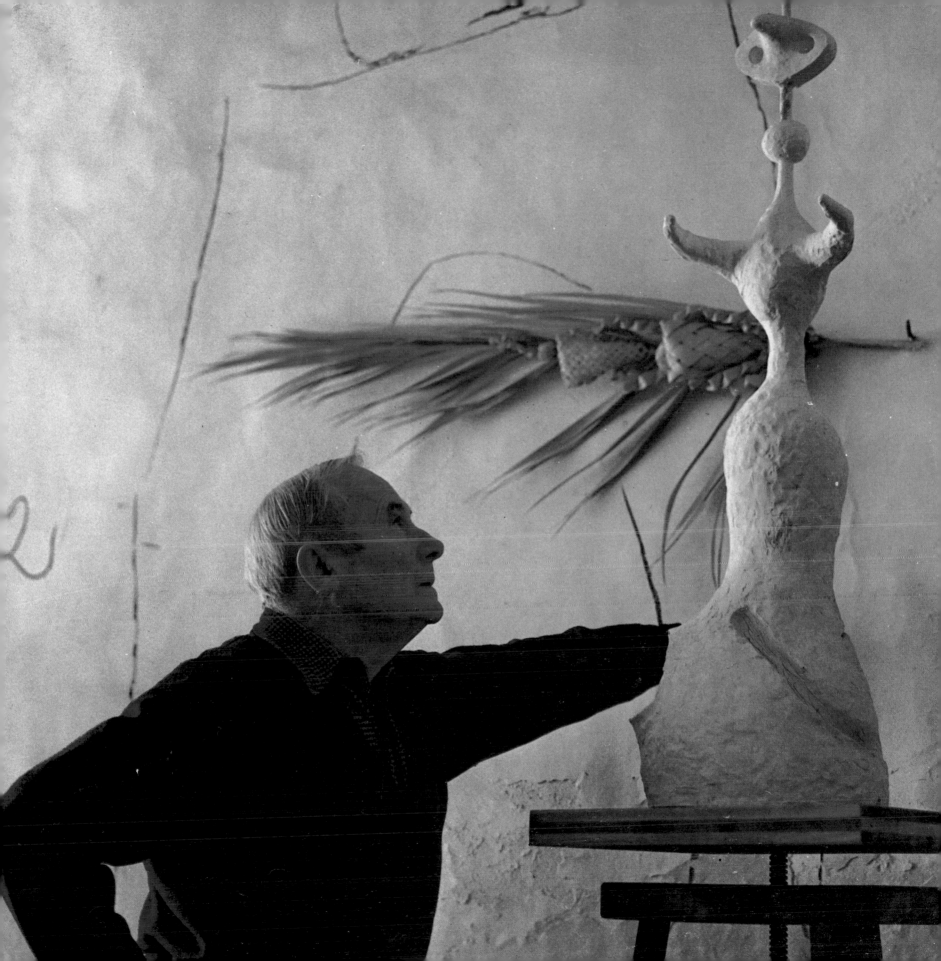

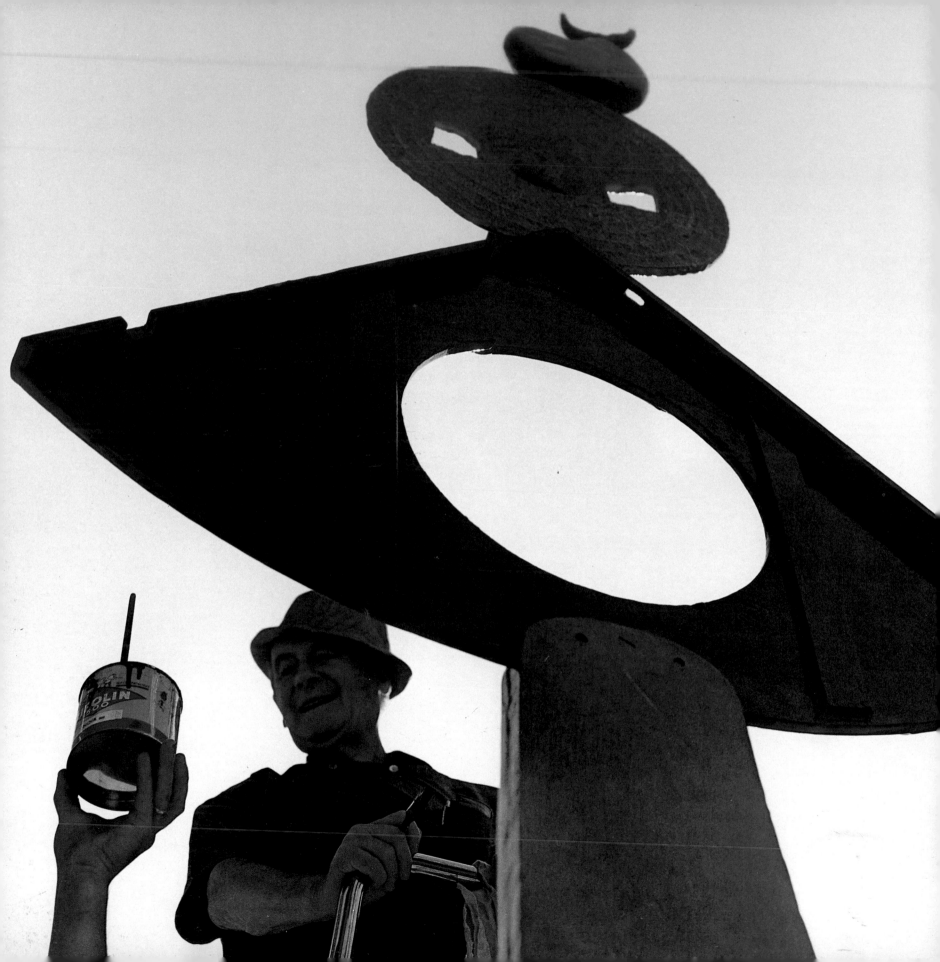

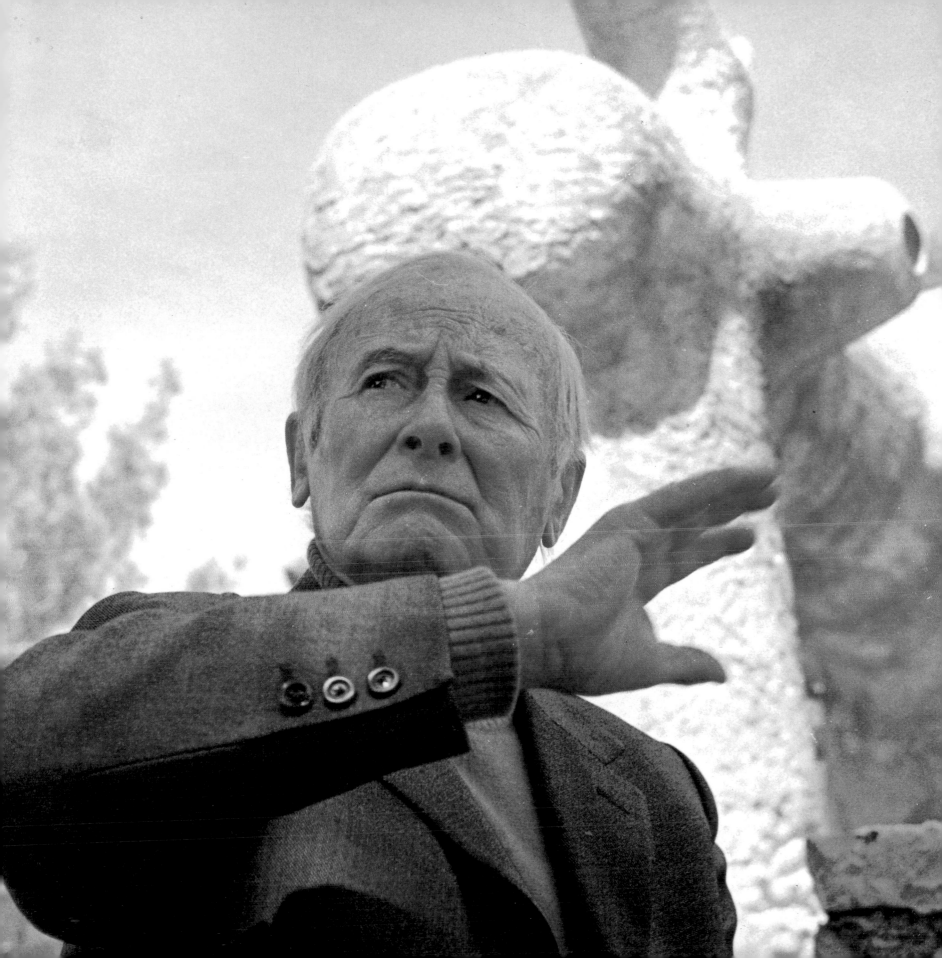

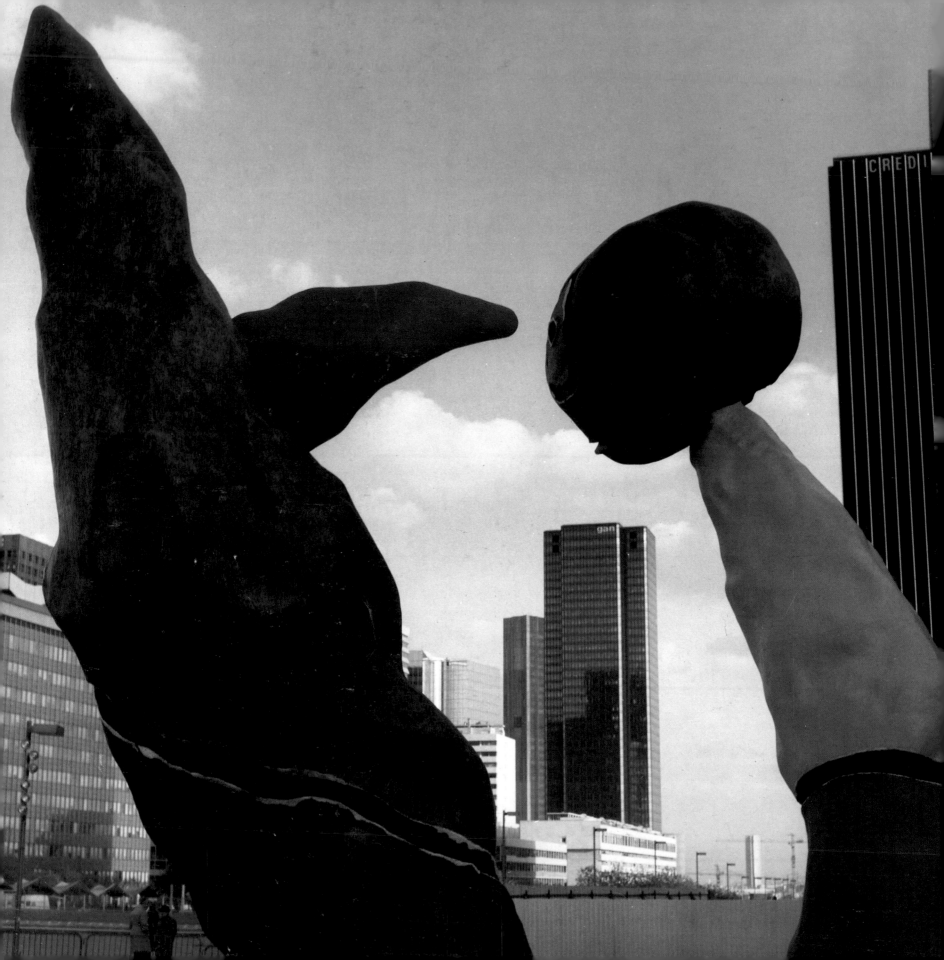

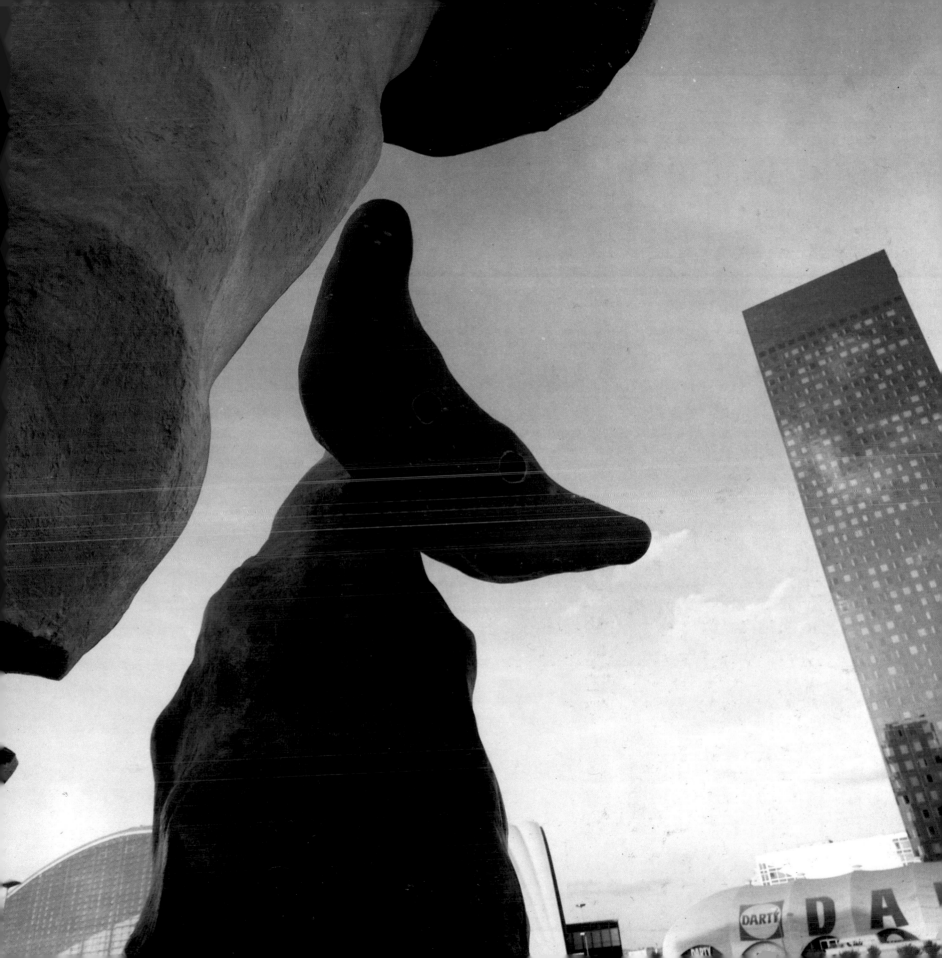

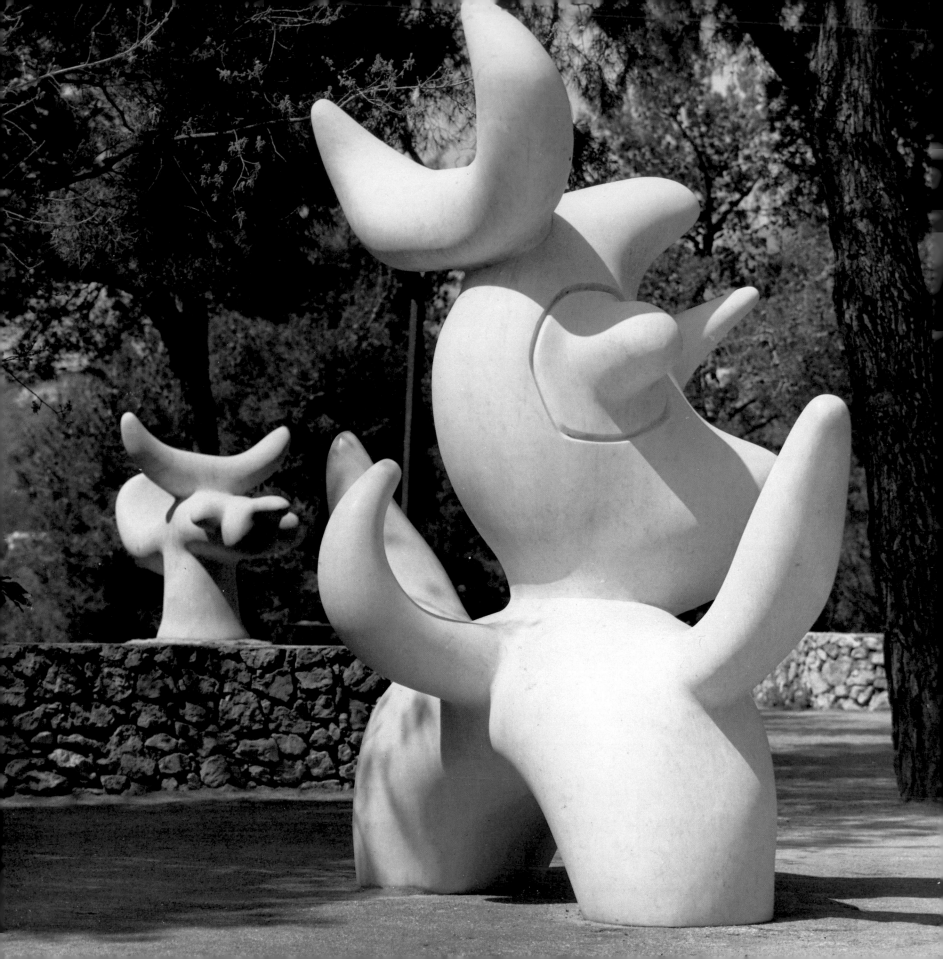

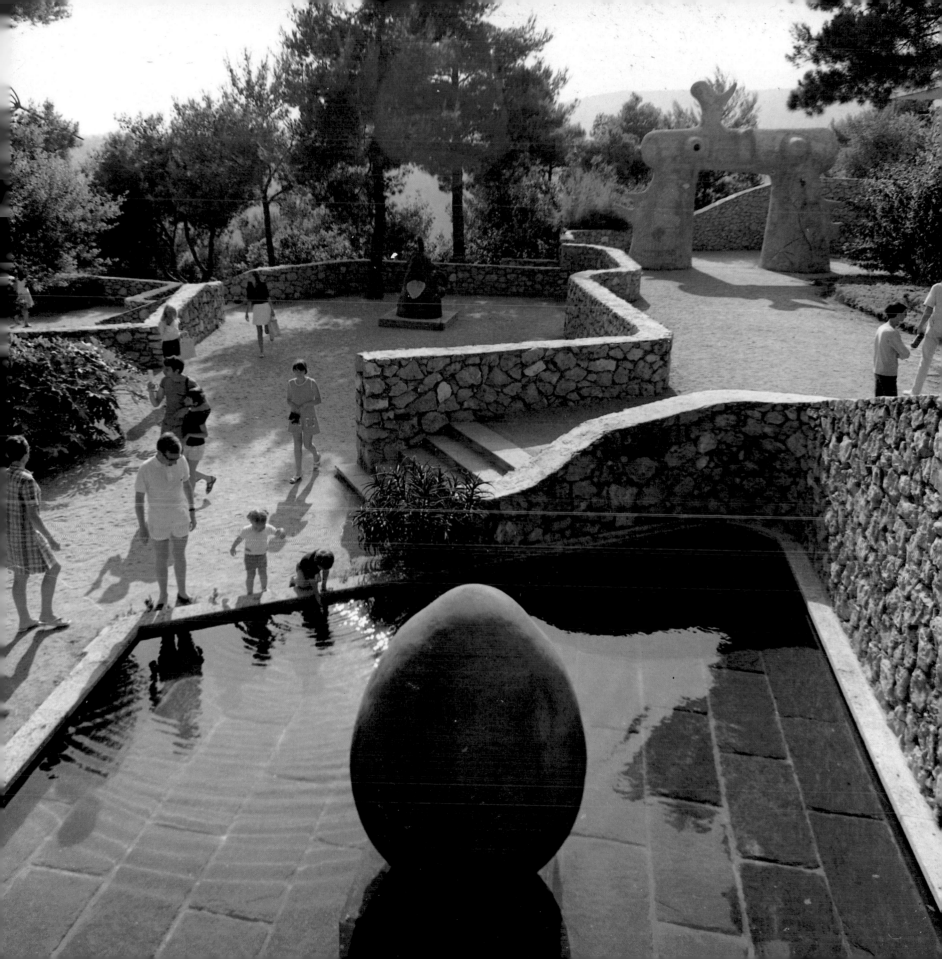

79.
With the Parelladas, who perfectly understood his avant-garde sculptural creativity, in their studio, where he created a vast number of magnificent pieces.

80.
The most surprising instruments, the most unexpected objects, become important elements, able to provoke and unleash sculptural inspiration.

81.
He told me repeatedly that one should find the purity, simplicity and intuition of the primitives. We see him immersed in a creative act as ancient as man himself.

82.
The result of the former action, now cast in wax-mould bronze. Man is the hand, as the first muralists in history had already understood.

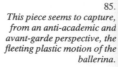

83.
There was only a limited number of copies of the sculptures made in the Parellada foundry. This one was christened Woman with Bird (1968).

84.
He believed not only that sculpture had to be viewed from every possible angle, but also that great care had to be taken to avoid any weak points.

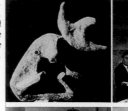

85.
This piece seems to capture, from an anti-academic and avant-garde perspective, the fleeting plastic motion of the ballerina.

86.
La Chunga, with her face, hand and skirt, seems to have inspired in the artist—who observes her fixedly—the sculpture on the preceding page.

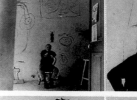

87.
He had to rest his body, but he never allowed his creative imagination the slightest respite, and it can be said that he spent all day busying himself with one thing: his work.

88.
Some pieces, like this one, were first made in plaster, The Moon, the Sun and a Star (1968); done in bronze and cement, it is outside the Foundation. Poetry was his main source of inspiration.

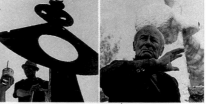

89.
He knew how to combine a wide variety of objects. Once they had been worked with, they took on a surprisingly new meaning. He is giving the last touches to La carícia d'un ocell (1967).

90.
He was absolutely honest when it came to expressing what he thought. He could become intransigent with things he detested, and he did not conceal the fact.

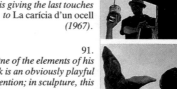

91.
One of the elements of his work is an obviously playful intention; in sculpture, this tendency appears even more forcefully. Monumental urbanistic ensemble at the Défense (Paris).

92.
The sculpture, worked in synthetic, painted resin, is 12 metres (40 feet) high. The maquette, a quarter of the original, was donated by Miró to the Foundation.

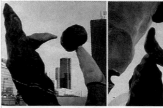

93.
Two birds, sculpted in Carrara marble, placed in the heart of the Mediterranean gardens at the Maeght Foundation, built at Saint-Paul-de-Vence by the Architect Josep Lluís Sert.

94.
The outside spaces at the Maeght Foundation abound with sculpture by Miró. Some of the works are, like the three examples shown here, ceramic pieces made in collaboration with the Artigas.

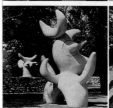

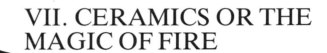

VII. CERAMICS OR THE MAGIC OF FIRE

Miró was aware that many artists who try their hand at ceramics often encounter practical difficulties, so he contacted an old friend and colleague from the Sant Lluc Artistic Circle, Papitu Llorens Artigas. Papitu was an incomparable master in the art of firing—the mystery of the kiln fascinated Miró—he also found in Artigas' son Joanet, a virgin spirit who interpreted to perfection the heterodoxy that the painter proposed to bring to the most ancient art of mankind. Like Gaudí, Miró believed that 'originality means going back to the origins', and consequently he rejected perfection and aestheticism, in favour of the spectacular, brutal strength of a voluntary primitivism.

With this proposal in mind the textures, ripples, blobs and deformities acquire a new value for they lead up a path as yet untrodden, through lack of courage and genius. In the quiet village of Gallifa, immersed, like Montroig, in the depth of nature and rural life, a revolutionary type of ceramics emerged, breaking all the laws that had been established throughout millennia.

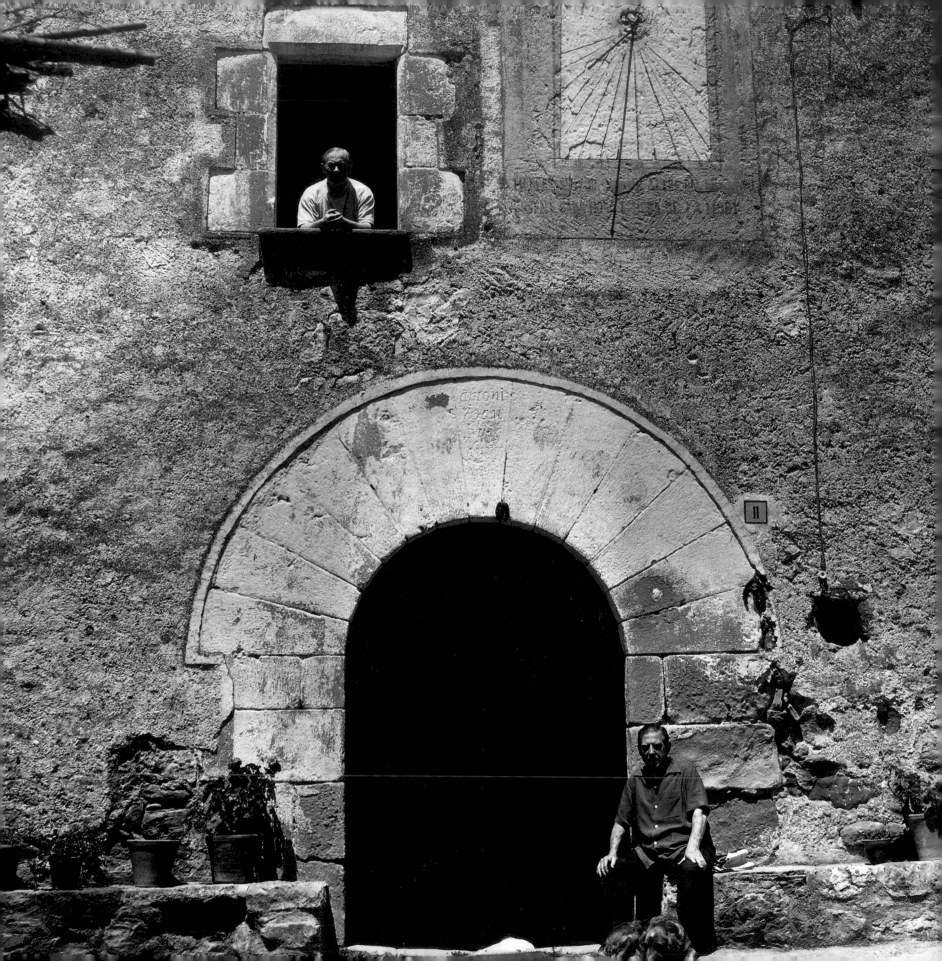

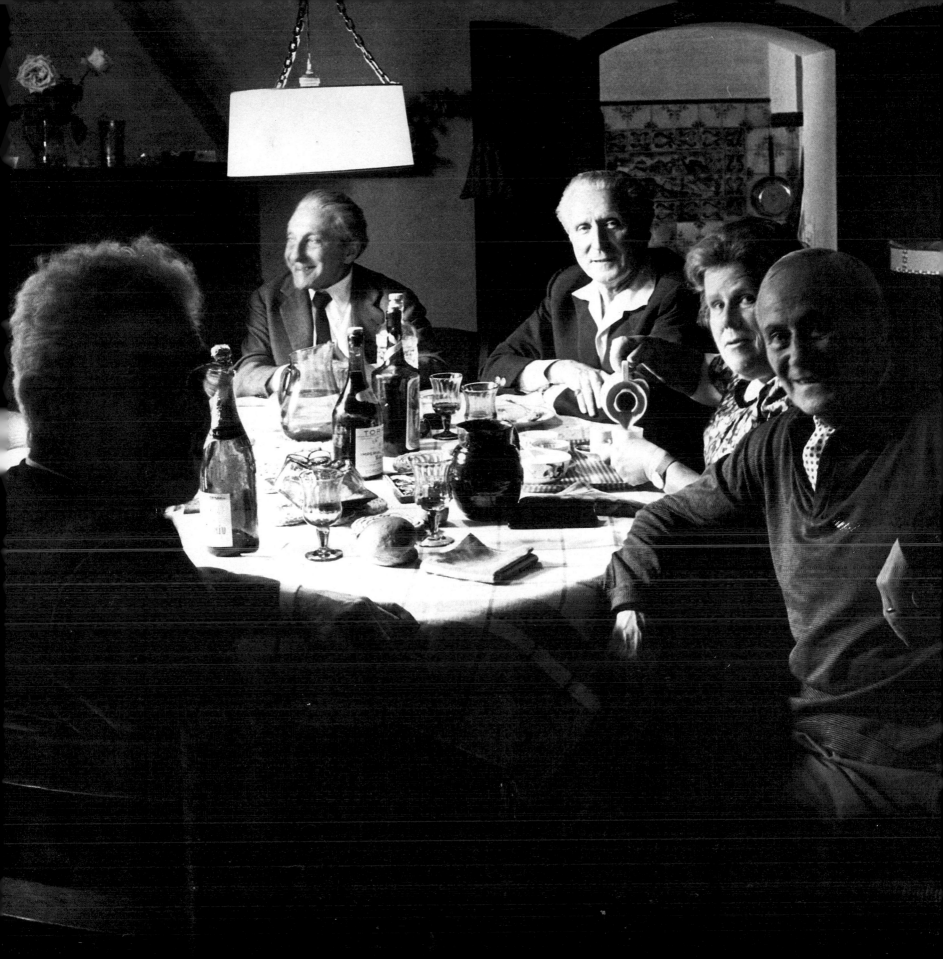

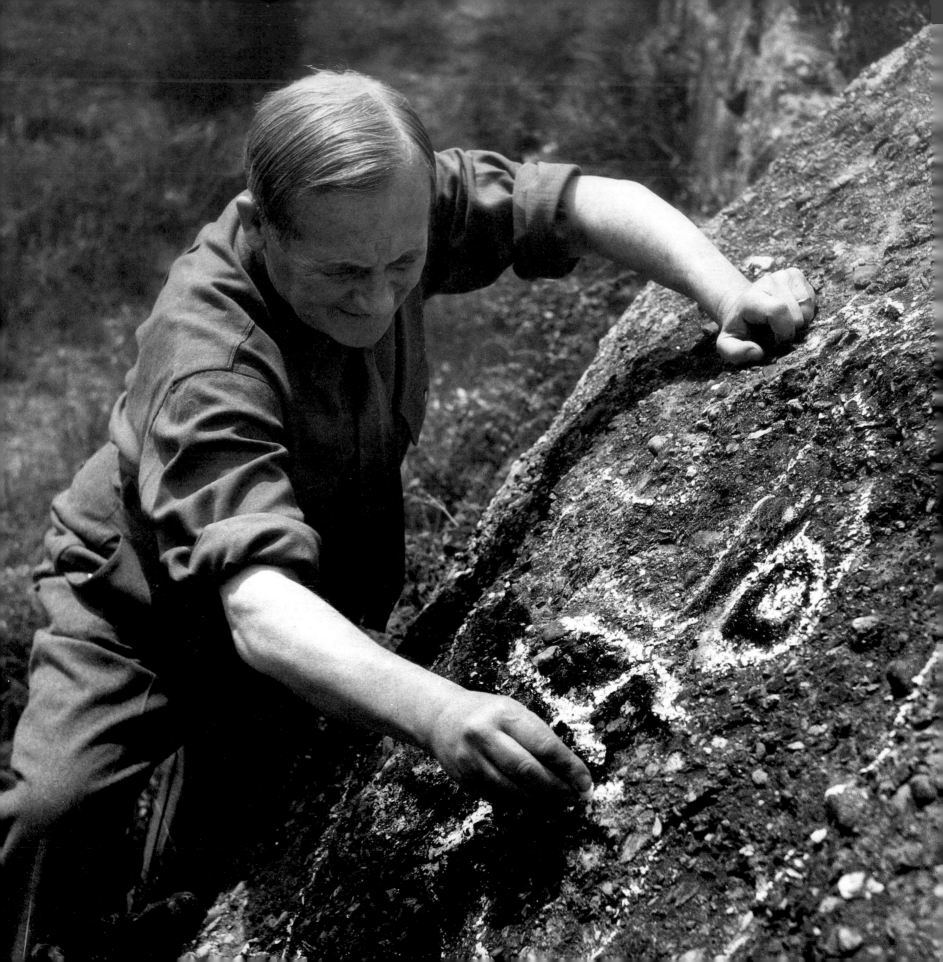

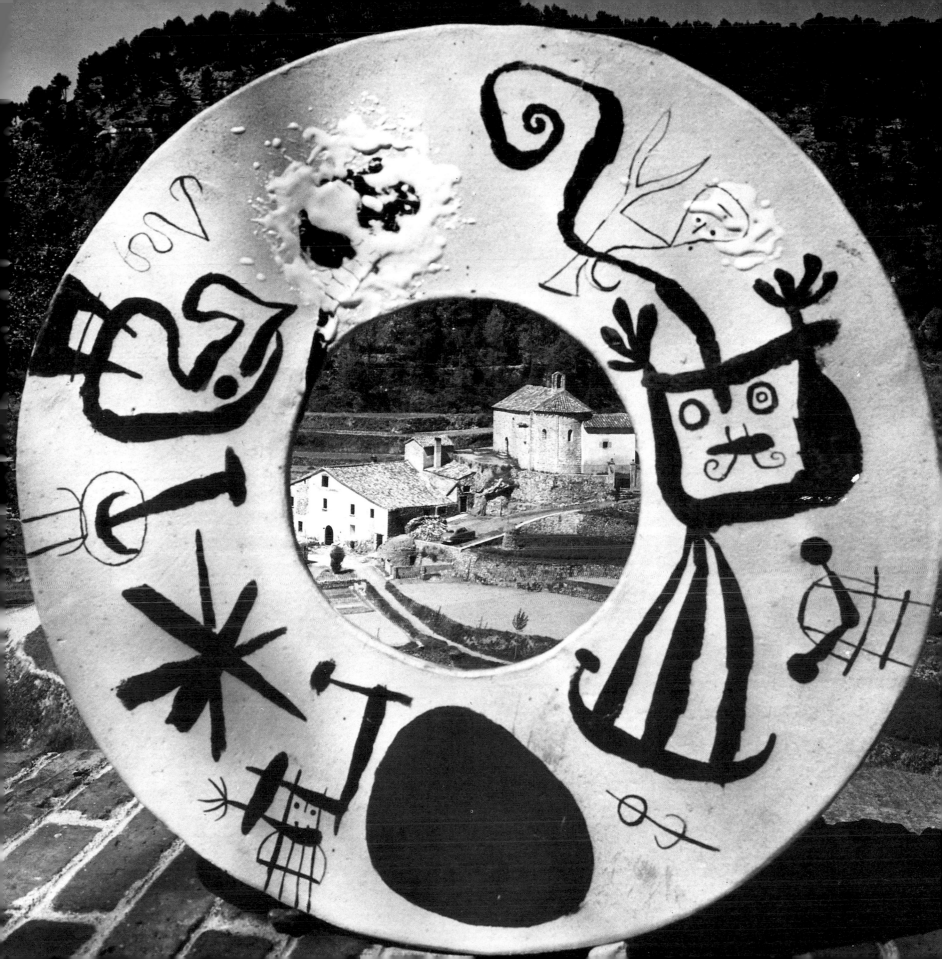

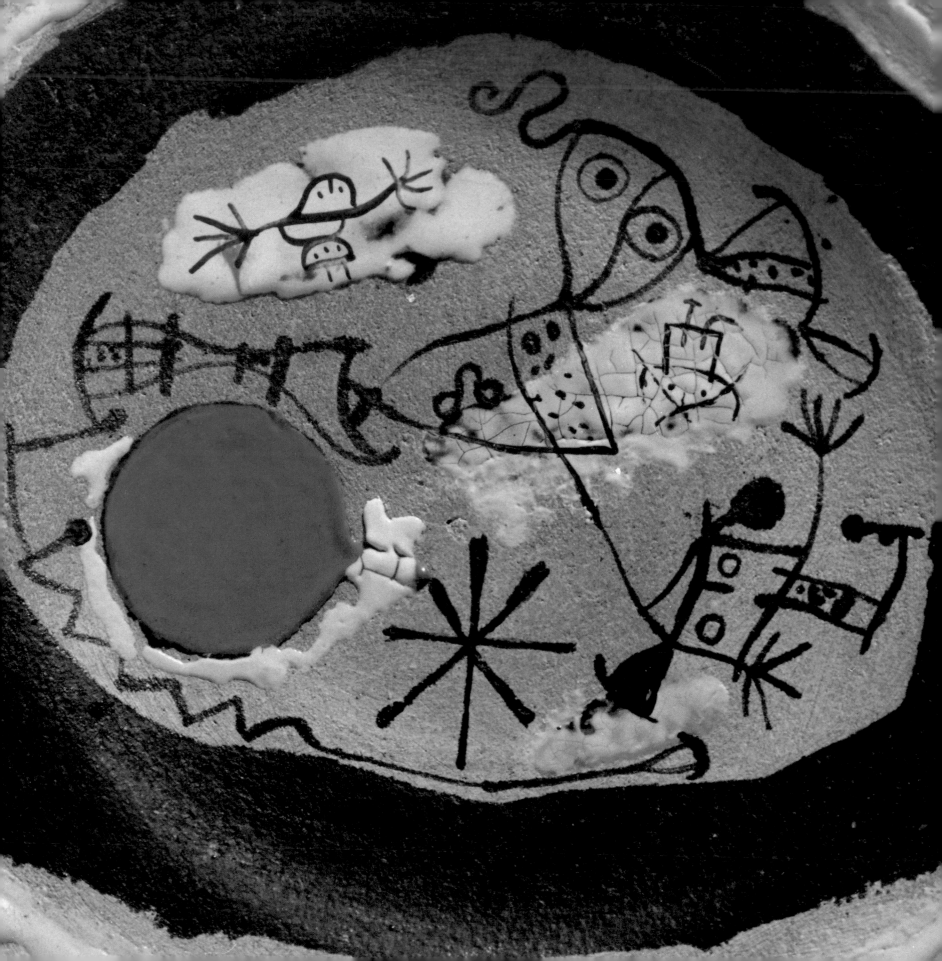

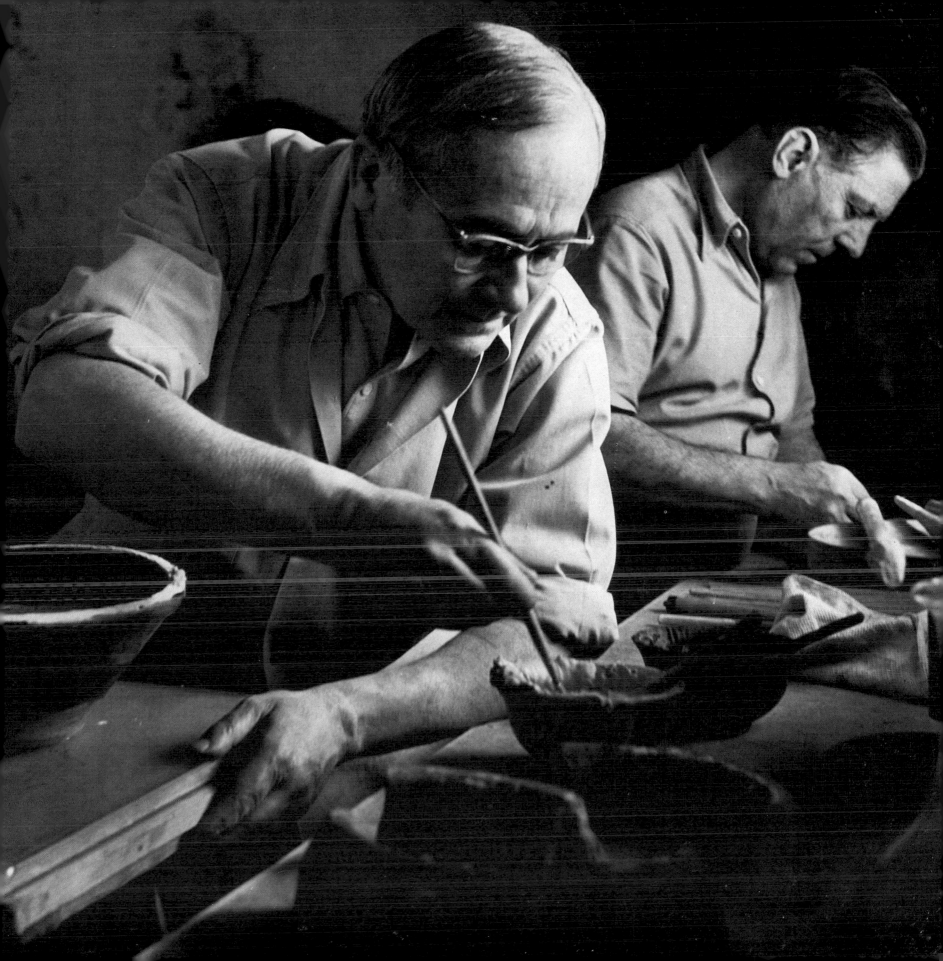

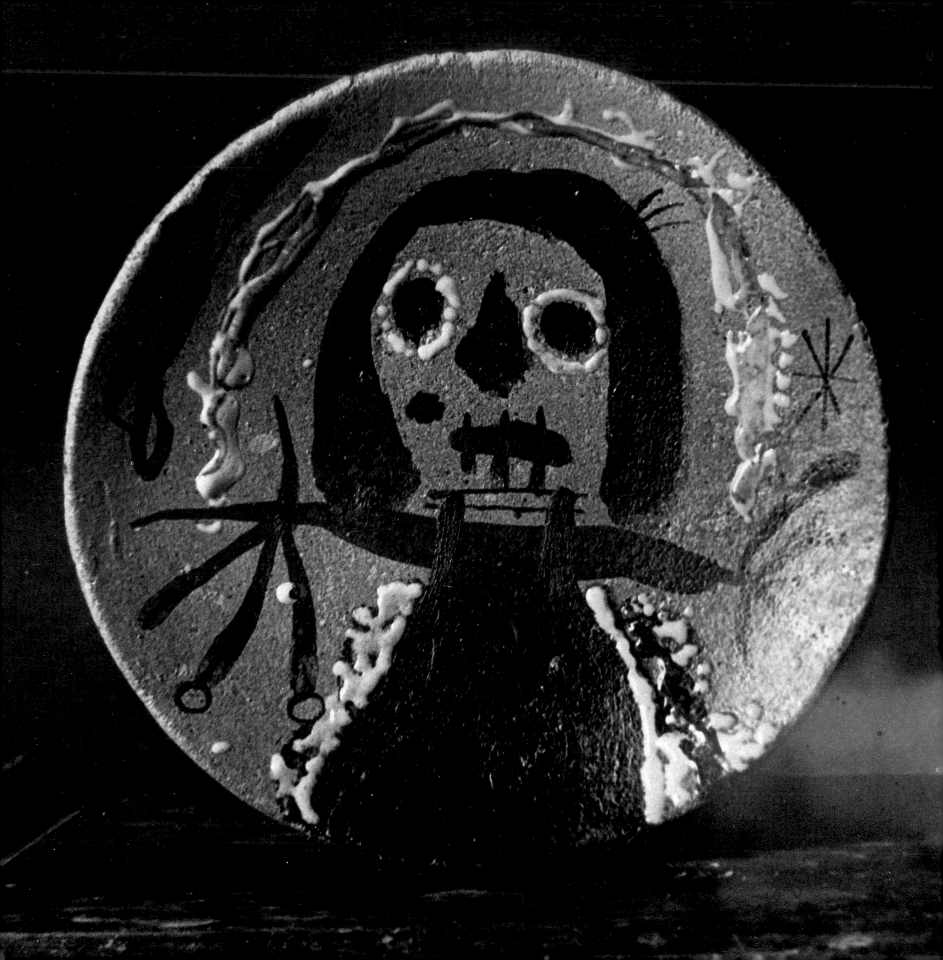

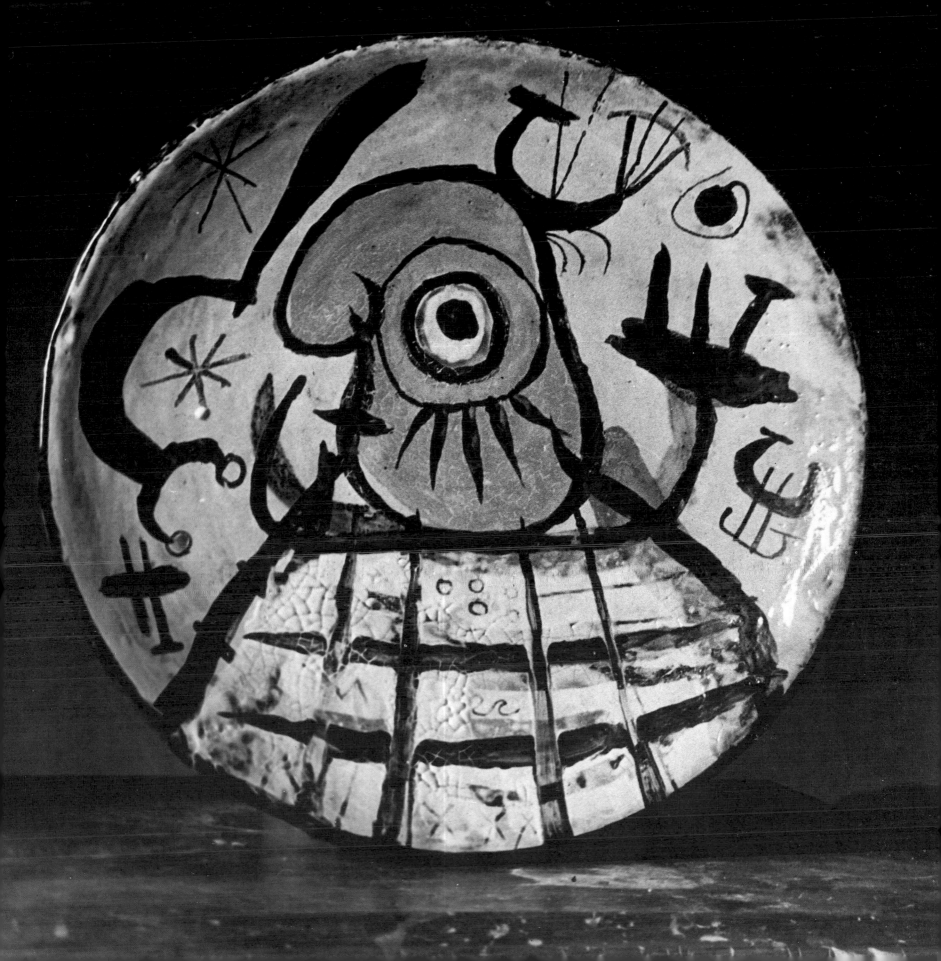

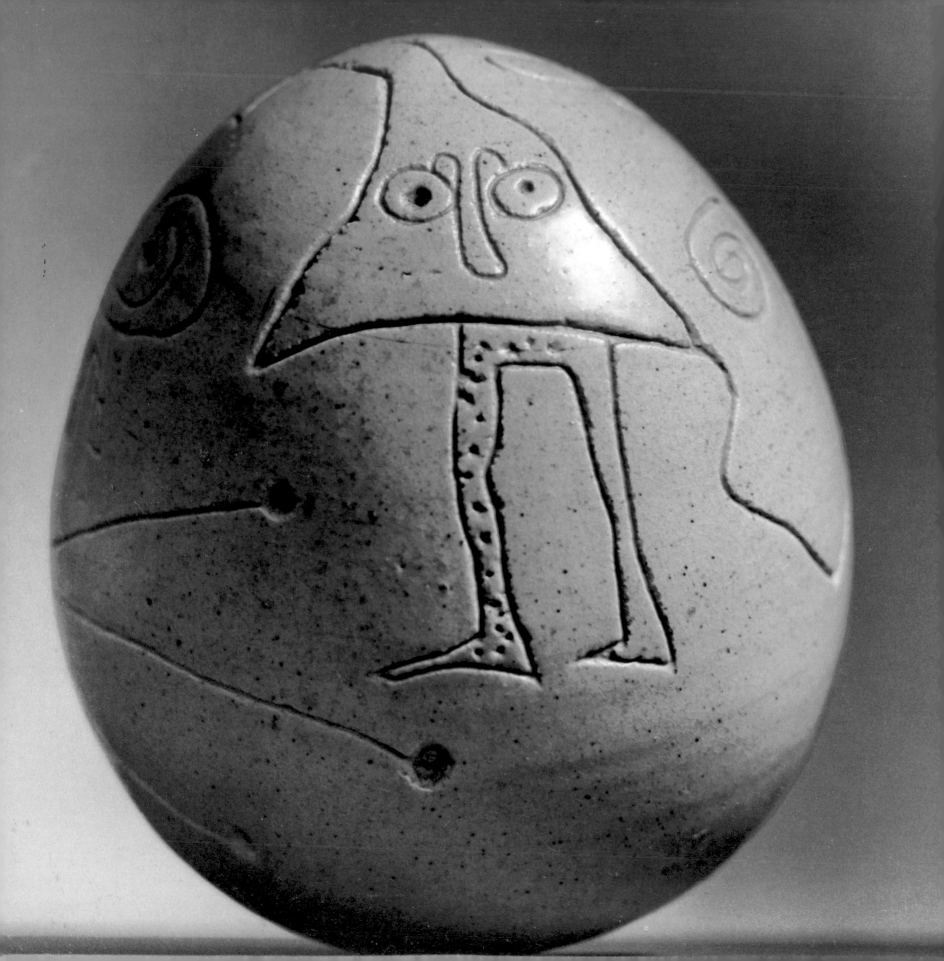

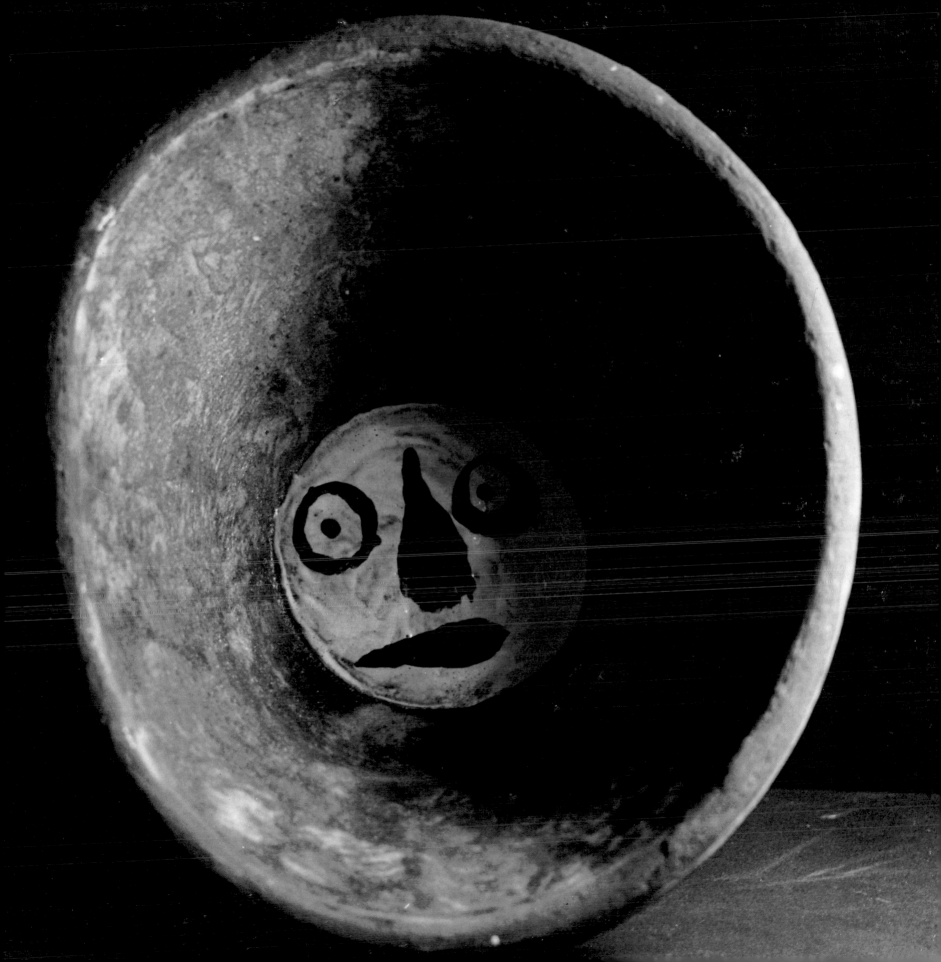

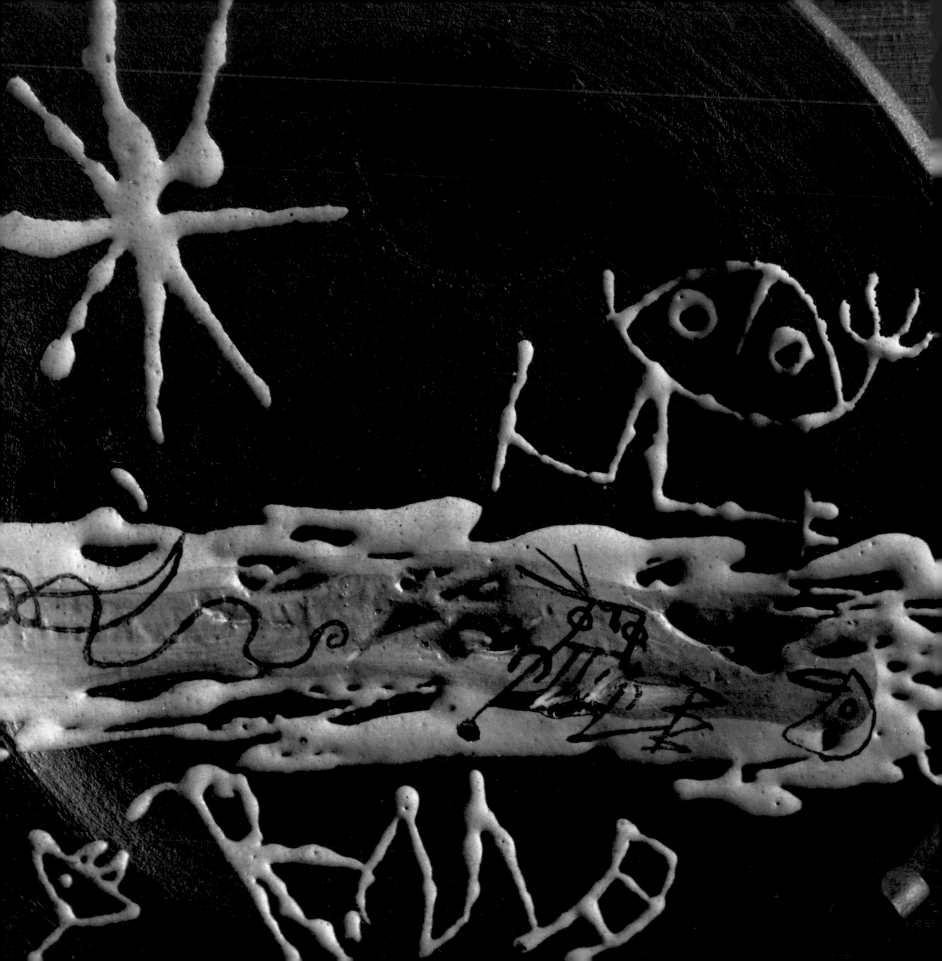

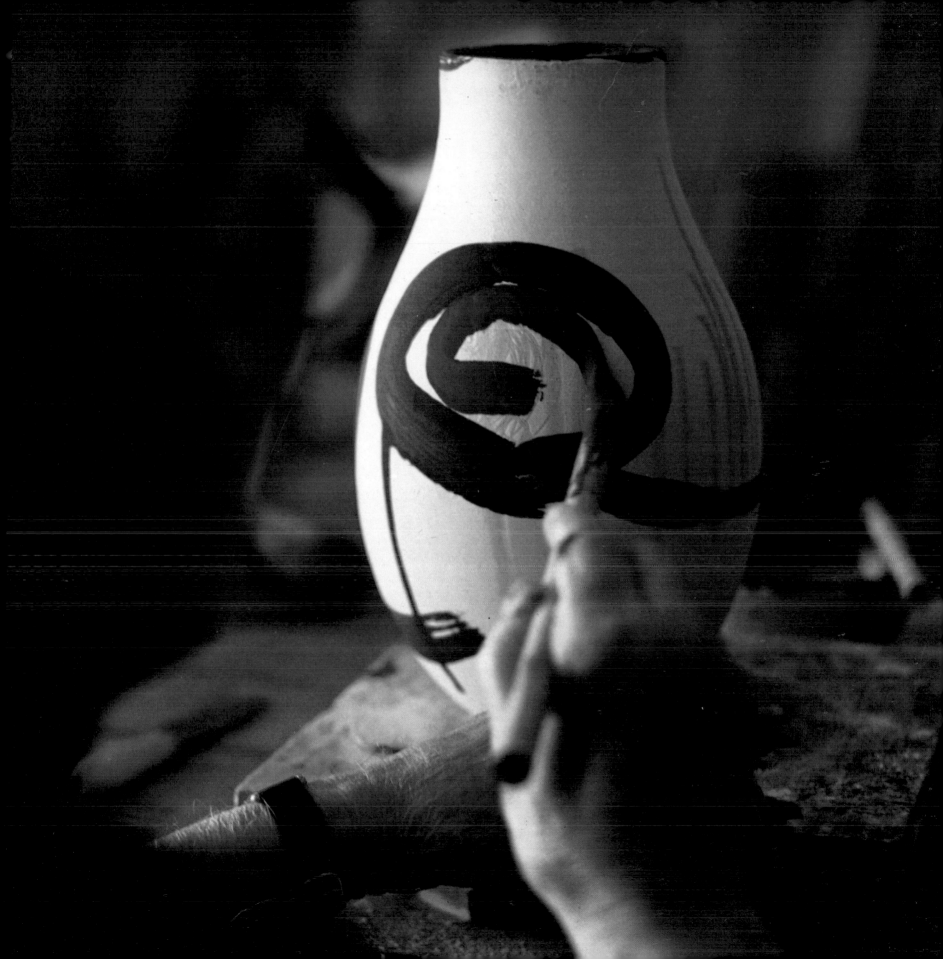

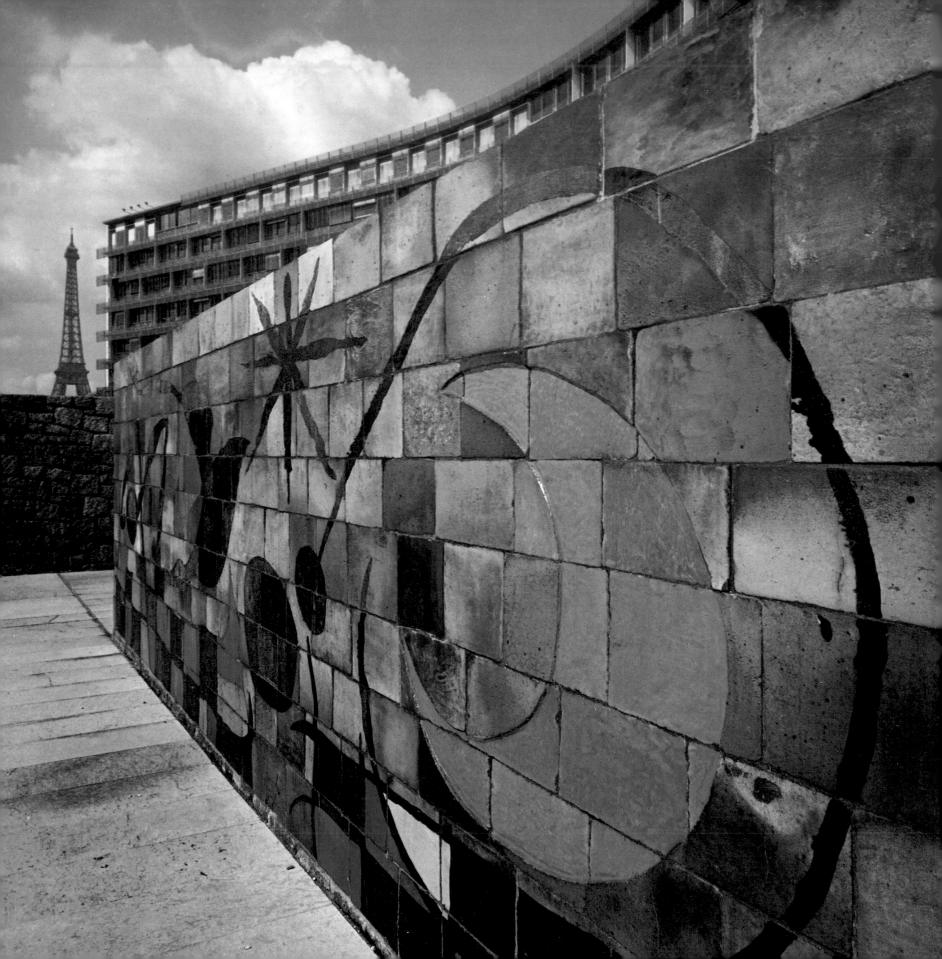

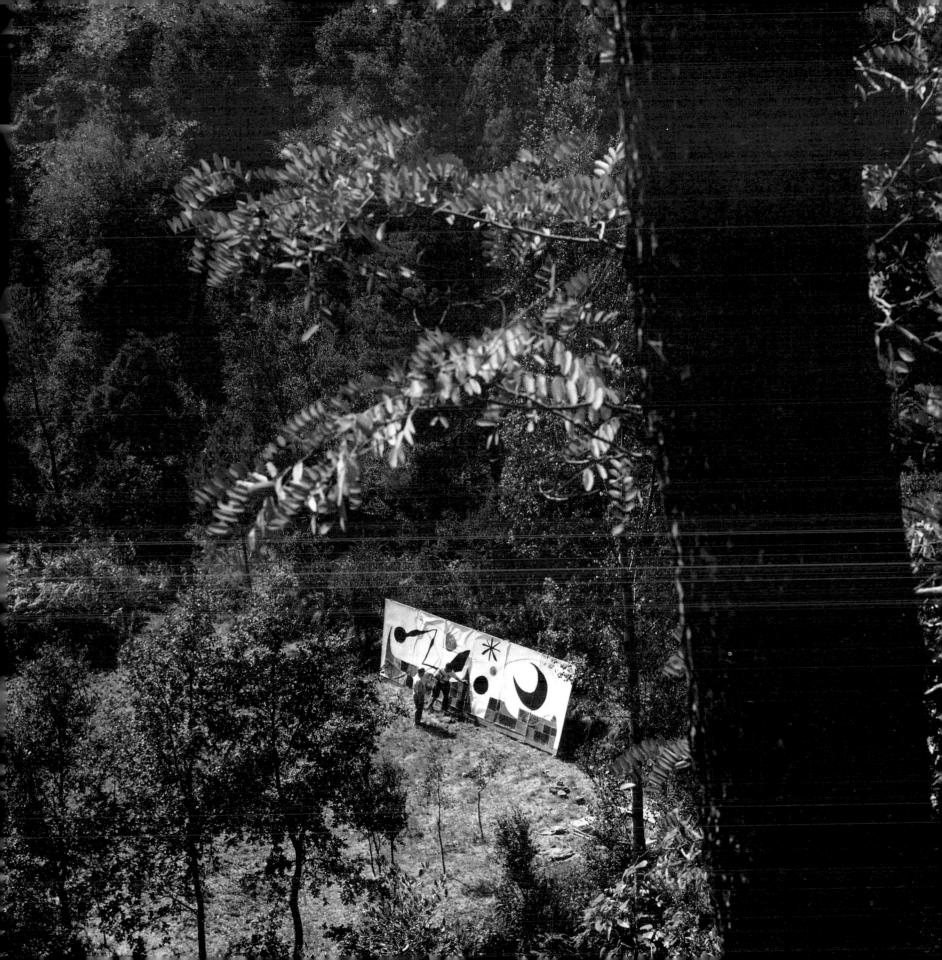

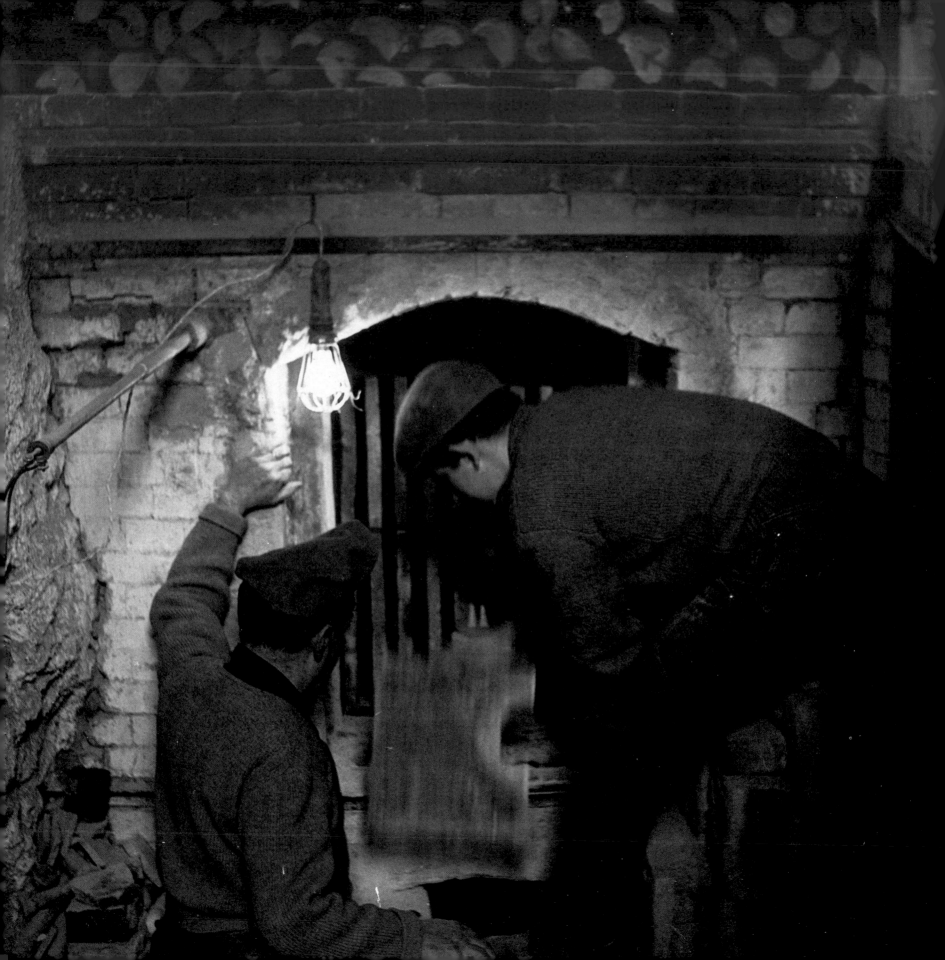

95.
Two friends, two great artists, the painter Miró and the ceramist Papitu Llorens Artigas—at the latter's country house in the village of Gallifa—revolutionized an art as ancient as mankind.

96.
The hospitable country house at Gallifa was open to numerous friends from various parts of the world. Here we see Joan Prats, Aimé Maeght, Violette Llorens Artigas, Joan Miró and Josep Parellada.

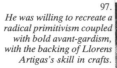

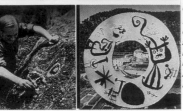

97.
He was willing to recreate a radical primitivism coupled with bold avant-gardism, with the backing of Llorens Artigas's skill in crafts.

98.
In the centre of this daring ceramic composition, we see the Romanesque hermitage of Gallifa and, at bottom left, Papitu Llorens Artigas' studio-house, 'El Racó.'

99.
One of the numerous ceramics—ranging from small formats such as a chicken egg to grandiose sculptures first fired in separate pieces—which from 1944 bore the signatures Miró-Artigas.

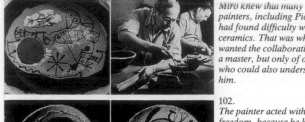

100.
Miró knew that many painters, including Picasso, had found difficulty with ceramics. That was why he wanted the collaboration of a master, but only of one who could also understand him.

101.
Sometimes a very traditional form was more than sufficient to support the brutal intervention of Miró's brush.

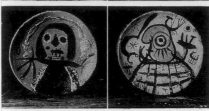

102.
The painter acted with total freedom, because he knew the ceramist would manage to interpret everything he wanted to express.

103.
He also embarked on a search for new forms, perhaps because ceramics had paradoxically become self-limiting, above all because of certain functions it had to fulfil.

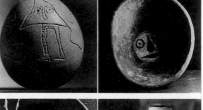

104.
A paradigmatic example of the fact that he knew how to adapt his language to the new means of expression. A piece that is stirring in its simplicity.

105.
He was very careful with the textures, the widths, that this art allowed him to attain, and he was capable of achieving surprising results.

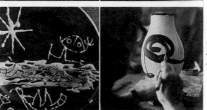

106.
Working days at Gallifa were intensive, and the wild landscape and absolute solitude worked in favour of optimum efficiency.

107.
The Wall of the Sun *and* Wall of the Moon *(1958), created for the UNESCO headquarters in Paris, had such a powerful impact that they constituted an authentic worldwide consecration.*

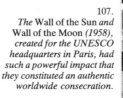
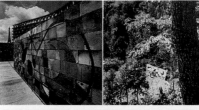

108.
One of the Walls, amid the thick pine groves and the idyllic tranquillity of Gallifa.

109.
Papitu, in a Catalan cap, and his son Joanet, busy at the kiln at the most delicate moment, the moment of truth. The result of the firing is always an absolutely unknown quantity.

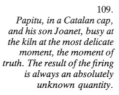
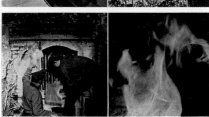

110.
No one knows how the fire, which is the arbitrary protagonist of the firing process will behave. The Artigas, however, had achieved the secret of a certain degree of mastery.

VIII. GIGANTIC CERAMIC WALLS

The exceptional collaboration which the painter found at Gallifa not only allowed him to undertake the hazardous adventure of bringing ceramics to walls, but also allowed him to work on ever larger surfaces. The team went to Altamira on a UNESCO assignment; in the cave paintings Miró searched for brutality and primitivism but also for the purity that distinguishes these pioneering works. This is why, from the very beginning, there is in the walls an evident rejection of accepted norms and, consequently, a break from them. As always, Miró confronts the challenge starting from zero. The result achieved with the two walls—the Sun and the Moon—that rise in the very heart of the city of the Seine, encouraged the creation of others: at Harvard University, the Guggenheim Foundation, Galerie Maeght in Saint-Paul, the Cinémathèque Française, Osaka, Barcelona, West Germany, Switzerland, Madrid. More than a dozen around the world, these works sometimes cover gigantic surfaces—as much as 600 square metres—but, far from losing their vitality, they preserve the intensity and brilliance of the small formats.

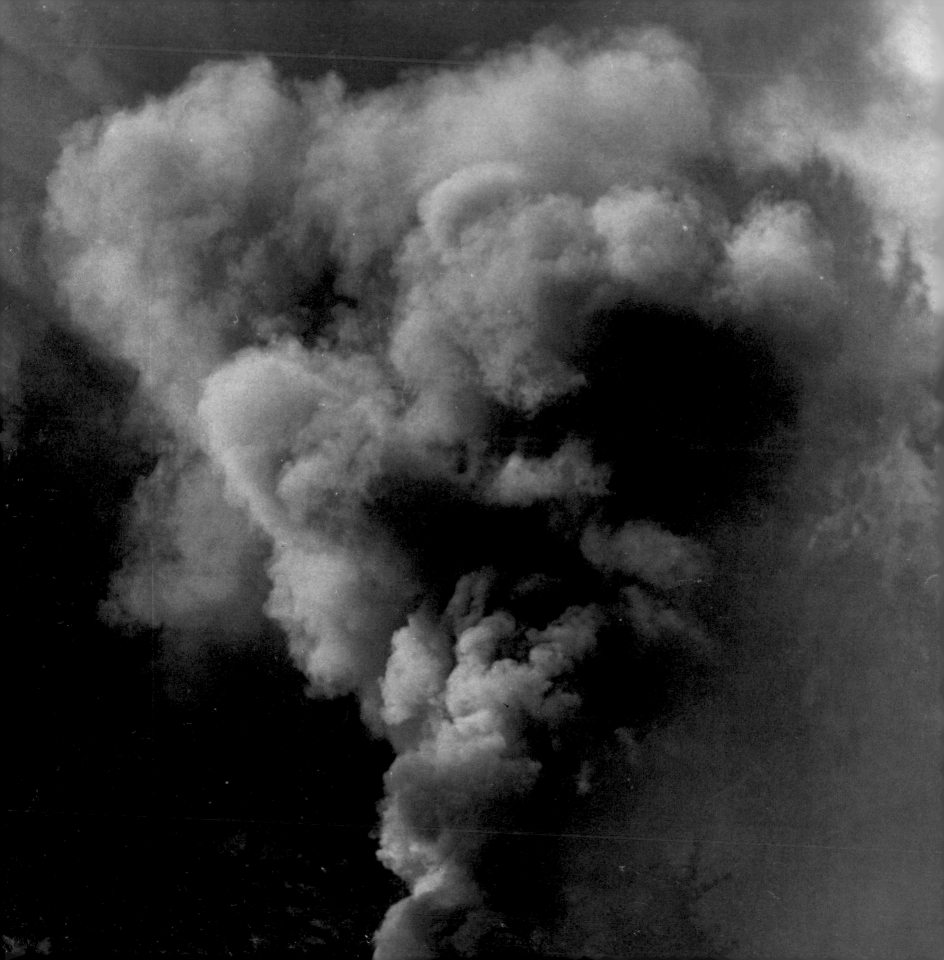

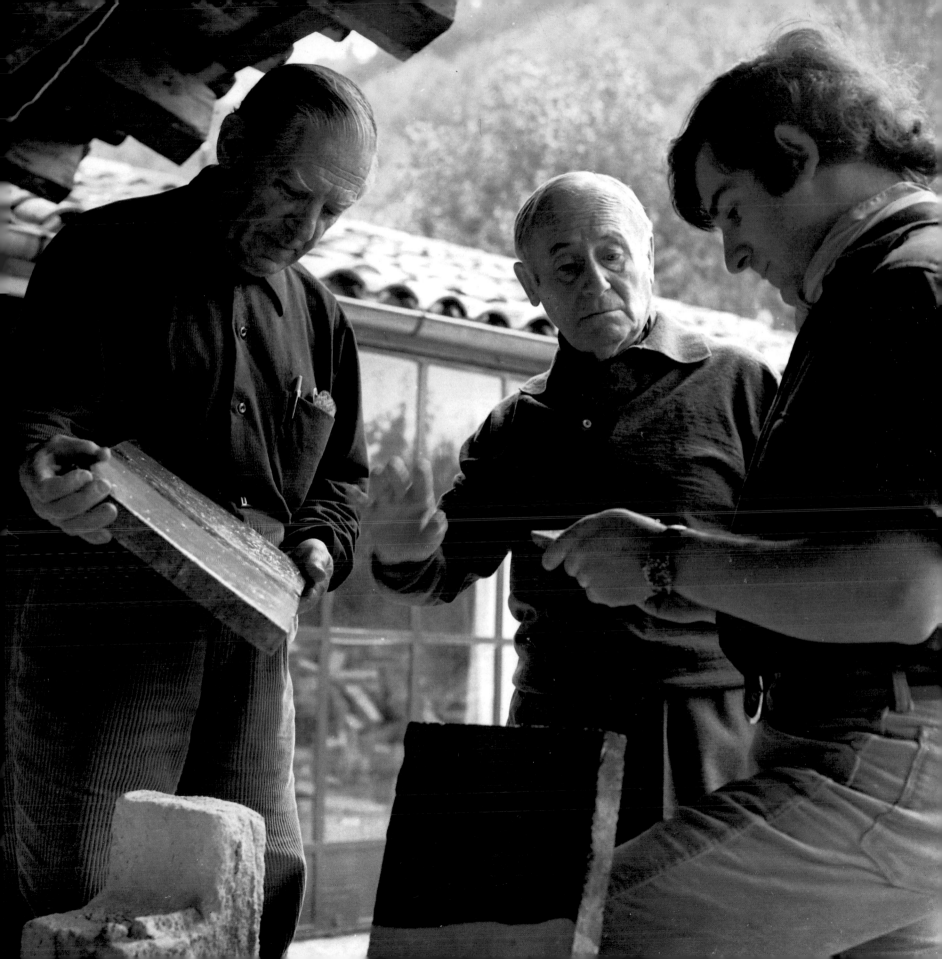

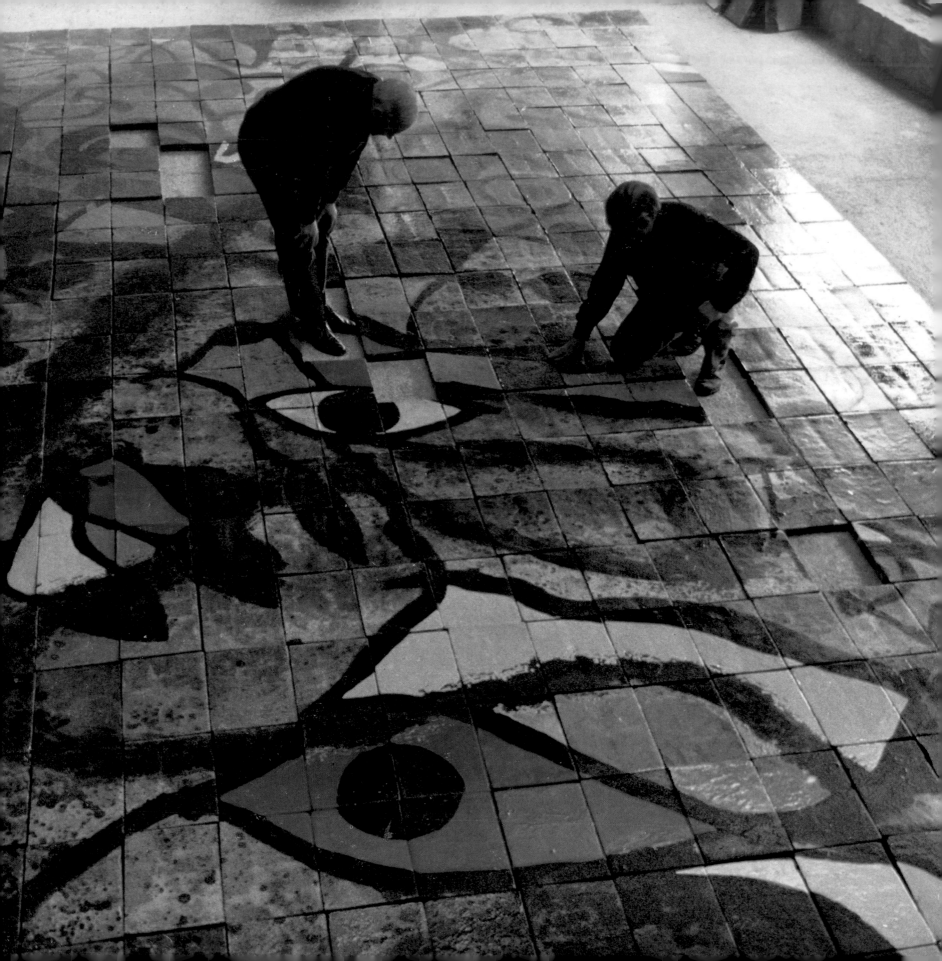

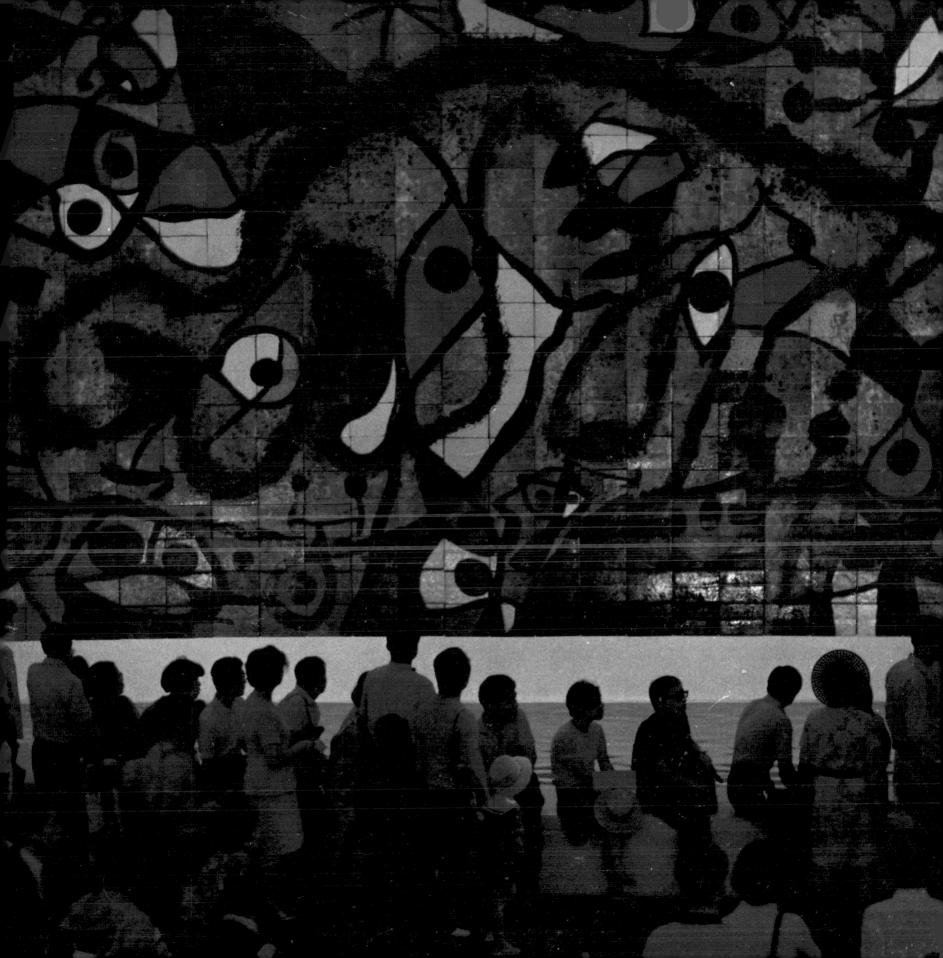

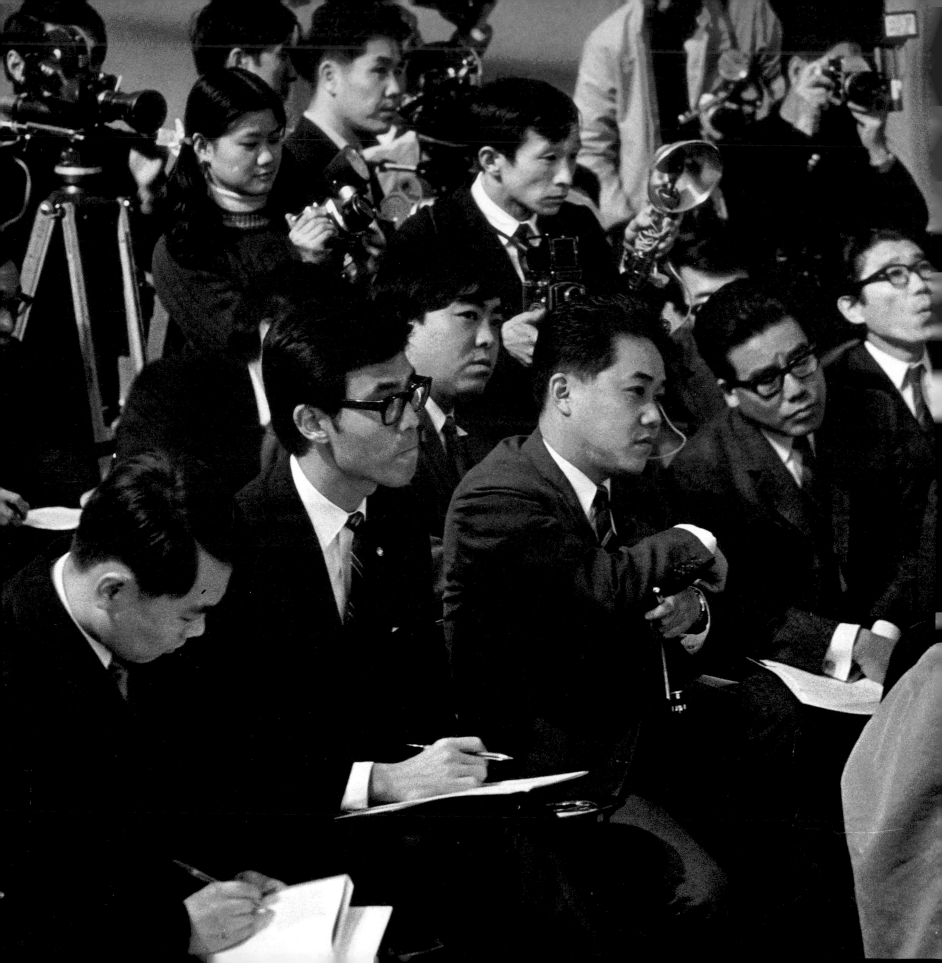

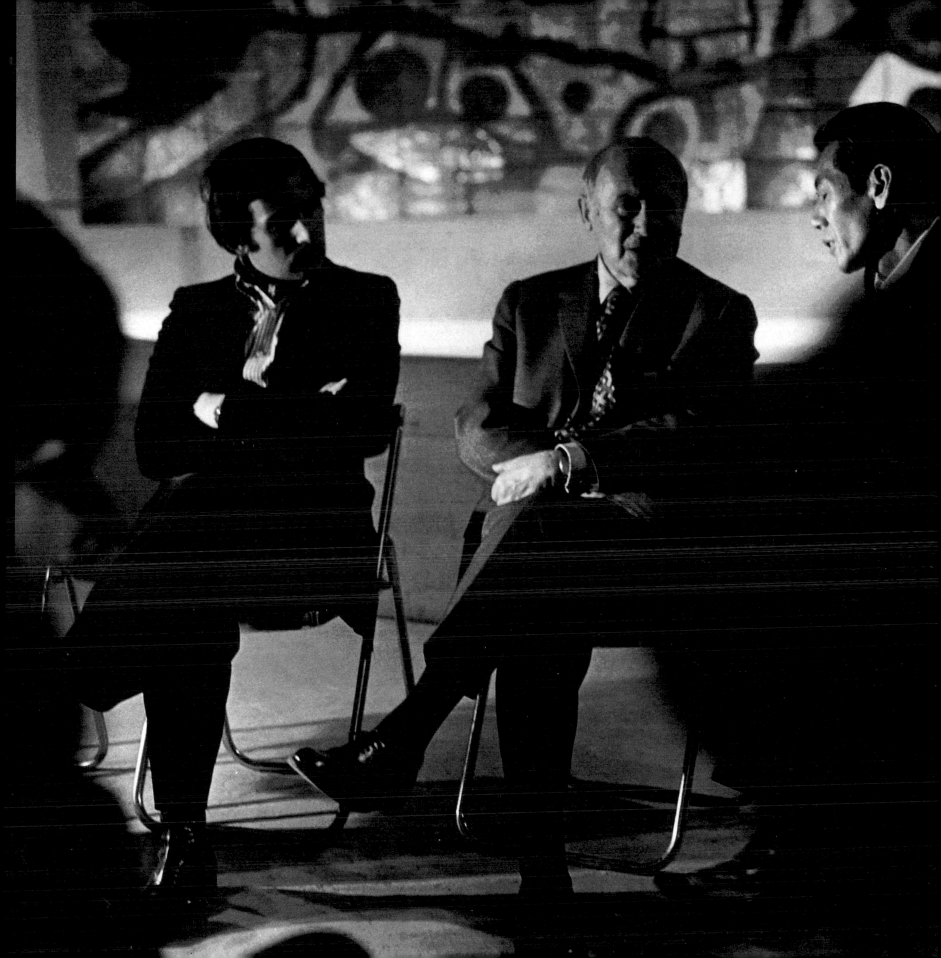

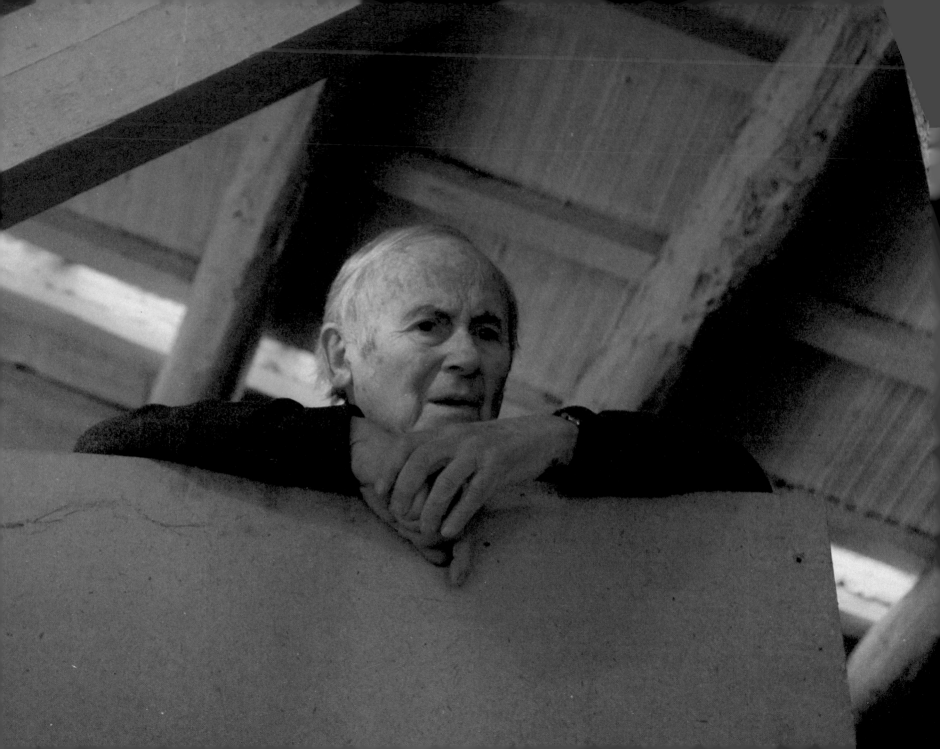

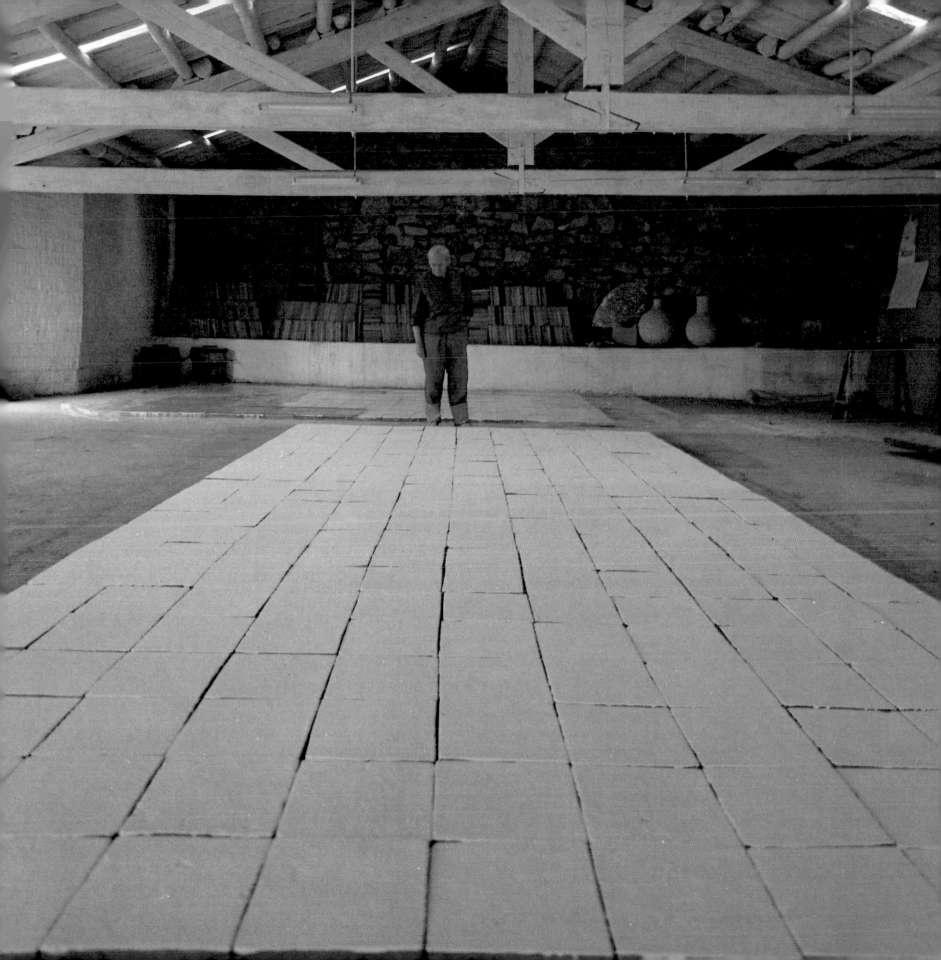

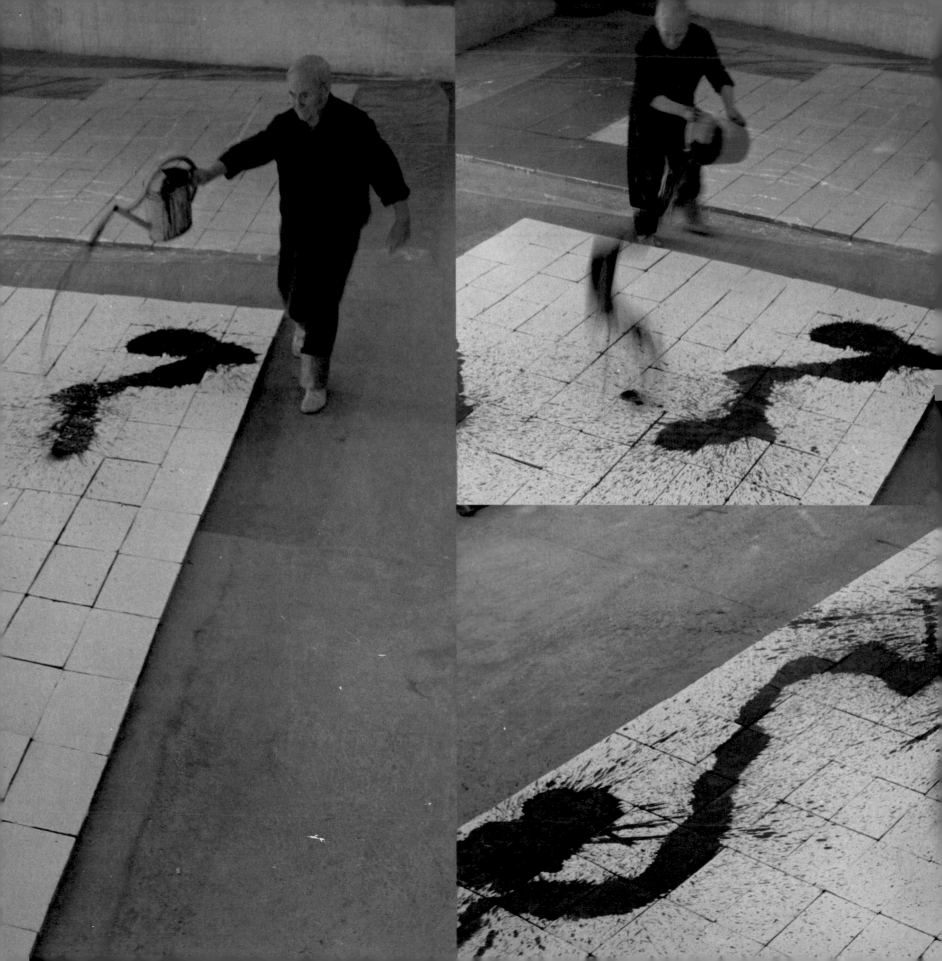

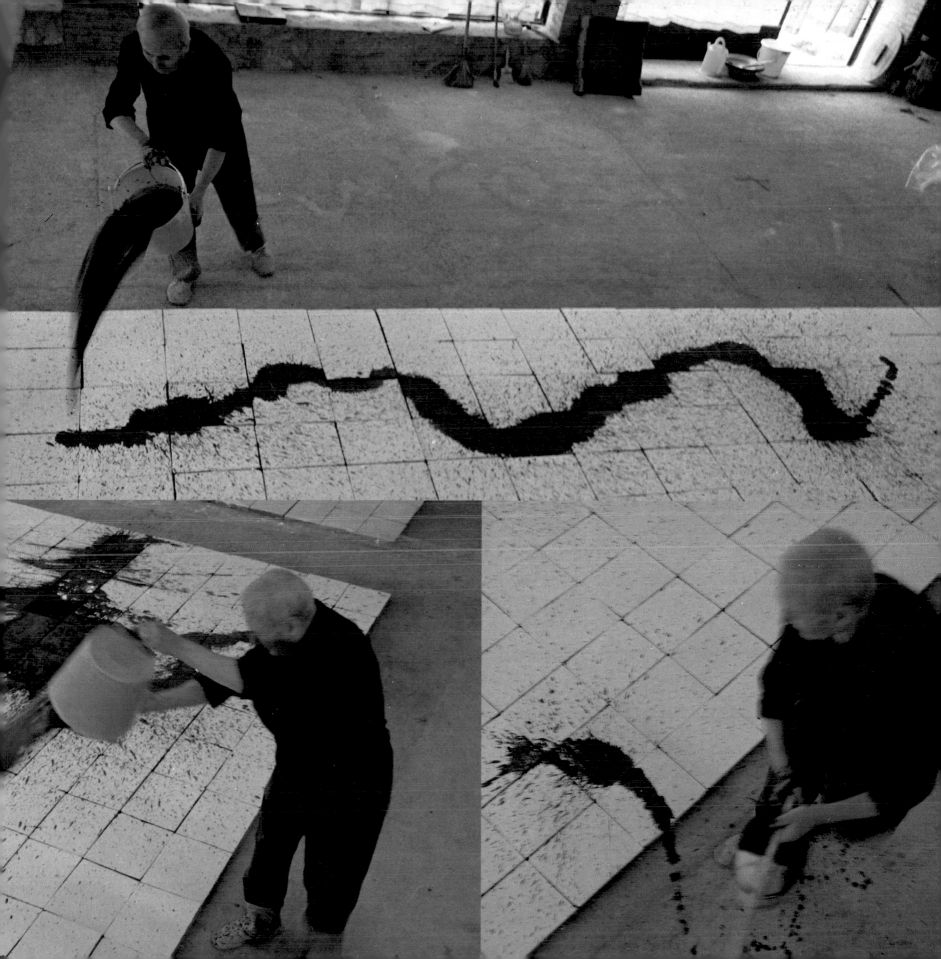

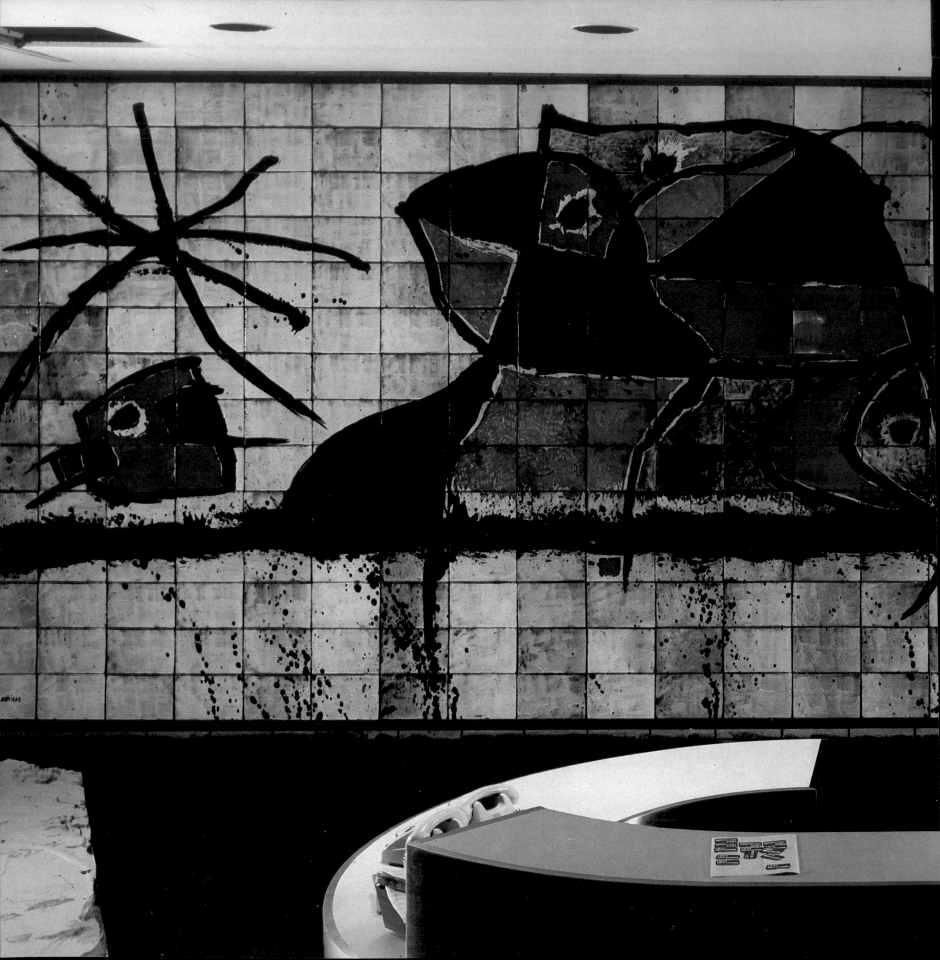

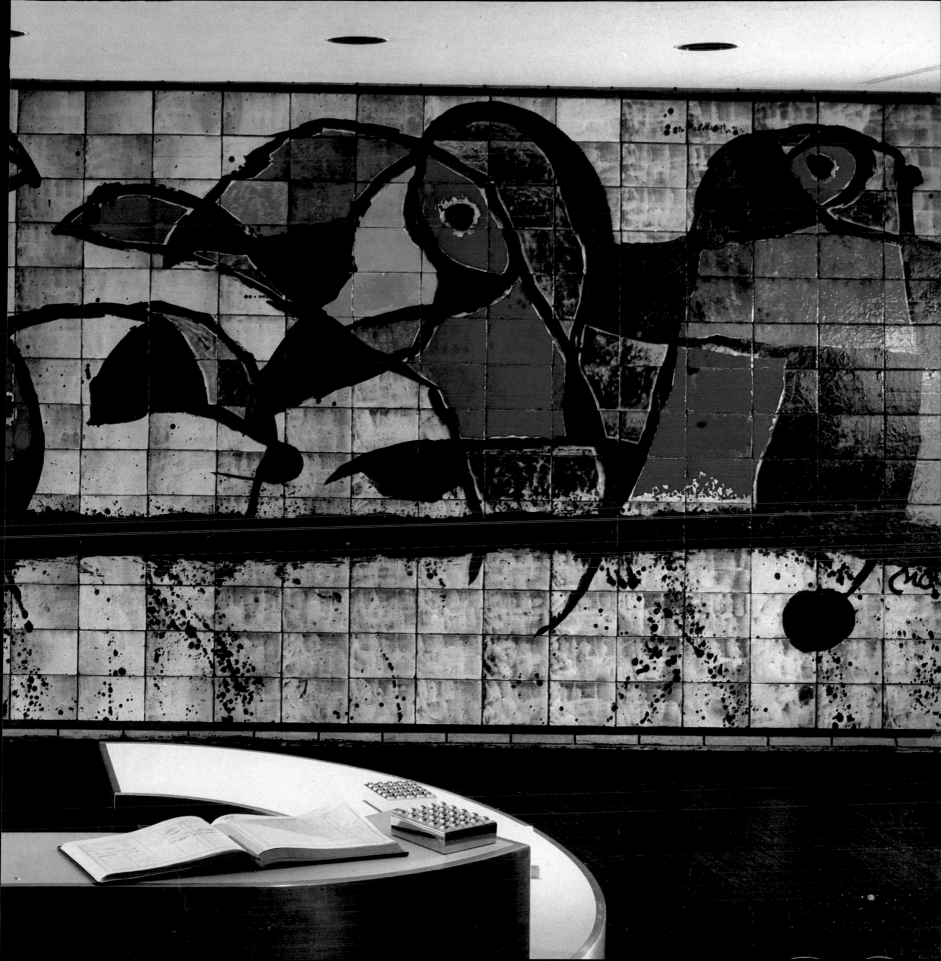

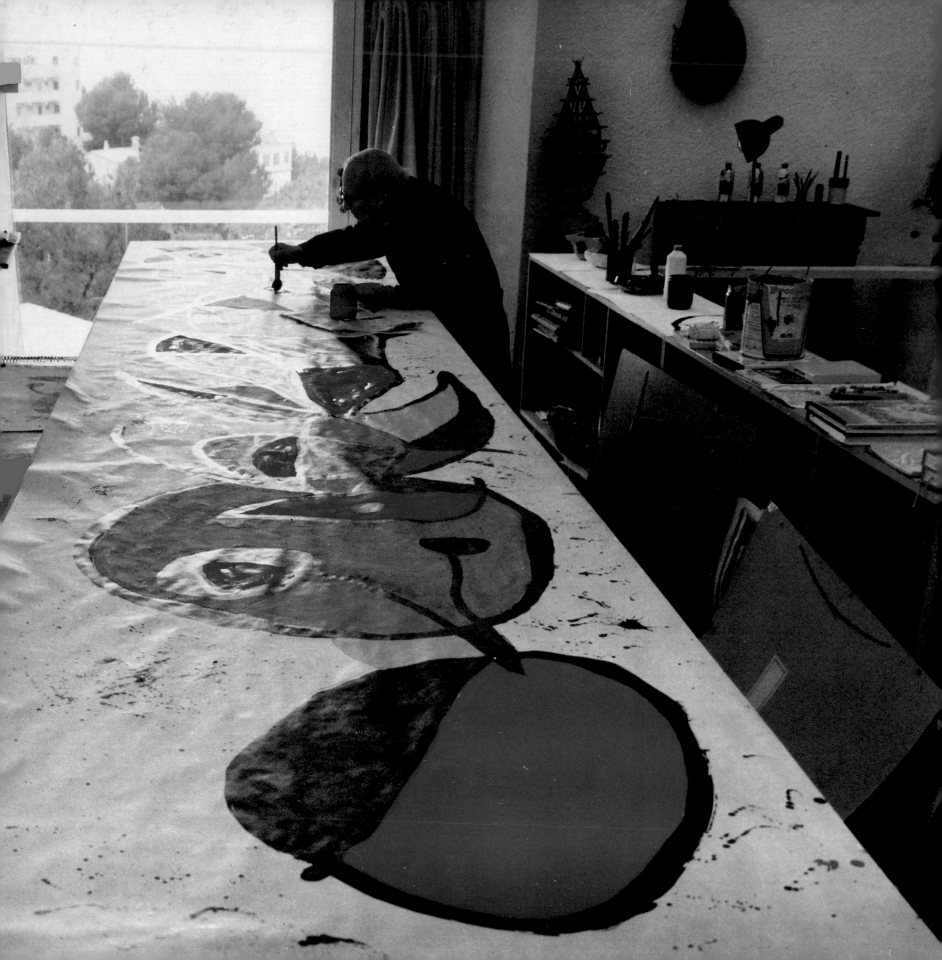

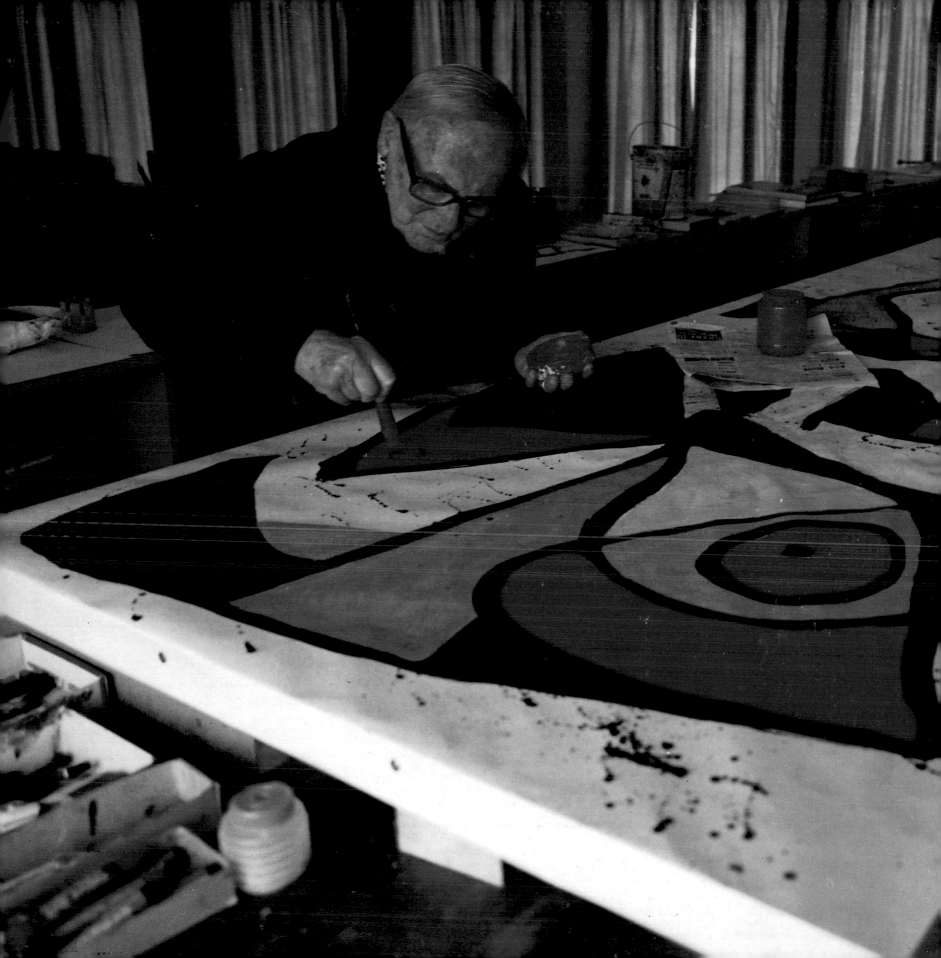

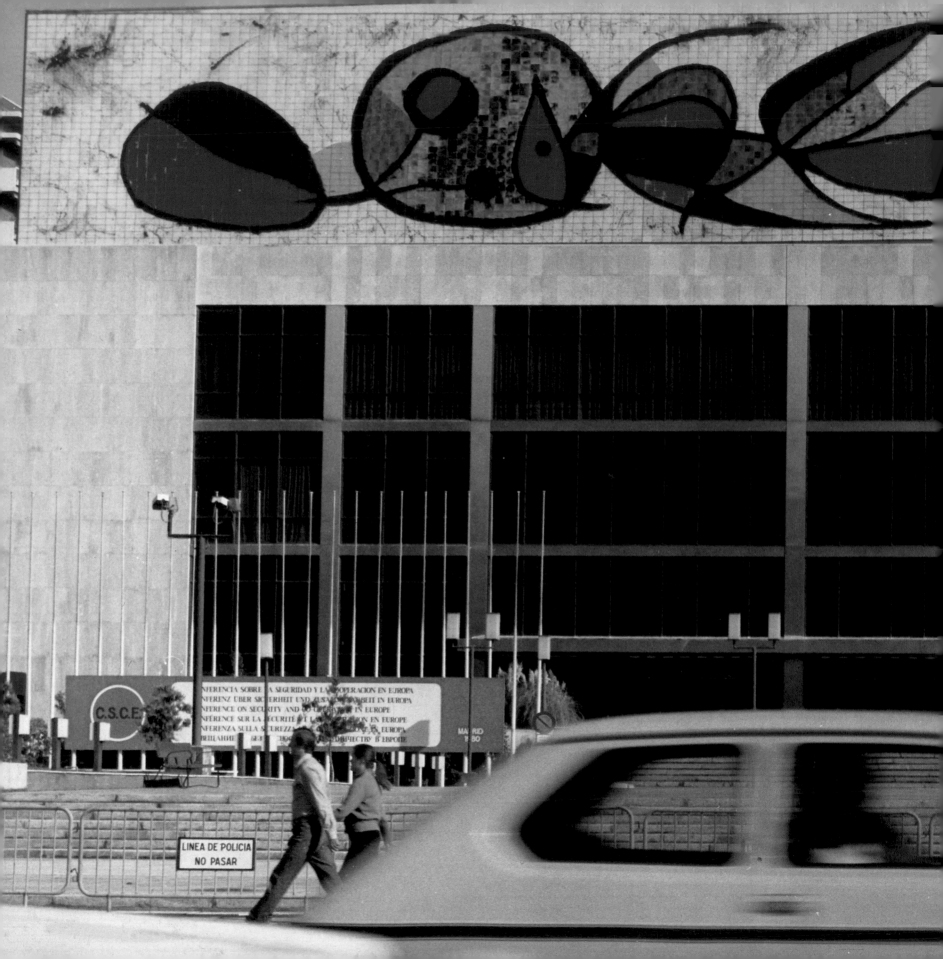

LINEA DE POLICIA
NO PASAR

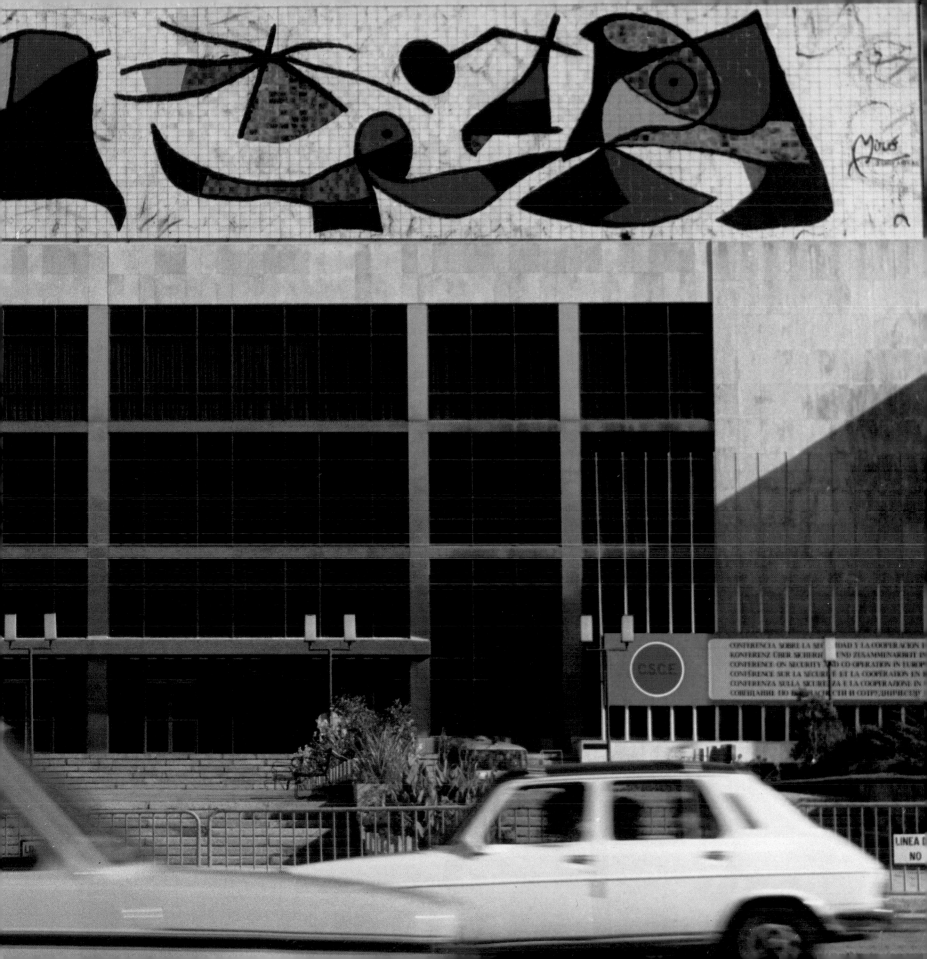

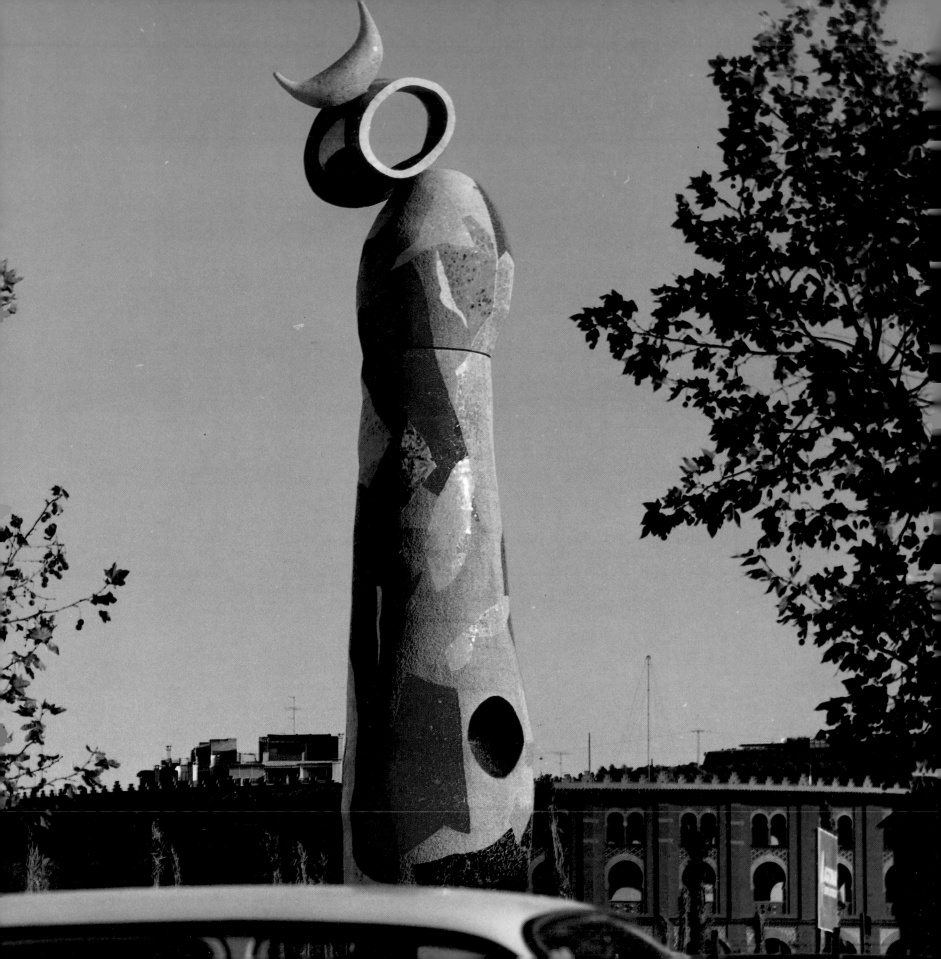

111.
After the success of the UNESCO Walls, assignments kept coming in from all over the world. The three kilns at Gallifa were in constant use.

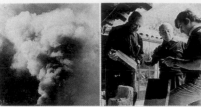

112.
Joanet Gardy Artigas's introduction to the art of ceramics was through working with Miró, and his lack of preconceived ideas made him the ideal interpreter of the painter's avant-gardism.

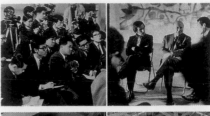

113.
In Gallifa, Llorens Artigas and Joan Miró are putting the final touches to the immense ceramic wall that the Japanese had ordered for the International Fair at Osaka.

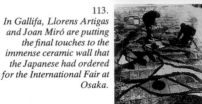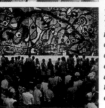

114.
The mural in Osaka, once installed in the gas company's pavilion, was a cause of indescribable expectation, followed by admiration, in the land of the greatest masters of ceramics.

115.
The press conference the artists had to give at Osaka is proof of the importance attached to the Catalan artists' mural.

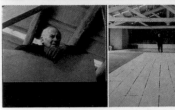

116.
Joanet Gardy Artigas and Joan Miró, through an interpreter, are assailed by questions from reporters from all the Japanese media.

117.
For Miró, a white surface was neither a stimulus nor a starting-point—as were a spot, a colour, material qualities—but rather a creative challenge that tormented him.

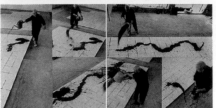

118.
At Gallifa, in the building expressly constructed for the creation of ceramic murals and in front of a large surface ready to be worked on.

119.
With a broom, a watering-can, a bucket, he drew the black stroke with a totally impulsive gesture.

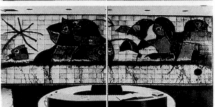

120.
First, like the Chinese and Japanese masters of calligraphy, he concentrated in order to see in his mind's eye the strokes that he intended to make.

121/122.
Once the mural signed Artigas/Miró was finished, it was installed in the Barcelona offices of IBM, where it can be admired.

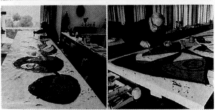

123.
In his studio in Palma (Majorca), after having thought a lot, taken notes and made little pencil-drawn sketches, Miró painted the final maquette.

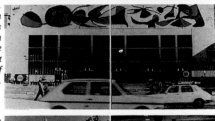

124.
This maquette would serve as a guide for the ceramist and for himself when, in Gallifa, they worked on the various fragments that the gigantic murals had to be divided into.

125/126.
The maquette we have seen him painting was for this immense mural, which dominates the Palacio de Congresos in Madrid. It was made after the death of Franco.

127.
The 22-metre (72-foot) sculpture Woman with Bird, *standing in the centre of Plaza de Joan Miró in Barcelona, is covered with ceramic fragments.*

128.
On the Pla de l'Os in Barcelona's Ramblas, in the 1970's he presented this mosaic to the city.

IX. HIS WORK FOR THE THEATRE

The spectacular work Miró carried out—on the 1978 production of *Mori el Merma* by the Catalan company Claca—was not his first experience of working for the theatre. In 1926, together with Max Ernst, he had created sets for the ballet *Romeo and Juliet*, after which, the Monte Carlo Ballet asked him to design the sets, toys and costumes for Bizet's *Jeux d'Enfants*. The première of *Jeux d'Enfants* which was held in 1932 in Monaco was an enormous success. This taste of the theatrical world's appealing 'poison' was nectar to him. Thus, in spite of his 85 years he accepted this new theatrical challenge and, true to his unique style, he attacked the project with characteristic vigour. The result of a week's obsessively feverish work was breathtaking. Nothing like it had ever been seen on stage: a procession of Mironian monsters and curtains, paint applied by hand, or by bucketful, or by a Japanese syphon spraying under pressure, or by broom. The instrument was after all of secondary importance since it was the result that was essential: action, destruction, creation, revolt, provocation.

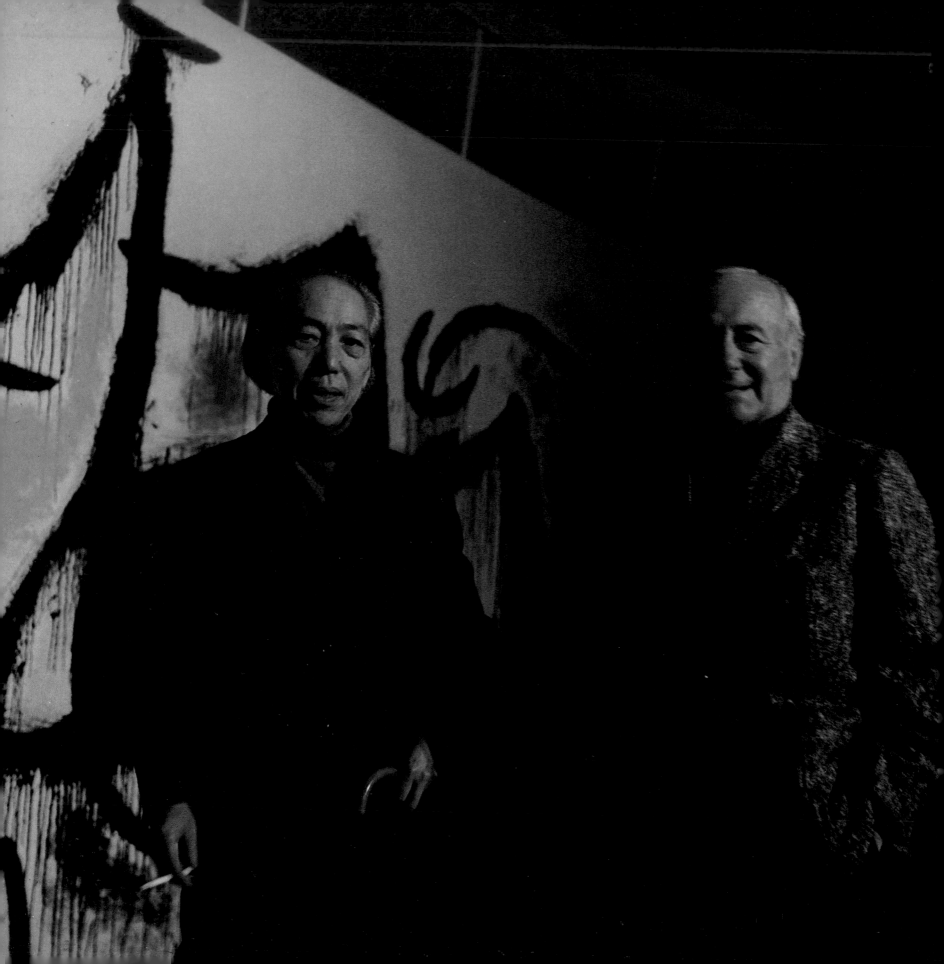

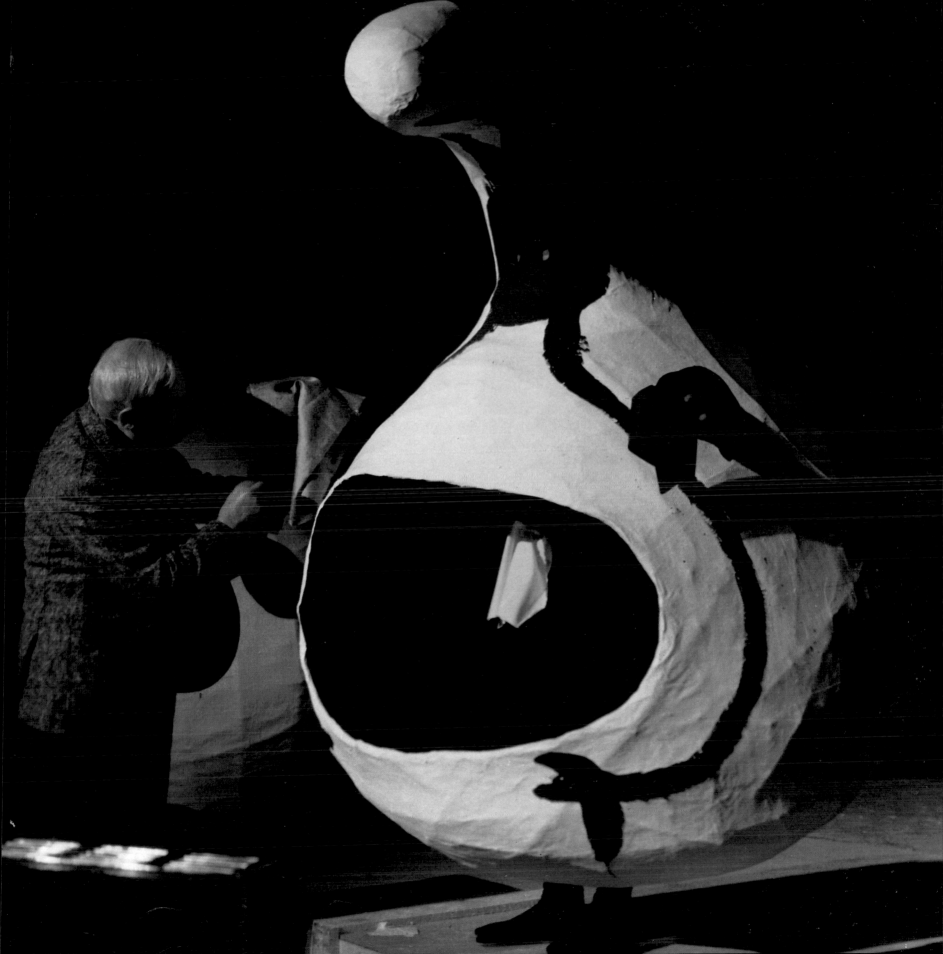

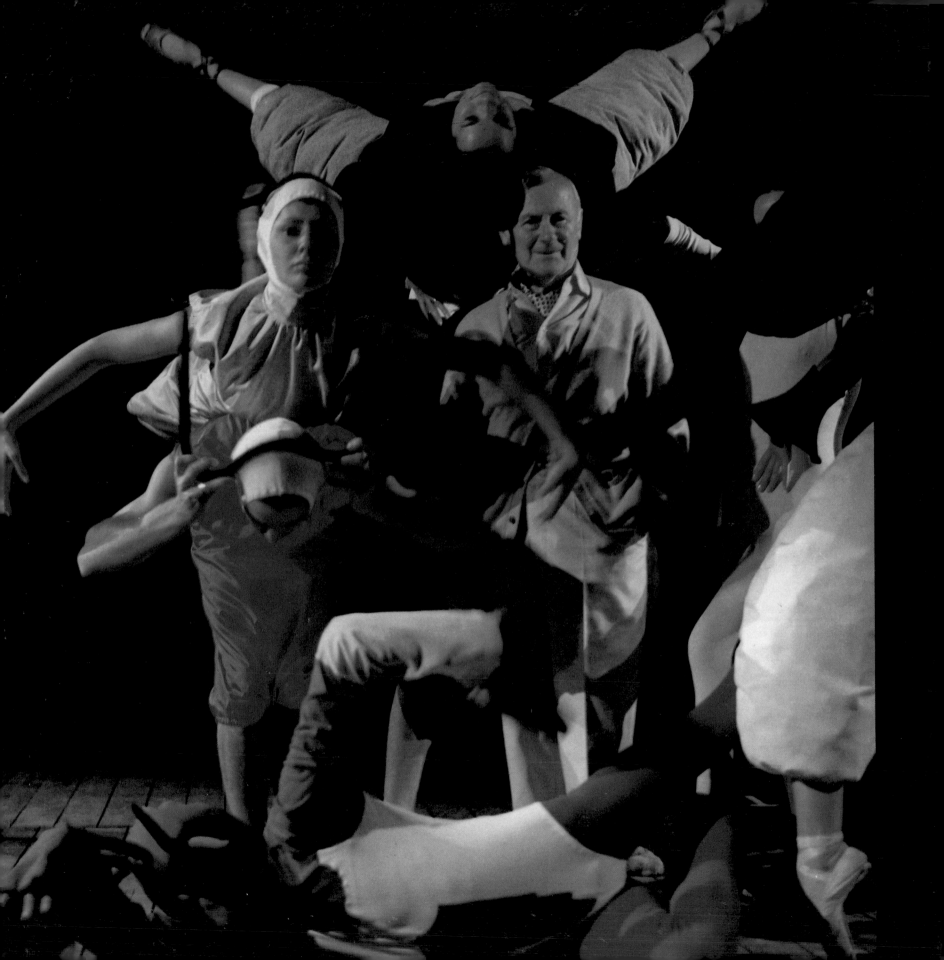

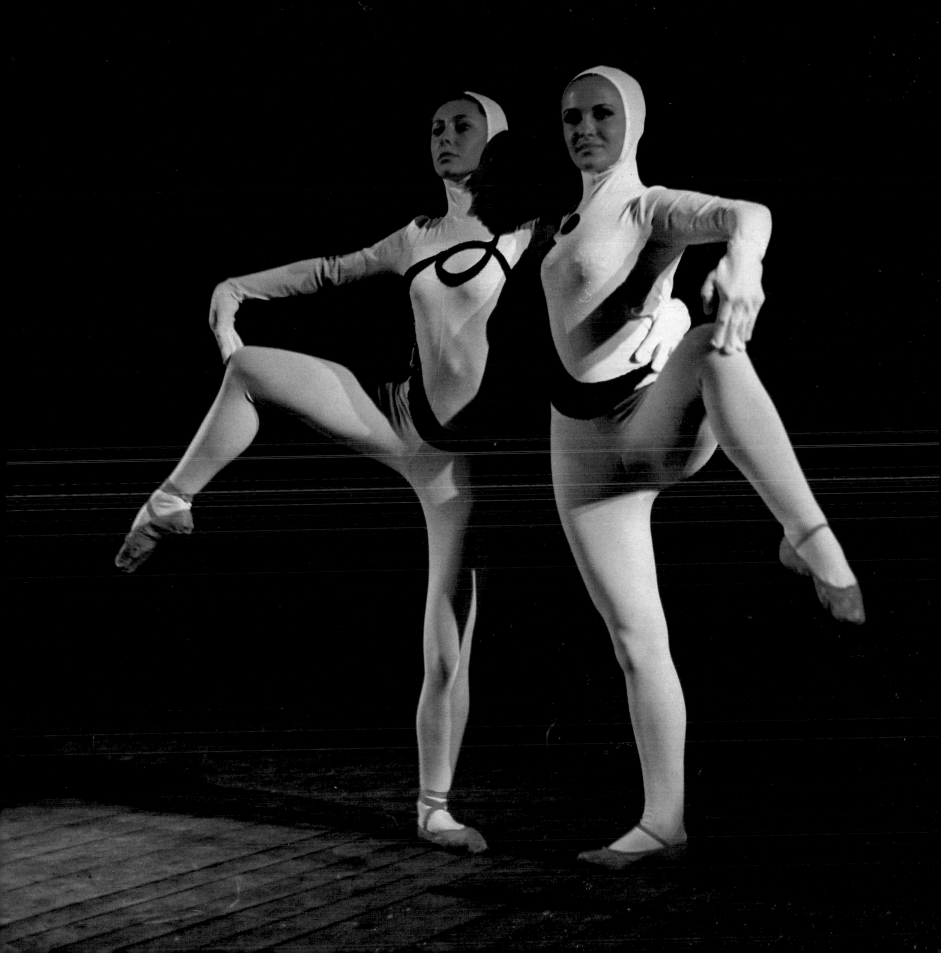

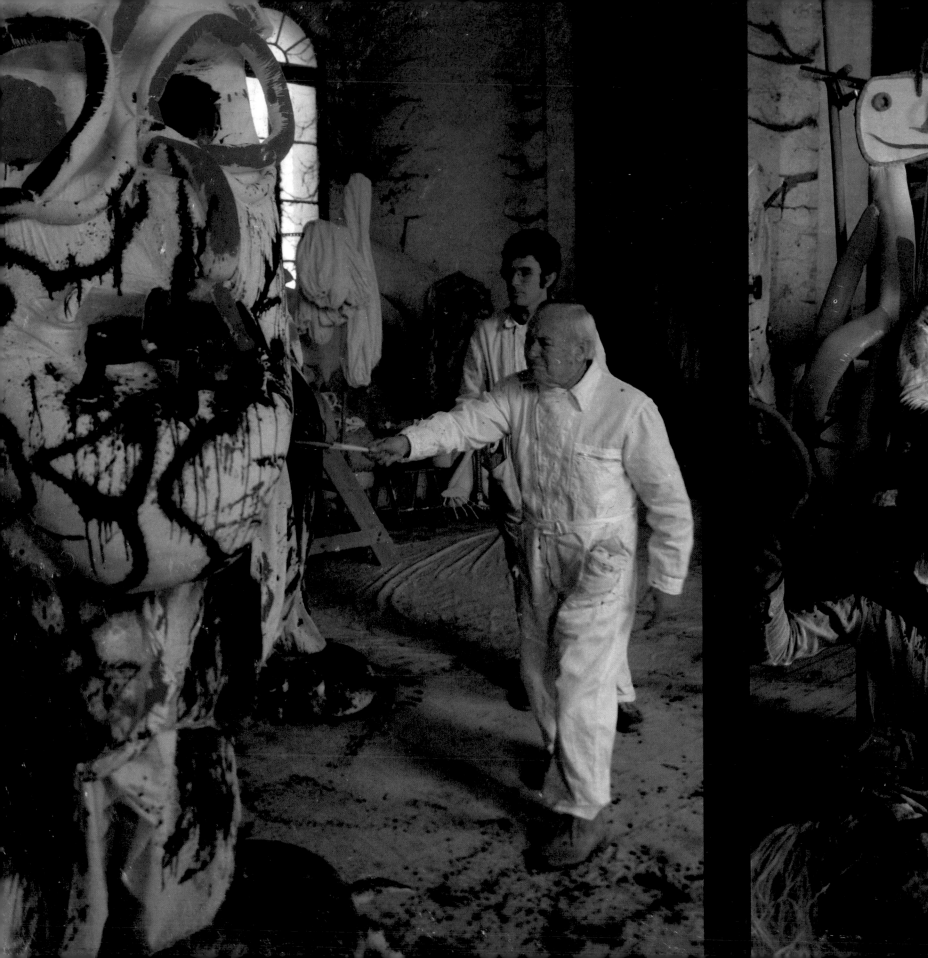

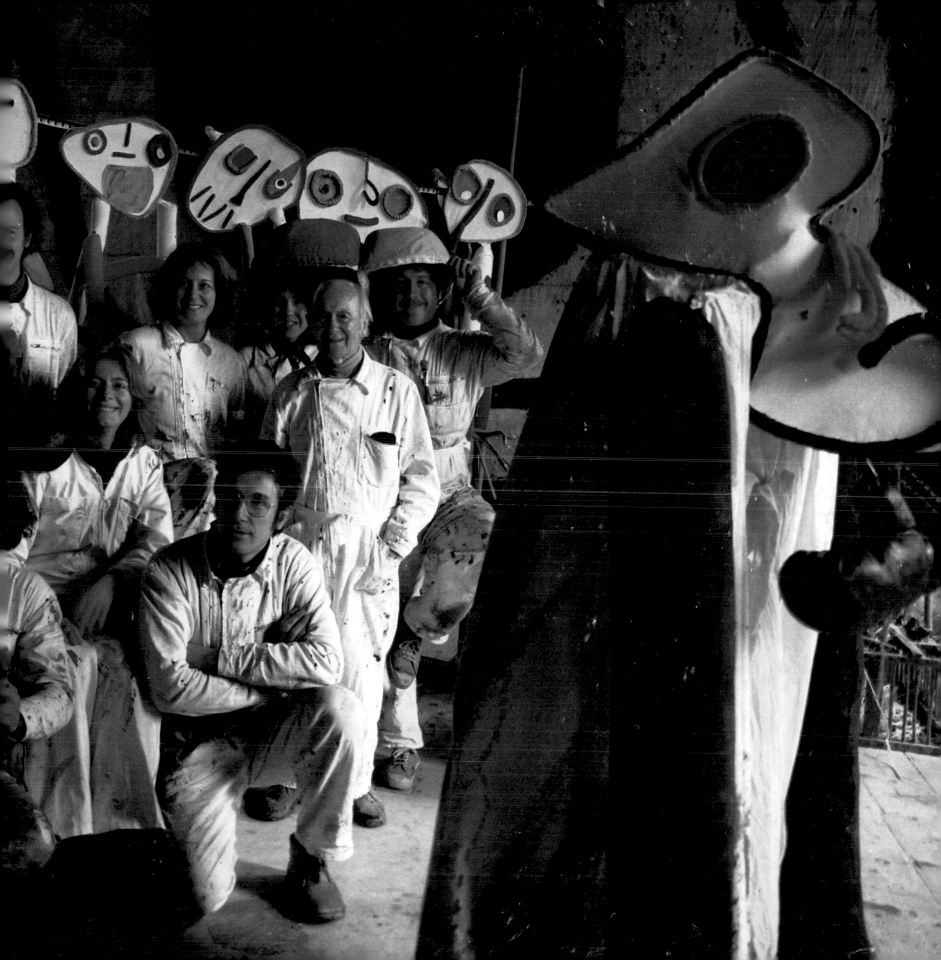

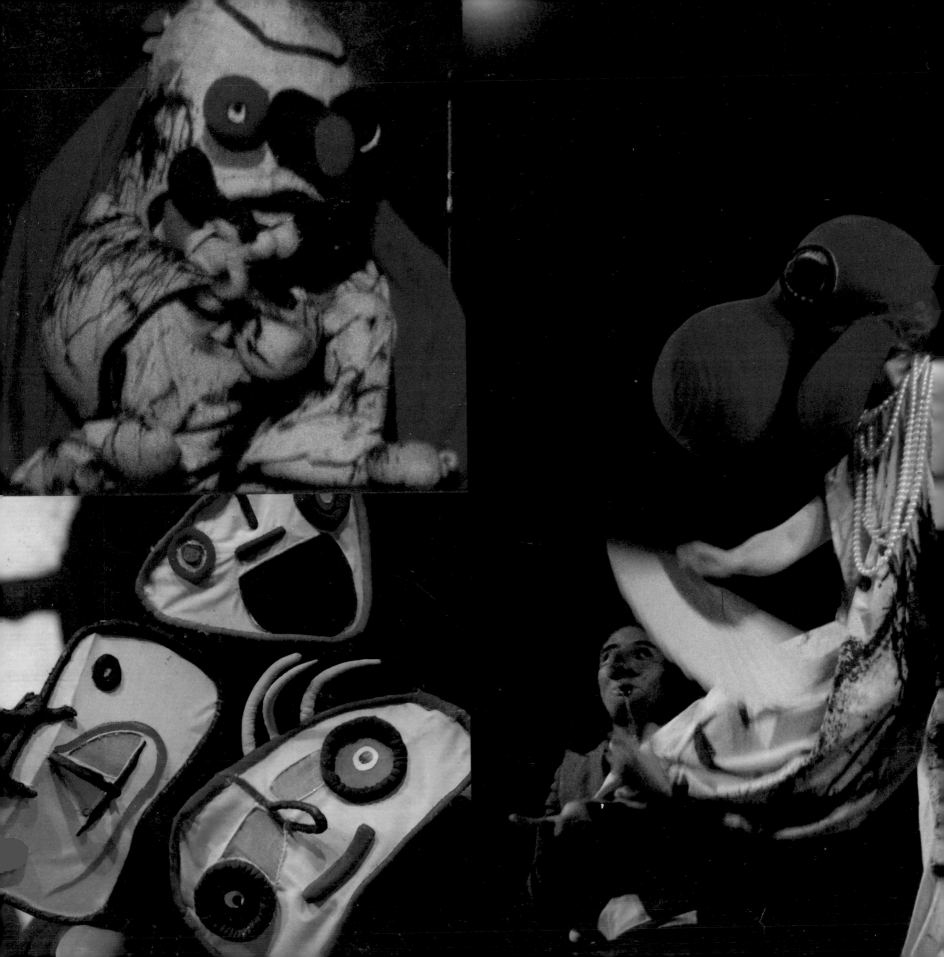

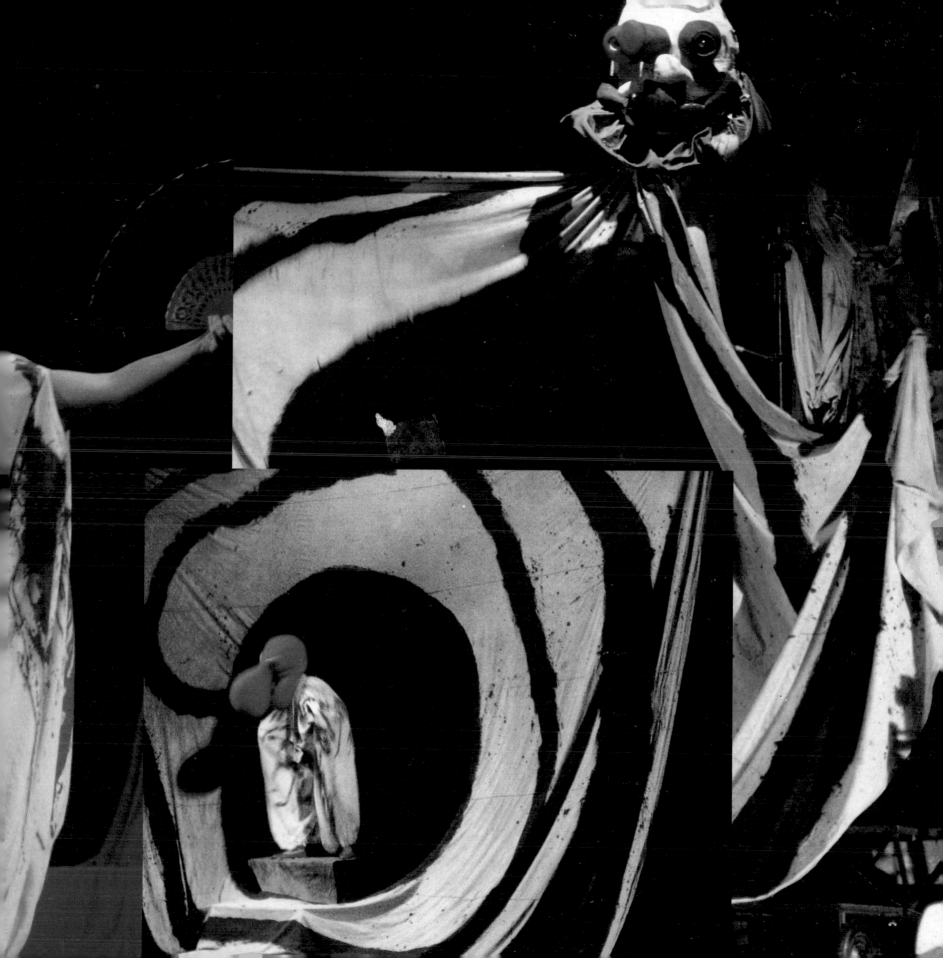

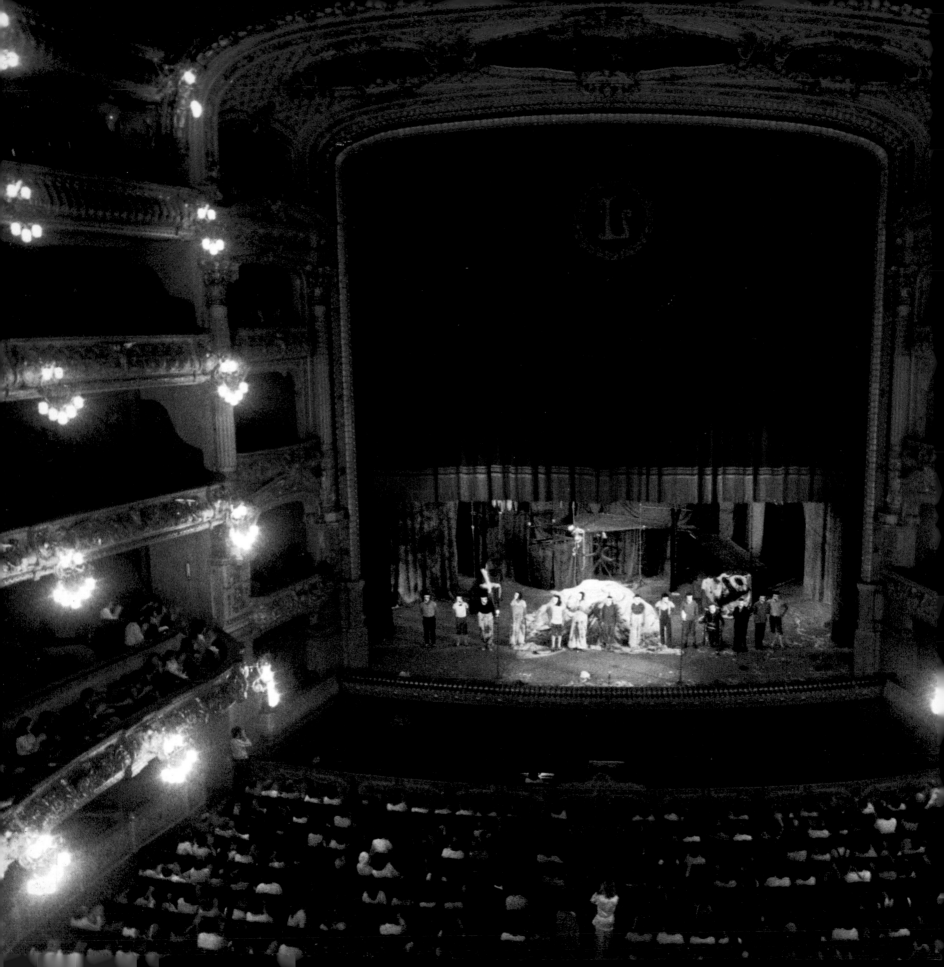

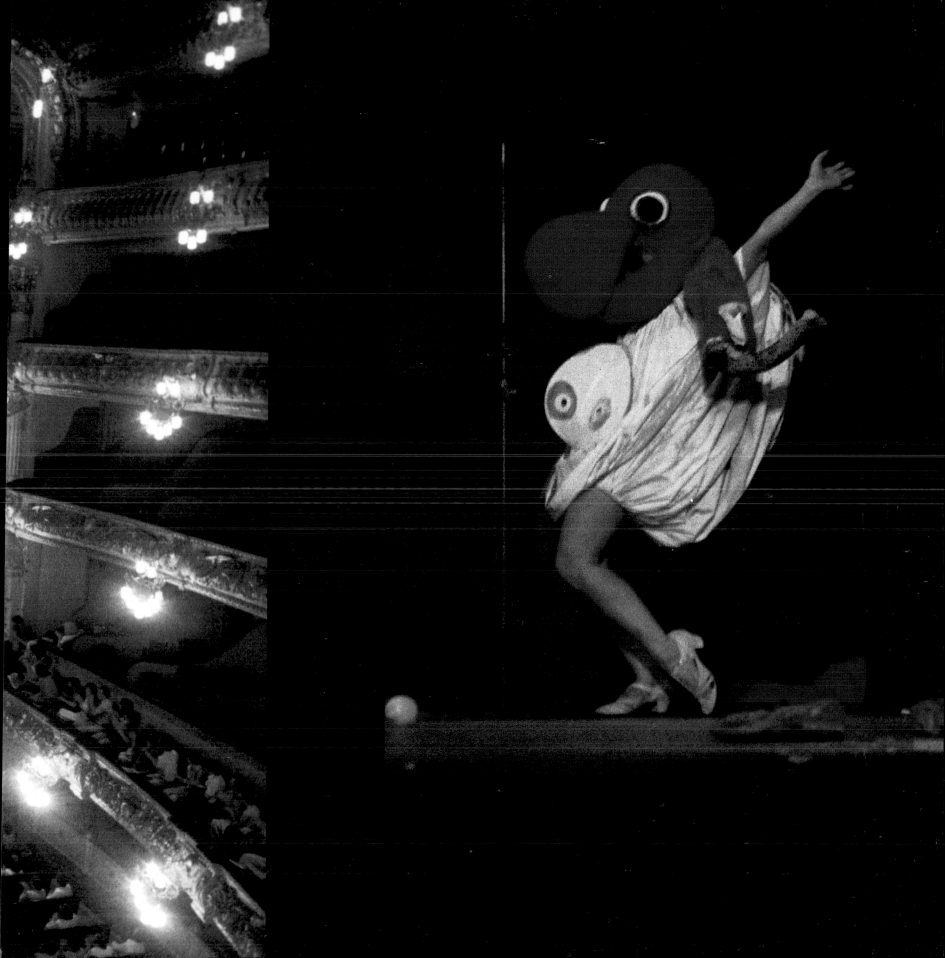

129.
The Japanese poet Takiguchi, an admirer of Miró, went to Osaka to witness an event the artist had planned.

130.
Miró is completing this huge pumpkin which, with a man inside, will dance at the event in Osaka that is to celebrate the presentation of the mural.

131.
He made the puppets for an avant-garde ballet by his poet friend Jacques Dupin. The artist surrounded by the ballerinas.

132.
The mystery of the theatre cast a spell over him, for it gave life and movement to his works.

133.
For a whole week in 1978 he shut himself up with the actors of Mori el Merma *and, improvising frenetically, dedicated himself to painting all the puppets.*

134.
Amid the players in Mori el Merma, *taking a well-deserved rest after an exhausting task.*

135.
When everything he had made came to life, it created one of the most violent—but also thought-provoking—effects ever remembered on stage.

136.
Besides the puppets and objects, he also painted two large, gravely dramatic curtains.

137.
In Mori el Merma, *a Ubuesque satire against Francoism, avant-gardism and sarcasm invaded the citadel of academicism and the bourgeoisie.*

138.
The spectacle of the monsters on the stage of the Liceo displayed a satire that was quite surrealistic.

X. TEXTILES AND TAPESTRIES

The last experiment that Miró undertook outside the realm of easel painting was with the craft of tie-dyeing. We would have to wait until the early 1970s to see the first tapestry and woven work. Here the man—like the Parelladas for sculpture, Papitu Llorens Artigas and Joanet Gardy Artigas in ceramics—was Josep Royo. Once again Miró had made a good choice. This artist knew how to interpret Miró's atmosphere and create it through manual work and textile material. And lest any doubt about his innate rebelliousness remain, we find with astonishment how, (at 80!), he embarks, with bold determination, on the adventure of weaving. This was a completely new language that even incorporates humble, playfully handled materials. In my view, it is a demonstration of enthusiasm which will stand as an example to future generations.

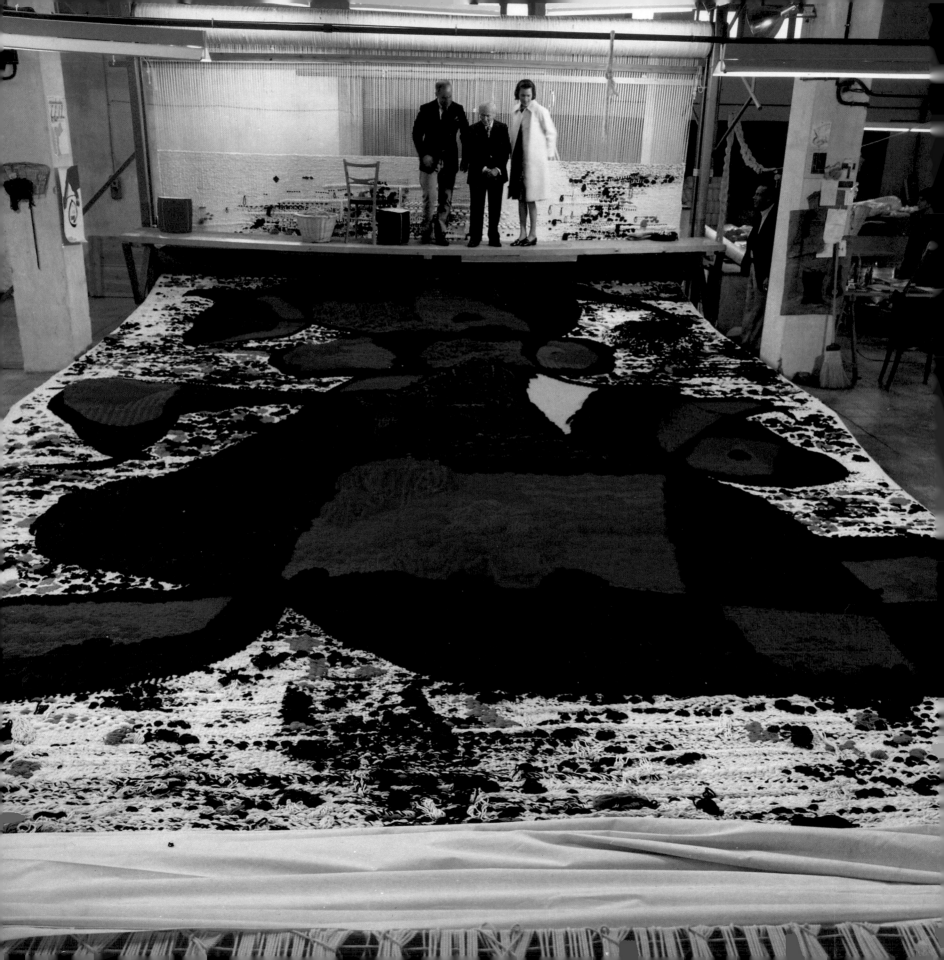

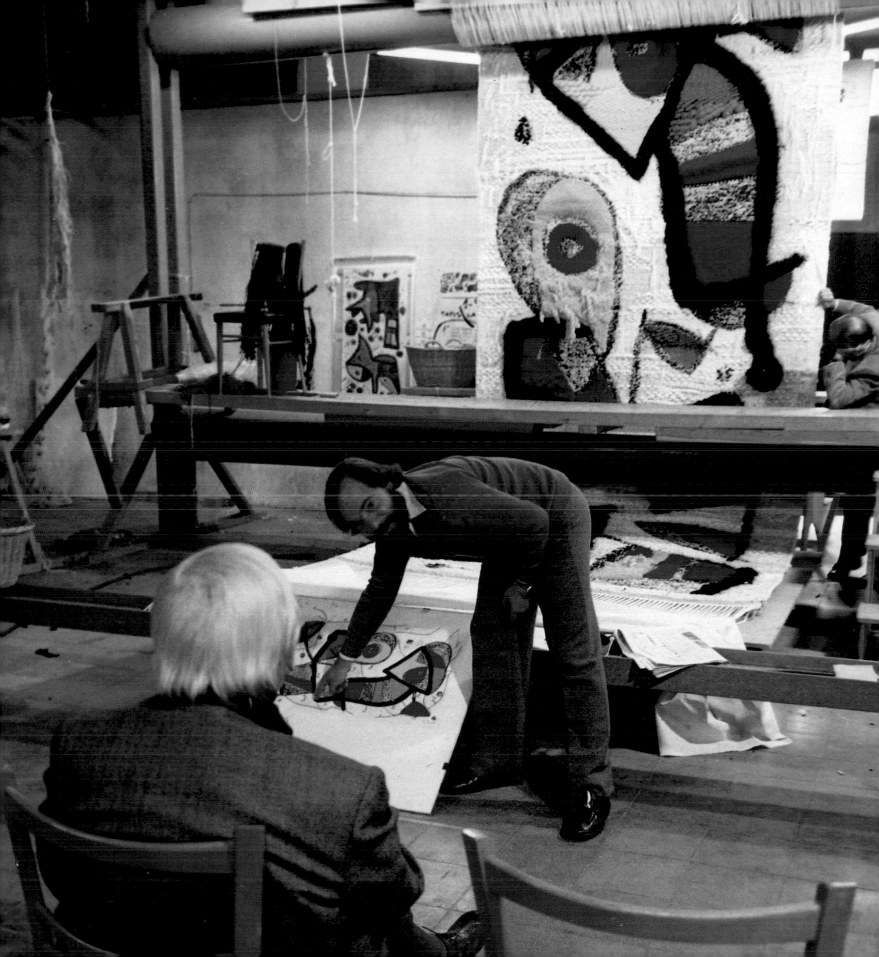

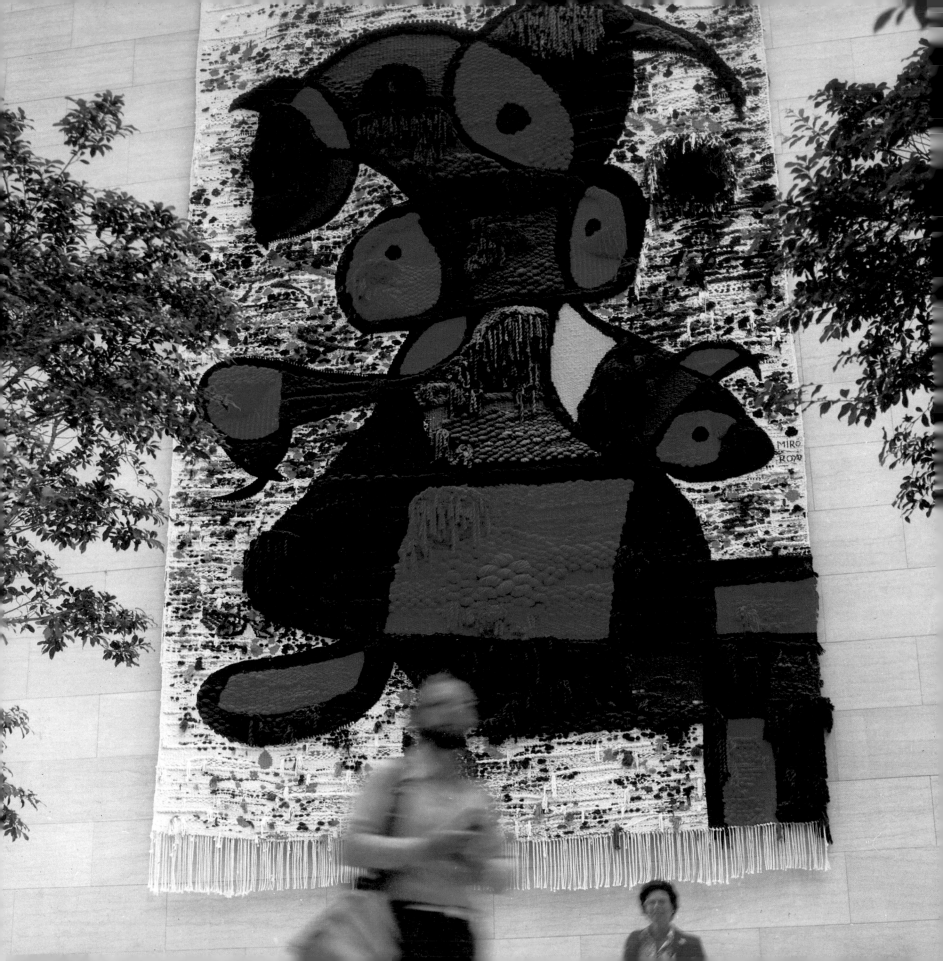

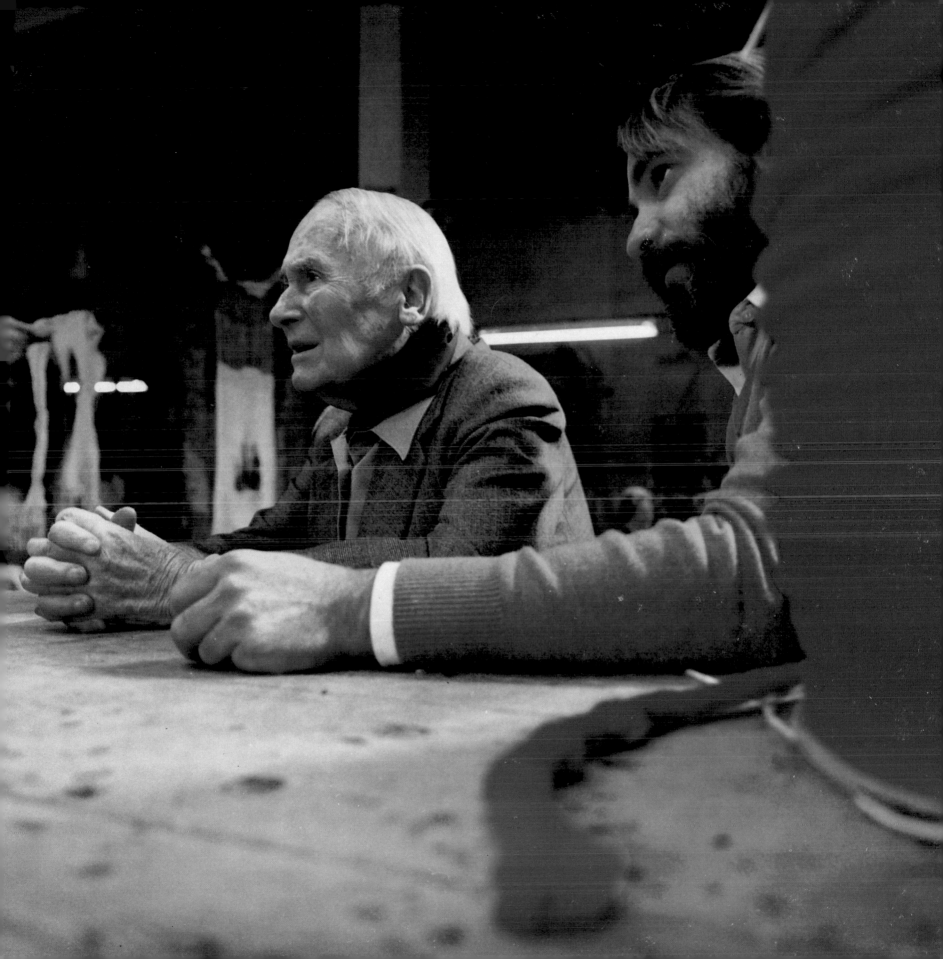

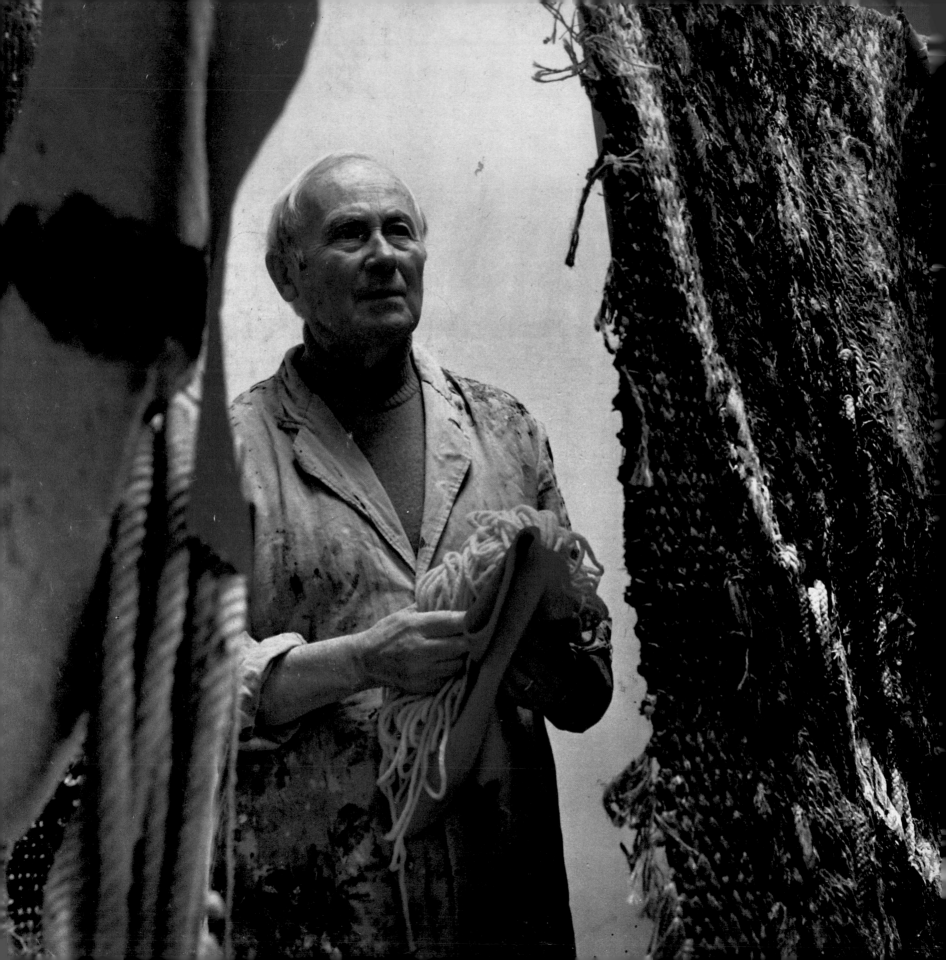

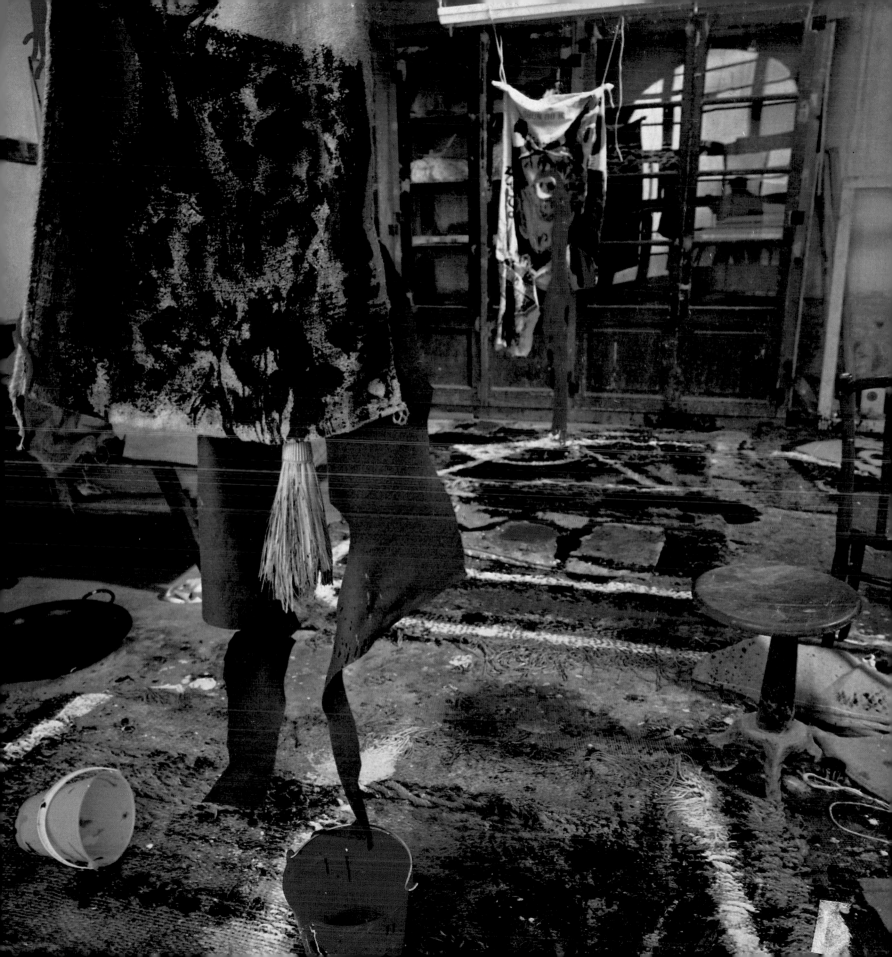

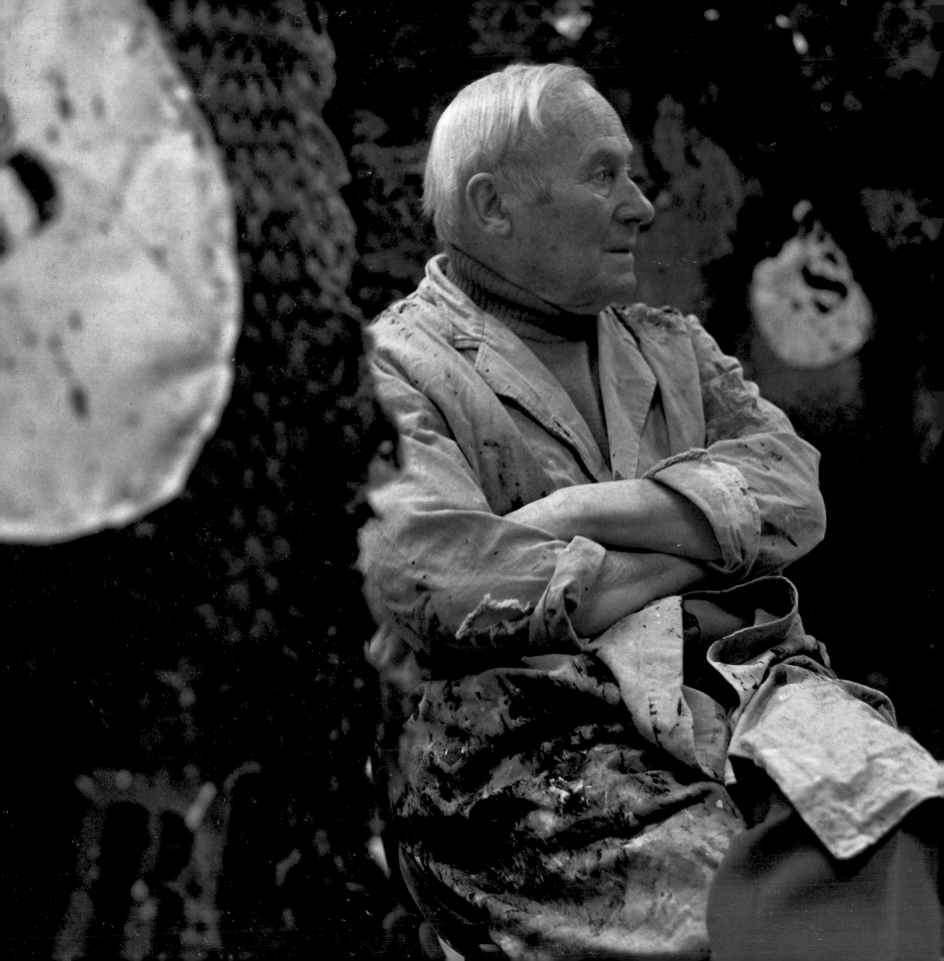

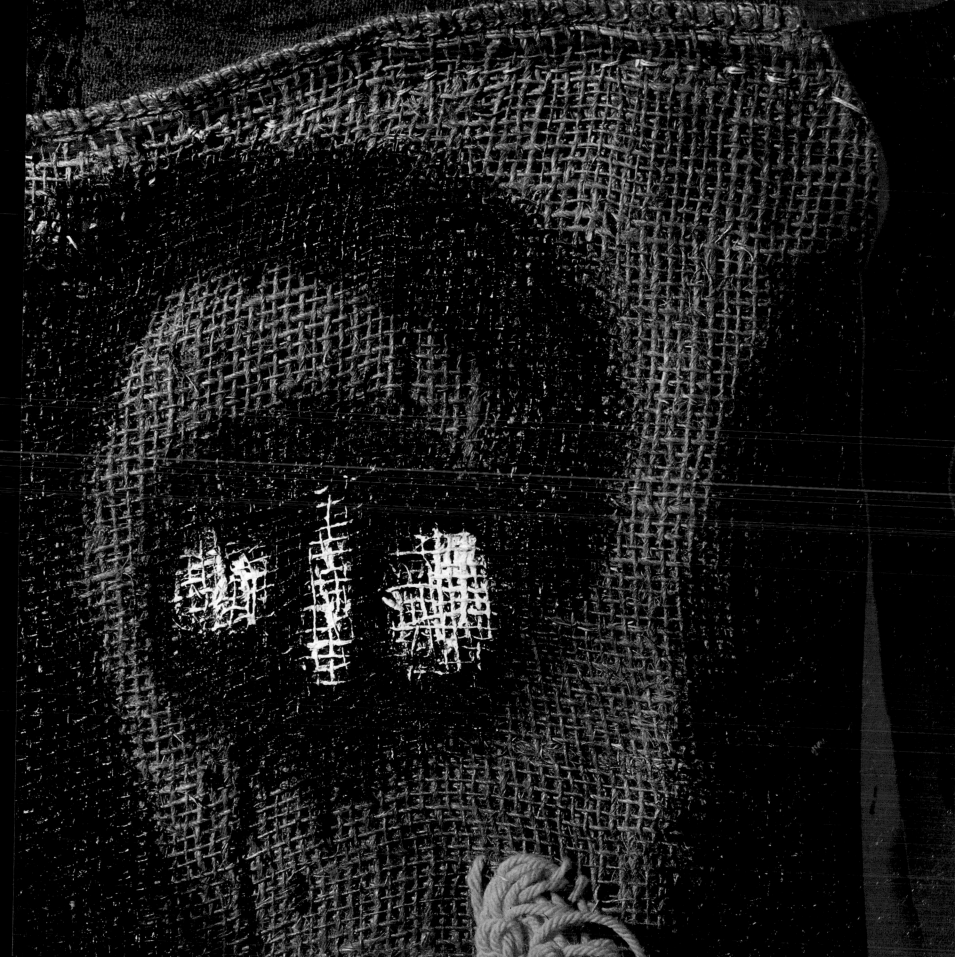

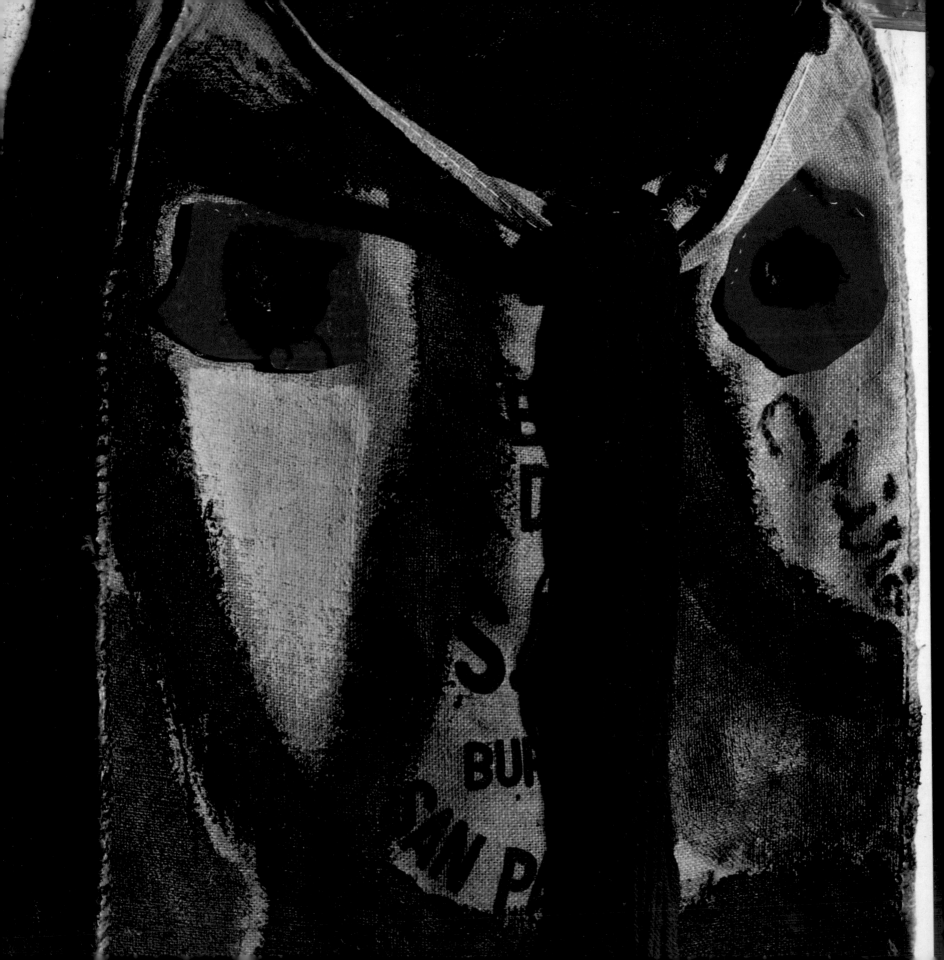

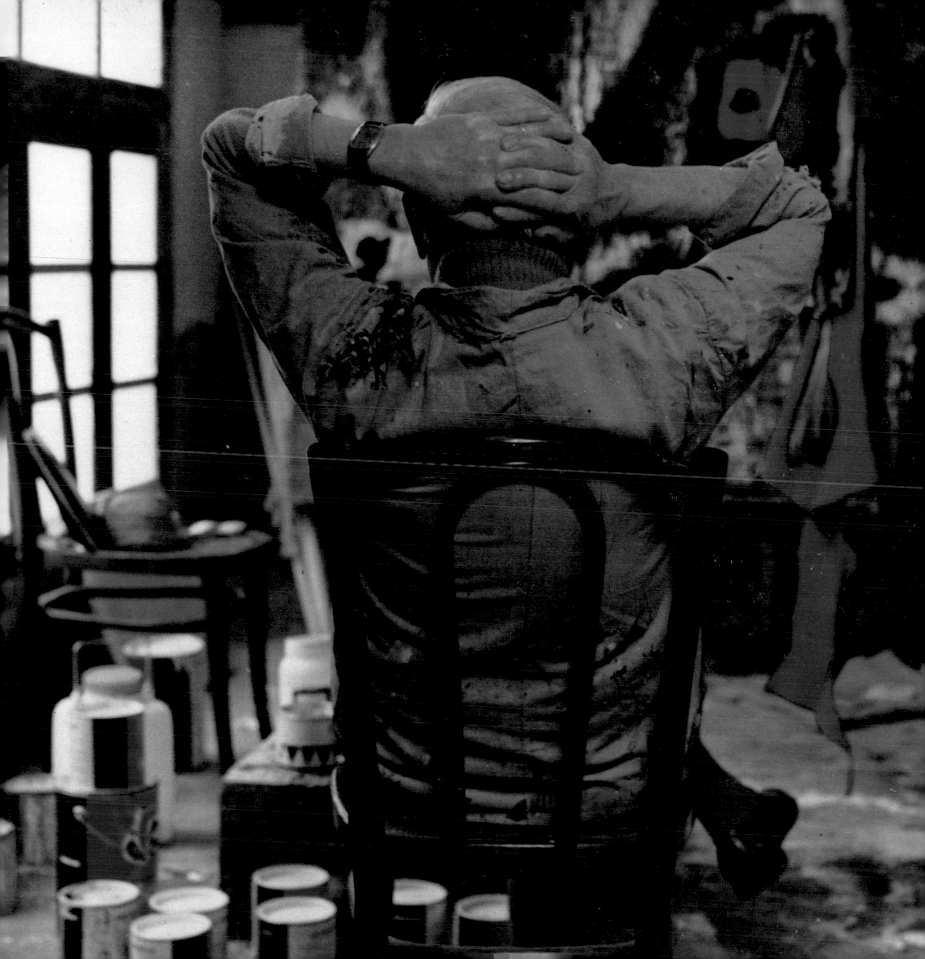

139.
With Maeght he follows the course of one of the large tapestries he made in collaboration with Royo in Tarragona.

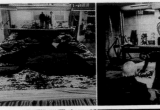

140.
Josep Royo was for tapestry what the Artigas had been for ceramics. Royo knew how to interpret Miró's creativity.

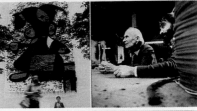

141.
One of the two largest pieces they made: the tapestry in the National Gallery in Washington, 6 metres (19 feet) wide and 11 metres (36 feet) high. The other is in the Miró Foundation.

142.
Miró and Royo approached the tapestry directly and studied the incorporation of new elements or discussed the result of the work that had already been done.

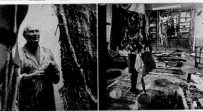

143.
In 1972 and 1973 he spent his time creating textiles and this led to the woven works and the sacks. As always, he concentrated entirely on the new medium of expression.

144.
The woven cloths and sacks once more indicate his application to front-line avant-gardism even at the age of 80.

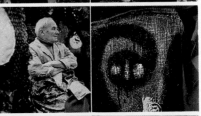

145.
All day he would be busy going over and over the same work until he found the solution; then he would plunge deep into it with determination and his unique brand of courage.

146.
No matter how difficult the object was, as soon as he had started working on it, a sack or anything else, it would disappear amid the brilliance of the strokes and colour.

147.
It used to be a sack: now it's a Miró. We have here an example of adaptation to the medium: this Mironian character was formed in a different way from the previous ones.

148.
In the studio, surrounded by the plastic world he had created, he felt truly happy and time ceased to matter. For Miró, work was life, and he lived as long as he could go on painting.

CONTENTS

INTRODUCTION

'The more I work, the more I want to work. I'd like to experiment with sculpture, ceramics, prints, to have a press. I'd like to move beyond easel painting, which I find restricting, and discover new ways of getting closer through my work, to ordinary people'.

Joan Miró, 1938